D0578891

HANDS AT WORK

PORTRAITS AND PROFILES OF PEOPLE WHO WORK WITH THEIR HANDS

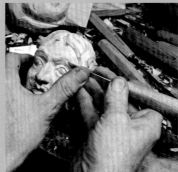 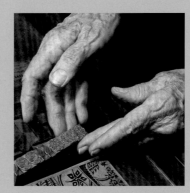

PHOTOGRAPHY BY SUMMER MOON SCRIVER
STORIES BY IRIS GRAVILLE

Thank you
for your Support
Summer Moon

For Sue & Phil –
Iris

Copyright © 2009 by Heron Moon Press

"Hands" by Phil Ochs
© 1972 Barricade Music, Inc. Copyright renewed.
All Rights Administered by Almo Music Corp. (ASCAP)
Used By Permission. All Rights Reserved.

All rights reserved. No part of this book may be reproduced in any form,
except for brief reviews, without written permission of the publisher.

Heron Moon Press
P.O. Box 923
Lopez Island, WA 98261

ISBN: 978-0-615-22018-5

Library of Congress Control Number: 2008930837

Designed by Lanphear Design, Seattle, WA

Body text set in ITC Legacy Serif

Printed in China by Oceanic Graphic Printing, Inc.

Heron Moon Press supports the use of recycled paper with environmentally
friendly inks in an effort to reduce the book industry's environmental impact.
We are pleased to use 100% recycled paper and soy-based inks for this book.

First Edition

TABLE OF CONTENTS

INTRODUCTION

Passion. Satisfaction. Connection. Surprise. Pure love. These aren't the words people typically use when talking about their work, but they are said over and over by the forty-two people whose thoughts and images fill these pages. This book is a response to questions about what provides meaning and fulfillment in work. These stories and photographs offer insight into that mystical, awe-filled rightness that many people yearn for, but often don't feel, during the long hours spent at work. Such fulfillment can be experienced in many kinds (and perhaps any kind) of work, but the people profiled here find it in labor with their hands.

In *The Reinvention of Work,* Matthew Fox writes, "When work moved from farm to city, from land to concrete, from hands to machine—in short, when the industrial revolution redefined the meaning of work for us—much was lost. Perhaps the greatest loss was the sense of cosmic wonder, of interrelationship with the universe, with nature, with the stars and breezes and plants and animals that was integral to workers on the land. No paycheck can make up for that loss." The people featured in this book have found a way to make up for this loss: they use their hands to shape, slice, birth, repair, heal, communicate, and harvest. They talk of living in their hands and needing to get their hands dirty, cold, or wet. For them, the materials they use are alive and responsive; their hands teach them things they didn't know and connect them to different times, places, and people.

Hands at Work was inspired by a 2004 art exhibit of Summer Moon Scriver's black-and-white photographs of hands. Those images of strong, weathered, soiled, muscled hands engaged in knitting, kneading dough, digging potatoes, and spinning wool hinted at a passion for work that has become rare for many Americans. The photos suggested that these people were not only willing to labor with their hands but were also nourished by that labor. As a writer, I immediately wanted to give voice to their stories.

It was as a nurse that I first listened to people's stories. In hospital rooms, exam rooms, and homes, I experienced an uncommon intimacy as people shared their fears, hopes, grief, and pain. I knew that, in many instances, my listening supported their healing. Twenty years later, disillusioned with the changes in health care, I shifted my work from caregiving to storytelling. I've written about a variety of people and places: homesteaders in Mexico, hurricane survivors in Nicaragua, life in a remote mountain village, and senior citizens in my rural community.

I never know who or what will call to me for telling, but I've learned to heed those stirrings of a good story. Summer's photographs conveyed a sense of passion rarely found in images of work and prompted me to approach her about combining words with the images she had captured on film. Thus began a collaboration between photographer, writer, and people who work with their hands.

We had no difficulty finding a cross section of individuals who rely on their hands for their work in our small, rural community on Lopez Island in Northwest Washington, though we did venture beyond our home for a few profiles. Most people were humble when asked to participate, doubting that their work, their stories, and their hands could be of any interest or importance. Yet as we talked with and photographed them at work, their fervor for painting, weaving, fishing, cooking, quilting, sculpting, boat building, puppeteering, and car repair was palpable and exhilarating. All expressed gratitude that someone was eager to watch and listen as they went about the work that feeds their souls.

For some of the people profiled here, work with their hands is their livelihood. For others, the work is supported by a "day job." For many, their work is much more than a nine-to-five activity; it is a way of life. None of them followed logical, calculated paths to their vocations. Some, like the potter, vibraphonist, and letterpress printer, came to their work early in life and had an immediate sense of settling into their true calling. Others, like the chef and the oboe maker, were nudged into their work by someone else or, like the boat builder, got swept up in an element of romance and mystery. Some are on second or third careers, having arrived at their heart's work later in life. Most are drawn to what they do because it provides connection—to people, to old traditions, to nature, or to their heritage.

Gratitude is another word that repeatedly comes up as these people talk about their work—gratitude for the ability to do what they feel passionate about, for the support that allows them to do this work, and for their work environment. Many tell stories about their tools and materials. "I own no diamonds except the ones I use to cut stone," says the sculptor, and she cherishes her chisels which once belonged to an elderly Italian carver. The blacksmith retrieves steel from the recycling center, and the printer rescued her press from a barn in Idaho.

All talk of what their work teaches them: patience, precision, diligence, and appreciation for the process. Most have learned, as the quilter claims, "There's no one right way to do anything." Others, like the reef net fisherman, have gained wisdom that can be applied to much of life: "Don't be quick to give up, because you never know when the fish will come."

We were honored to spend time with the people whose skill and knowledge are portrayed here. They welcomed us and our lights, cameras, pens, and notebooks into their studios, farms, kitchens, and workshops. They shared their frustrations and disappointments as well as their delights and accomplishments. Whatever your work is, we hope you will be as moved as we were by their words and images and perhaps inspired to discover passion, satisfaction, surprise, connection, and even love in your own labors.

Iris Graville

Ali Tromblay kneels silently on the floor next to a six-foot-square bathtub. Her right hand strokes the head of the pregnant woman sitting in the warm water. Then Ali squirts gel onto a turquoise stethoscope and presses it to the woman's bulging belly. A muffled, rhythmic whooshing of a heartbeat brings a smile to both women's faces. With her hands, Ali cups warm water over the woman's abdomen and crouches close to her ear.

"Do whatever you need to do, Joan," Ali whispers. "You're doing great. With your next contraction, I want you to move your baby down." Joan scrunches her face, digs her chin into her chest, and grunts loudly. "Perfect," Ali says. "You're really close. That's why it's so intense."

Both women and the soon-to-be-father take some deep breaths. Ali, a midwife for the past ten years, has repeated these words and actions hundreds of times. Tonight at the birth center, things are proceeding quickly. Ali hadn't expected this woman to go into labor for two more weeks, but when Joan arrived fifteen minutes ago, she was in active labor and ready to get into the tub for a water birth.

A Bach sonata plays quietly in the background; four rosy votive candles flicker on the windowsill. Ali rocks slowly back and forth on her knees and hums softly until another contraction begins. Joan groans louder and pushes harder. "Your tissue is really stretching perfectly," Ali reassures her, gently pressing her hands to the woman's bulging vulva. "Reach down," she instructs Joan. "Feel that? That's your baby's head."

Joan leans her head on the back of the tub, and she and her husband make a sound that's part laughter, part crying. Over the next few minutes, she takes deep breaths and pushes, rests, then pushes some more. Ali says little; when she does, it's to offer soft encouragement and give simple instructions. The calm and concentration contrast with the drama unfolding.

Ali is ready for the transition she is witnessing—a woman becoming a mother. Joan pushes again, her grunt turns into a bellow, and suddenly Ali's hands are catching the baby as he appears in the warm bath. In an instant she has lifted him out of the water and placed him on his mother's chest. Ali drapes a white towel over the tiny wrinkled, mucus-covered body and briskly rubs him dry. "Hello, baby," she says.

The brand-new mom whispers, "Welcome to the family," and kisses the top of her baby's head. Joan and her husband stroke their baby's cheek and watch as he struggles to open his eyes. Ali slides a miniature white cotton cap over the swirls of damp, dark hair on the baby's head and presses a tiny stethoscope to his chest. The throbbing umbilical cord is still attached, continuing to provide the newborn with oxygen. "Hi, little feet," Ali says, rubbing the soles of each with her thumbs. The baby opens his mouth and takes a deep breath, and everyone else in the birthing room does, too.

As mother, father, and baby continue to get acquainted with each other, Ali stands by for the few additional contractions that release the

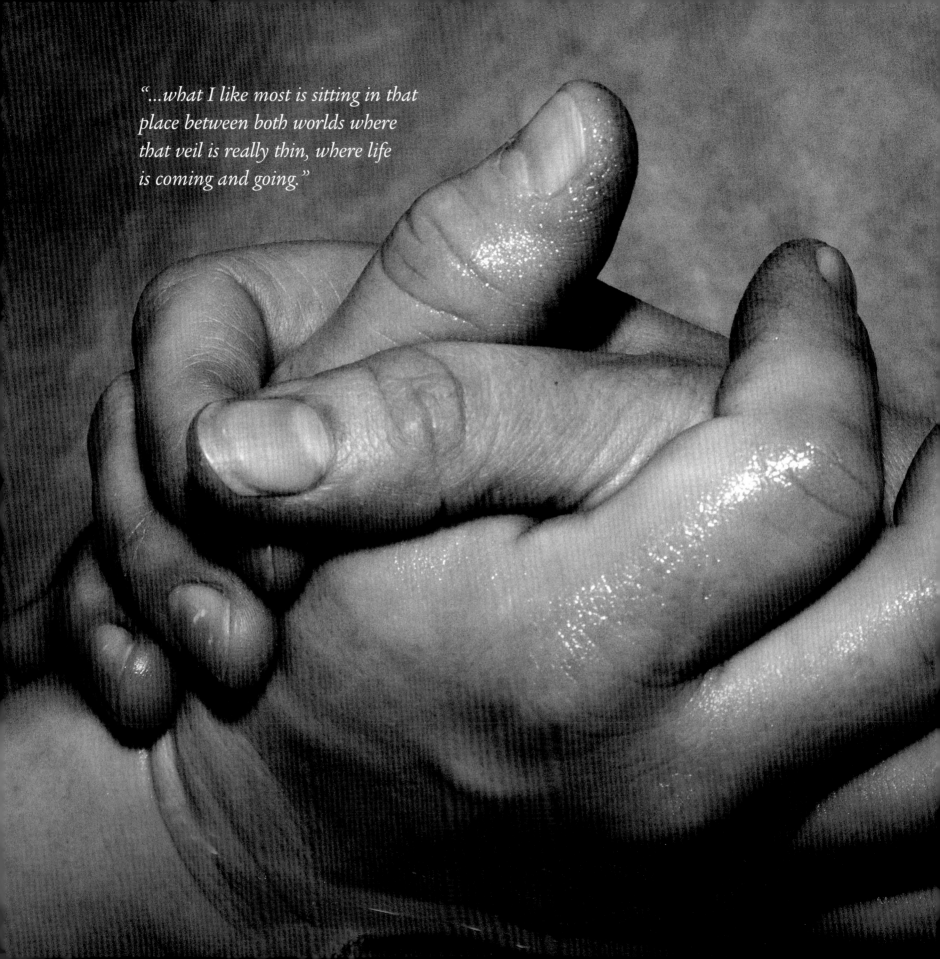

"...what I like most is sitting in that place between both worlds where that veil is really thin, where life is coming and going."

*Catching a baby coming out is the easy part. That's the big,
exciting moment. Getting to that point is the hard part."*

placenta. "Dad, do you want to cut the cord?" she asks, guiding the new father's hands to clamp and cut it.

Within twenty minutes, Ali has helped the mom out of the tub and guided her to nurse her baby for the first time. Over the next four hours, the midwife remains in the background, offering supportive care as parents and baby begin their new relationships as a family. Intermittently she checks the mother's vital signs and examines the baby. "Look at how peaceful you are, such a peaceful little guy," she coos as she weighs and measures the baby and takes his footprints.

The next day—one of the rare ones when Ali has a break from prenatal and postpartum visits and no one is in labor—she talks about her work.

"I've had a lot of 'jobs,' but midwifery is my soul's work, my work that comes from a deeper place," she says. "I'm a licensed midwife, but I always say I catch babies—physically, spiritually, and emotionally. Doctors typically say they deliver babies. I think it's the women who deliver them, and I catch them, or I help their partners catch them. Catching a baby coming out is the easy part. That's the big, exciting moment. Getting to that point is the hard part."

Ali isn't just talking about the hours of contractions that inch a baby into the world. "There's so much the mother has to travel through—her past, her fears. It involves birth and death for both the mother and the baby. Sometimes a woman will be really tired or afraid to push because of the pain, and the baby is showing signs of distress. I'll say, 'You need to push your baby out now.' Then I watch that shift where she cares more about her

baby than herself. That's the moment she becomes a mother, and being a part of that is huge."

Throughout the process, Ali makes hundreds of observations and decisions. "It always feels like a dream when I'm in the middle of a birth. Sometimes I'm doing ten things at once, like helping the woman focus, listening to the baby's heart rate, suggesting a different position for the mom, or demonstrating massage techniques the dad can use to relax her. But what I like most is sitting in that place between both worlds where that veil is really thin, where life is coming and going. Often I can feel a baby enter its body. Sometimes babies are born and don't breathe right away. It's like they're deciding if they really want to do this. I think there's something about them being called to life here."

Ali rides this roller coaster of birthing at the busy, free-standing birth center she owns with two other midwives. Women come here for prenatal care and postpartum and newborn follow-up. The center has three birth suites designed and furnished like large, comfortable bedrooms. Ali typically attends six of the twenty-five births a month that take place at the center or in homes. "People told me I couldn't make it financially as a midwife," Ali says. "I'm most proud that I've been able to do good in the world *and* make a decent living doing my soul's work."

It took Ali some time to find her soul's work, and when she did, a lot of preparation still lay ahead. "When I was a kid, I thought I wanted to be a veterinarian," she says, "so while I was in college, I worked as a vet tech. I discovered I didn't want to work with neurotic pet owners, so then I thought I'd go into medicine and be an obstetrician." She had

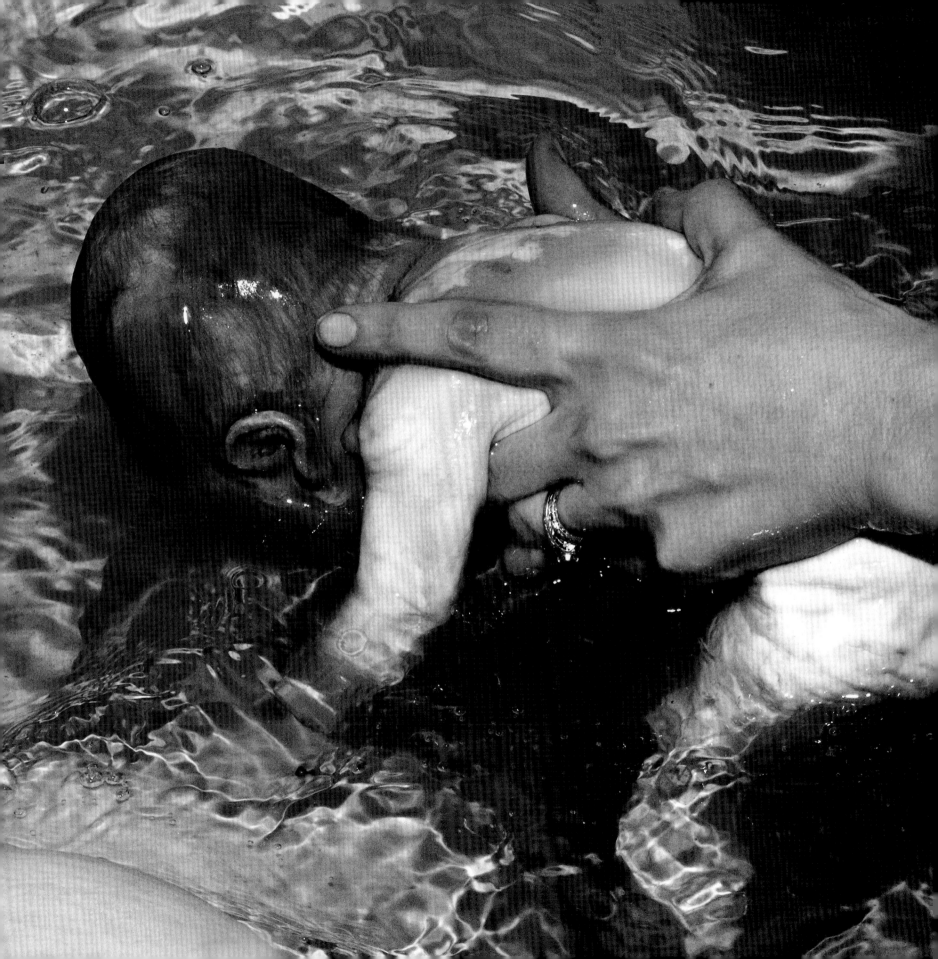

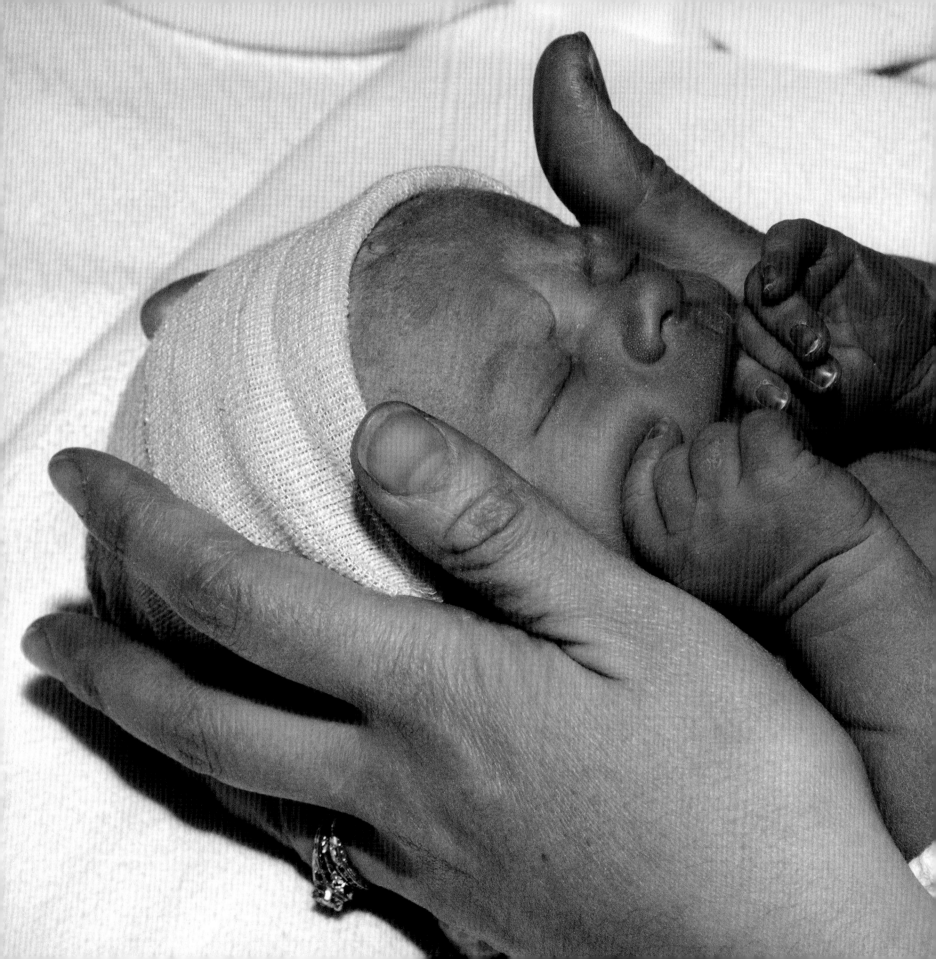

started pre-med classes when she was invited to a birth as a support person. "The birth was attended by an experienced midwife," Ali remembers. "I watched her as she sat, watched, and then suddenly shifted into high gear when the baby had trouble. I thought, 'I could do that.' It appealed to both sides of my brain."

For two years, Ali attended births and worked as a doula, supporting women during pregnancy, childbirth, and early postpartum. In 1997, she entered the Seattle Midwifery School. After three years of classroom study, a preceptorship with four different midwives, and attendance at one hundred births, Ali received her midwifery license.

"I've seen a lot since I graduated in 1999," she says, pushing a tendril of gray-streaked, wavy brown hair behind her ear. "Babies who are born damaged or who die—that's devastating. I had a baby die once. I reviewed the records with the doctor, other midwives, the hospital, the lawyers, and I knew I couldn't have done anything different. I came to believe that, like all babies, that baby had its own story and I was just one part of it."

Fortunately, most of those stories, like yesterday's water birth, are happy ones. "We screen all of our clients for HIV and hepatitis, and when I know the risk of infectious disease is low, sometimes with water births I'll do a bare-handed catch like in the old days. Without gloves I can feel nuances and some of the subtleties with the skin. Newborn babies are really soft and warm when they come out, and you can't feel that with vinyl gloves. The mom yesterday was fine with me catching the baby without gloves."

Photos of healthy newborns and glowing new parents blanket every inch of the bulletin board in the birth center's hallway. Women in various stages of pregnancy walk by on their way for prenatal checkups with one of the other midwives. In a few days, Ali will be back on duty.

"The other midwives in my practice and I spend all of our energy and our time taking care of our clients, encouraging them to eat well, rest, really pamper themselves," Ali says. "But we're so busy, that what we advocate for them is not what we do for ourselves."

In addition to seeing clients in the office and attending births, Ali is on call every other week. Equipped with a pager and a cell phone, she is available twenty-four hours a day in case any of the center's clients need help. "It might be something simple like cramping or concerns about the baby's movement, or it could be something serious or someone going into labor. I often leave home without knowing for sure when I'll be back. Sometimes it's days."

That takes a toll on Ali's beloved, Alysia, and the couple's two sons, fifteen-month-old Rafael and two-and-a-half-year-old Gabriel. "After a really busy on-call week, I spend part of the next week recovering," Ali admits. "As much as I try to make my calendar look like there's a routine, there's so much I can't control."

There's also much out of Ali's control during labor and delivery, but her years of experience have taught her the importance of sitting and listening. "I've learned that prayer works," she says. "And that it matters what you say to women at times of vulnerability. They'll tell me that what I said changed their lives. It's usually simple things such as, 'You're so strong. You can do this.' And I tell them they're not alone. I'm here with them."

How does a professional musician in Los Angeles end up on a small island in Northwest Washington making replicas of an ancient woodwind that dates back to Egyptian times? If you're Sand Dalton, you start out as an art student, stumble on a notice for a new kind of art school, hit it off with a teacher who was a New York musician, and become captivated with a forgotten style of music that makes a comeback. Twenty-five years later, you're one of a handful of baroque oboe makers in the world, a teacher, and a sought-after musician heralded by the Canadian Broadcasting Corporation as "one of the leading baroque oboists in North America."

After his freshman year at Sarah Lawrence College in New York, Sand remembers, "I saw a little ad about a new school Walt Disney was starting up in Los Angeles called California Institute of the Arts. Disney envisioned it as a melting pot of the arts that would attract talented people in music, dance, visual arts, drama, and animation." Sand transferred there and studied graphic arts, printmaking, and figure drawing as well as music.

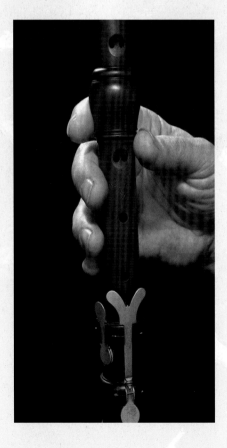

"Eventually," Sand says, "I shifted my focus to music because I got along so well with my teacher, Alan Vogel." While he was listening to recordings of baroque music played on original instruments of the mid-eighteenth century, Sand's ear picked up the great variety of sounds in those early oboes. "A desire for uniformity had steamrollered out of modern oboes the rich range that had existed for two centuries," he says. "I wanted to discover for myself those lost sounds by learning to play the original instruments that created them."

The growing popularity of baroque music, however, had driven up the price of antique instruments and caused a three-year wait for a copy of an original. "The only way around that roadblock was to learn how to make my own instrument," Sand explains.

Sand bought his first set of baroque oboe drawings from a Boston recorder maker, Friedrich von Heune, but the drawings alone couldn't tell him everything he needed to know to reproduce the old instruments. "In the winter of 1977, I made the first of several trips to museums in Europe to examine, photograph, and take

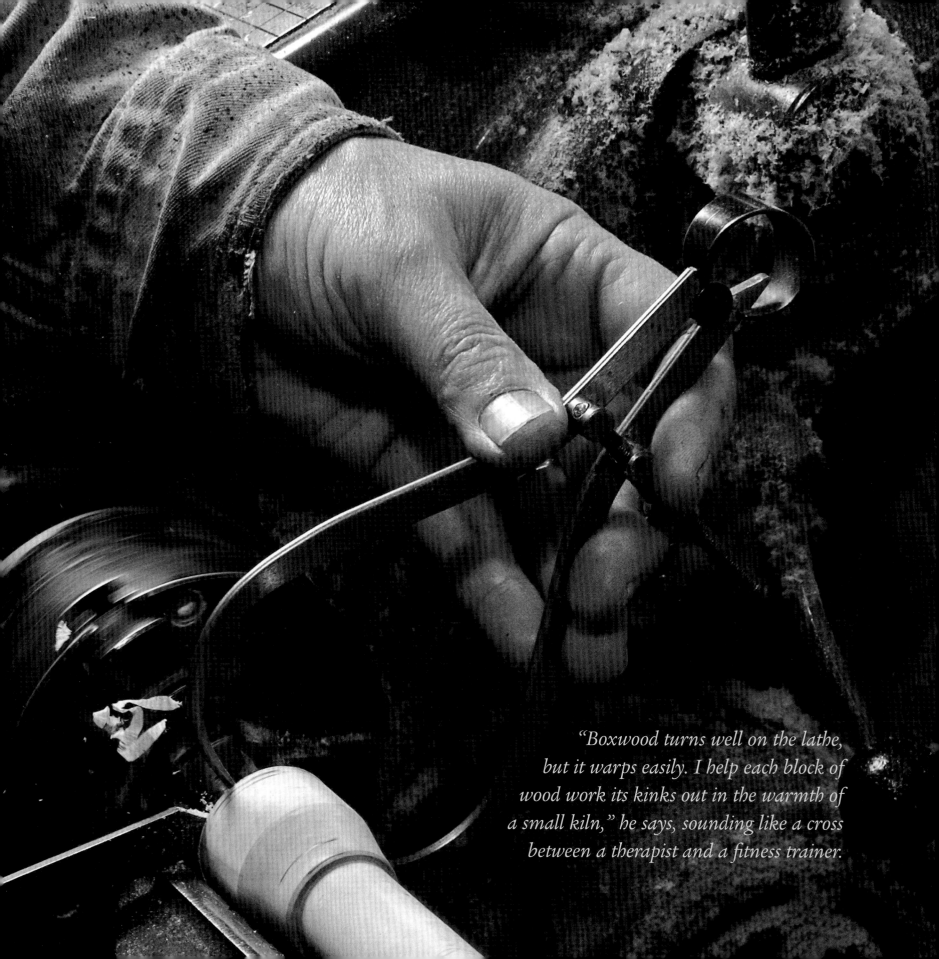

"Boxwood turns well on the lathe, but it warps easily. I help each block of wood work its kinks out in the warmth of a small kiln," he says, sounding like a cross between a therapist and a fitness trainer.

measurements of original oboes," Sand says, "and as often as possible, I played them, too." After his travels and a short stint in Boston, Sand joined his parents in their cottage industry making Christmas ornaments. He also launched his oboe-making business.

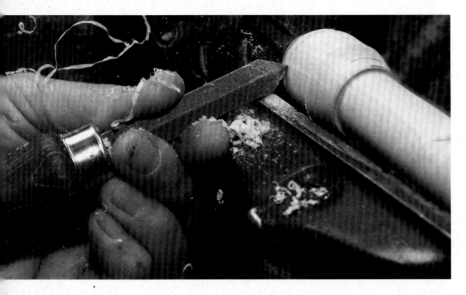

It seems fitting that Sand builds historic woodwinds in a rustic twelve-foot by twenty-foot cabin just fifty feet from his house in the woods. "This is where I spend most of my time," he says, leaning his lanky frame against the waist-high workbench, three inches of wood shavings cushioning his feet. His shaggy hair and beard, their color a match for his first name, are highlighted by the sunlight streaming through the workshop window.

Sand considers a stack of foot-long, three-inch-square blocks of yellow European boxwood and runs his hand over different squares, much as he does when searching for the perfect piece for each of the three oboe sections. "Boxwood turns well on the lathe, but it warps easily. For the entire first month of the oboe-building process, I help each block of wood work its kinks out in the warmth of a small kiln," he says, sounding like a cross between a therapist and a fitness trainer.

"First I trim the corners off the square blocks on the band saw and shape them into long cylinders on the lathe. I put the wood back in the kiln for another two or three weeks and then shave more wood off the outside." Though still oversized and rough, the instrument is beginning to take shape. "A lot of what I do when I'm seasoning and machining the wood is to anticipate its movement," Sand explains. "Sometimes, despite all those trips to the warm kiln, a piece will warp beyond what can be used. Then it becomes wine stoppers... or kindling."

Sand bores out the insides of the cylinders that do survive and enlarges the now hollow tubes with hand-built reamers. He carves sockets and tenons, or projections, at the ends, so the parts can be twisted together. Then he drills into the oboe's body, fashioning preliminary finger holes and slots for the instrument's two keys. "This stage is nerve-wracking," Sand says. "It's another time where things can go wrong."

Once the golden wood has been shaped into an oboe, Sand stains it a deep brown using an old technique in which dilute nitric acid is mixed with a little iron. Then the pieces sit in a warm linseed oil bath for two days while he cuts the instrument's keys out of sheet brass or silver with a jeweler's saw. When the oiled wood has dried, he files, polishes,

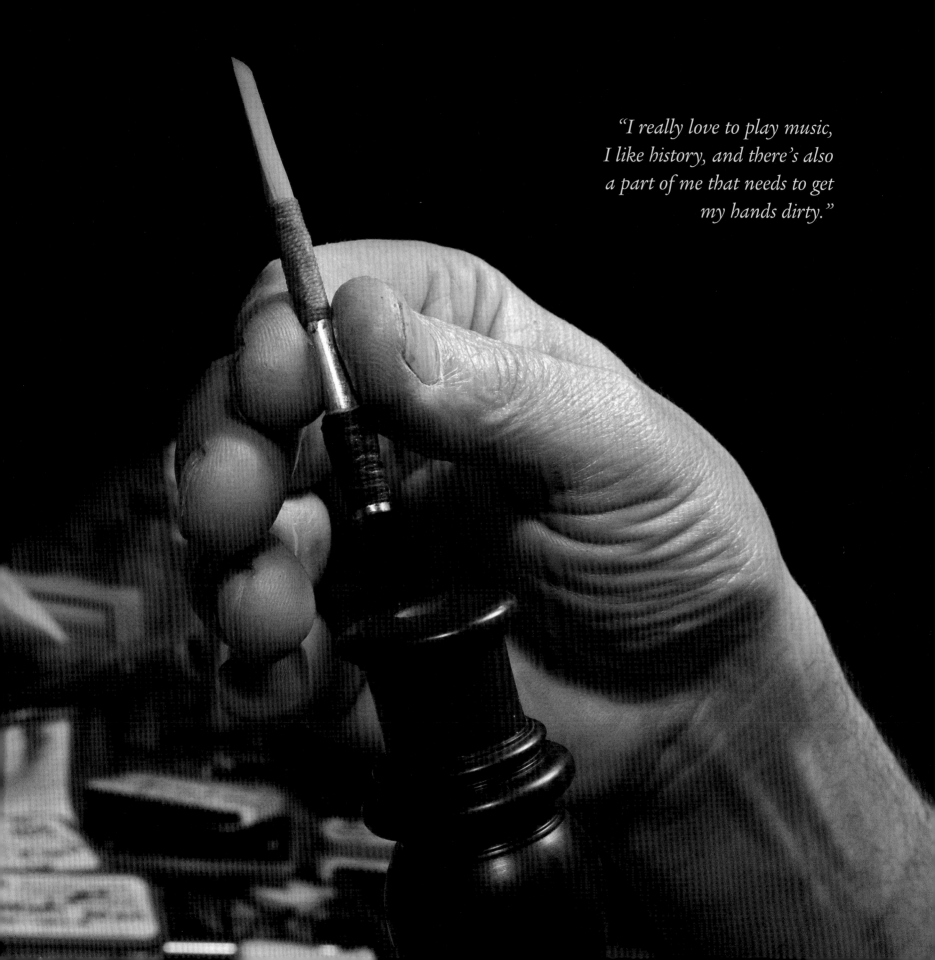

"I really love to play music,
I like history, and there's also
a part of me that needs to get
my hands dirty."

and mounts the keys. Finally, he spends ten to twelve weeks transforming wood and metal into a baroque oboe, and then wraps the tenons with red sewing thread so that the three sections will fit together snugly.

The hard part still lies ahead—building a reed and tuning the instrument. "Many original baroque oboes were preserved in museums," Sand says, "but their unique and fragile reeds didn't survive." Because so many of the oboe's playing characteristics are determined by the reed, re-creating it is the most important part of the process of building historical oboes. "It's like constructing a new little instrument to put on top of the oboe," Sand points out.

"The hollow cane I make the reeds from looks like bamboo, but it's the same material used for rattan cane furniture. I trim and thin it into a wedge shape, then tie it with thread to a very small brass tube that fits into the top of the instrument." Because reeds are so delicate and typically last only a month, most oboe players learn to make their own. Some are fortunate enough to learn this skill firsthand from Sand at reed-making workshops in San Francisco every summer.

At last the oboe is ready to tune. Sand uses handmade knives and circular files to enlarge the undersized finger

holes. "The basic purpose of the finger holes is to shorten or lengthen the oboe acoustically," he says. "The player tricks the oboe into thinking it can be a lot of different lengths, either by covering or uncovering the holes, thus producing a musical scale." Sand plays many scales while sizing the holes, to ensure that the oboe can produce the wide range of overtones and octaves typical of concertos that Vivaldi, Handel, and Bach composed with the instrument in mind. Once the precise tuning process is complete, the oboe is ready for the concert hall.

Sand is as dedicated to playing the baroque oboe as he is to building it. "Playing and building go hand in hand," he explains. "I do a dozen or so concerts each year to put my instruments through their paces." His performing and recording with baroque orchestras in Boston, San Francisco, Seattle, and Vancouver, British Columbia, sometimes take him away from home and his wife, daughter, and son, but for Sand, "It's a critical part of my work and feeds my soul."

Building oboes lets Sand combine his passions for art, music, and woodworking. "I've evolved into doing this because that's who I am," he explains. "I really love to play music, I like history, and there's also a part of me that needs to get my hands dirty."

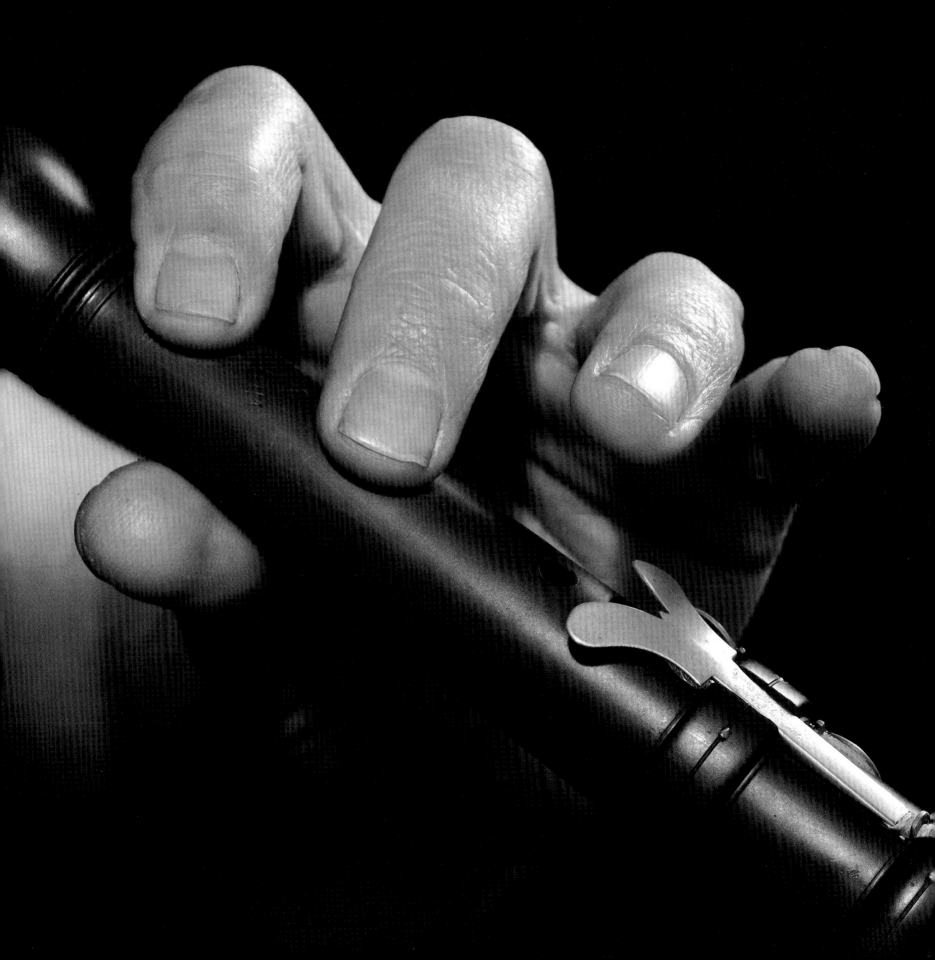

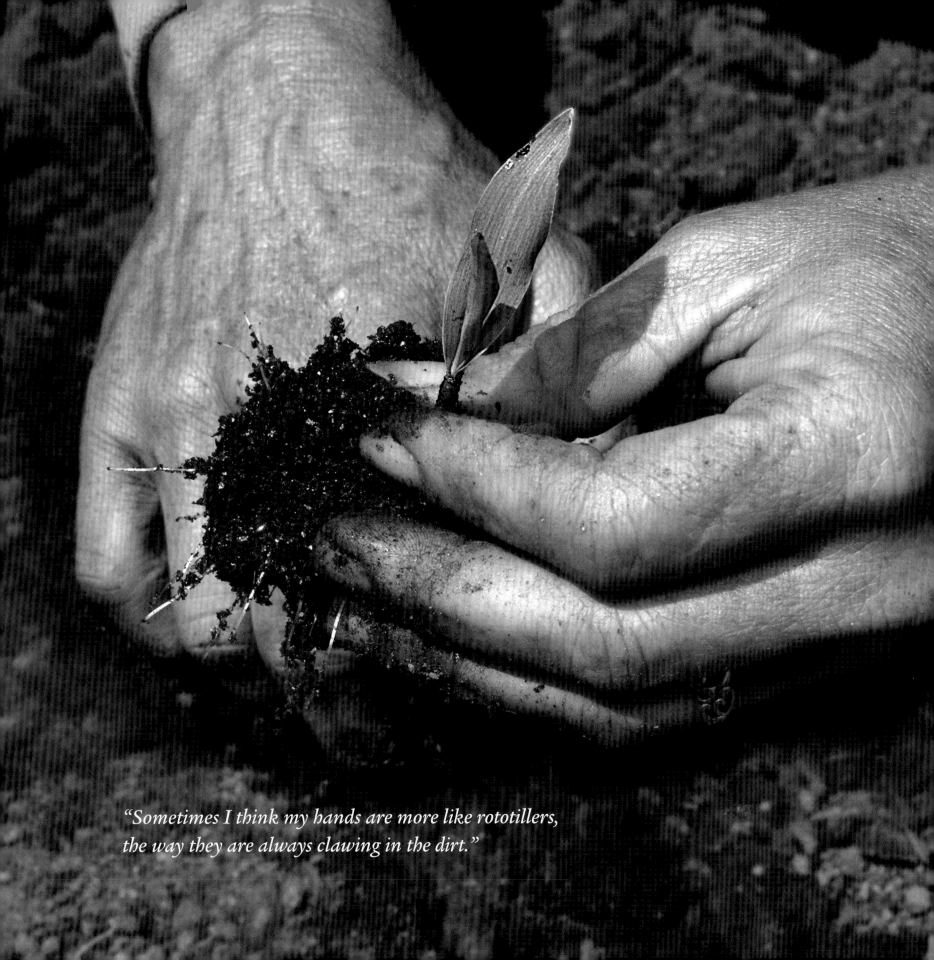

"Sometimes I think my hands are more like rototillers, the way they are always clawing in the dirt."

When they were courting, Irene Skyriver told her future husband that one of her ambitions in life was to have "a really good garden." The entryway to her half-acre growing plot offers the first clue that she's succeeded.

Irene pushes open the iron gate that she designed, its flowing leaves and vines welded by her husband; a blown-glass sun in one corner and a moon in the other were made by her son and his partner. An arbor laced with vines and tiny green grapes stretches over the garden entrance. On this August day, the path leading in is like a fireworks display; dahlias in maroon, magenta, crimson, pale pink, and lemon reach for the sky. Their spicy scent envelops all who enter.

"I grow lots of flowers, the smellier the better," Irene says. "The sunflowers are volunteers, but I've planted dahlias, lilies, roses, poppies. I used to think dahlias were 'old-lady flowers.' I guess I'm an old lady now, because I love them." She may be a grandmother, but old lady is not the description that comes to mind for this woman with shoulder-length raven hair and hazel eyes and a compact figure clad in a black halter top and an above-the-knee cotton skirt. "Gardening for me is primal," Irene says. "I feel connected to all humankind, and I derive so much pleasure from planting, harvesting, and putting things up for the winter. I feel the connection to my hunter-gatherer ancestors."

Irene's hands have been essential in her quest for a productive garden. "Sometimes I think my hands are more like rototillers, the way they're always clawing in the dirt. I used to be embarrassed by them because they're large compared to my body size. They're identical to my grandmother's, but she was tall—five feet, eight inches—and I'm

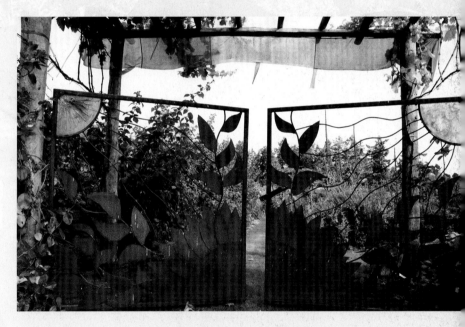

only five-three. Now I see the advantage of having strong, capable hands," she says, studying their dirt-stained crevices and calluses.

Irene and her family feast on the benefits of her strong hands every day. "There's joy in having nutritious, fresh food on our table and knowing that eighty percent of it, year-round, comes from

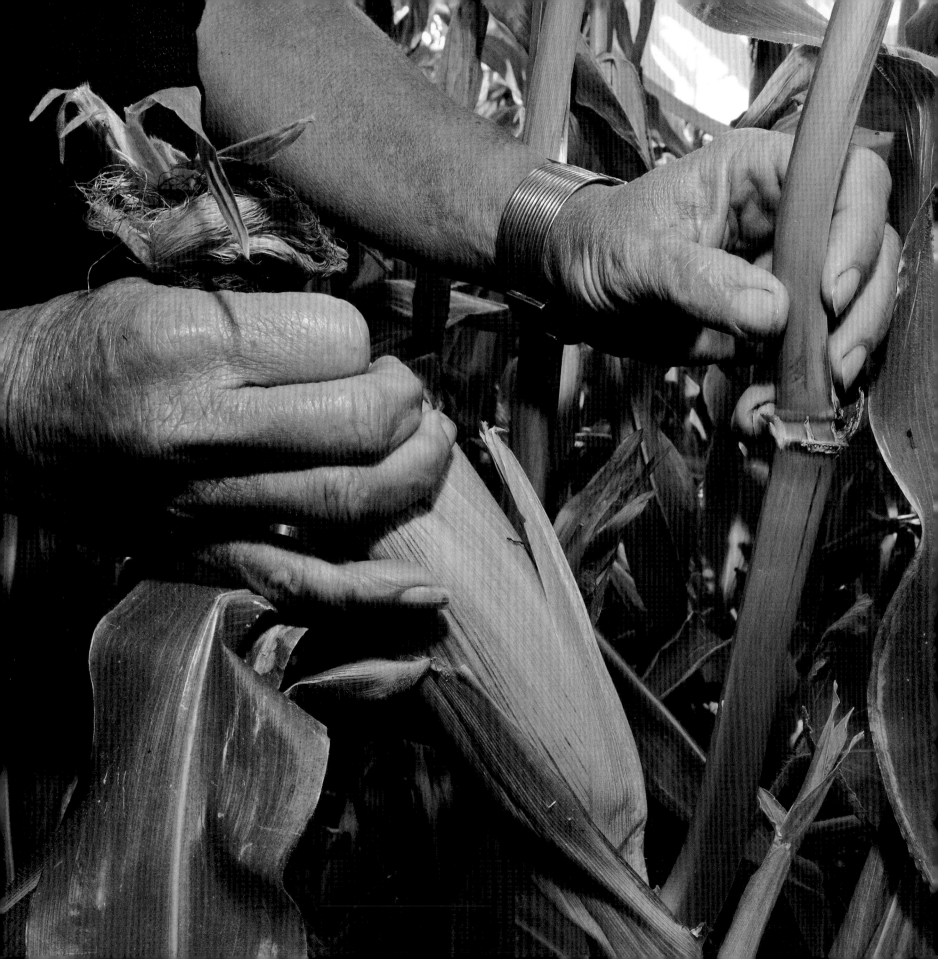

"Life is busy and things can get out of control in the garden. A little rain and a little sun, and it explodes. It can be intimidating."

what I raise," she says. "We only buy accoutrements that make eating fun, like olive oil and cheese. We raise our own chickens, pigs, and turkeys, and we have deer meat. I also help fish for salmon, and then I smoke it and can it."

Although she has her grandmother's hands, Irene credits another grandparent with her passion for gardening. "My parents grew up poor in the Depression era," she remembers, "and my mother was forced to do fieldwork on her father's farm as a young child. When she grew up, she never wanted to raise another vegetable. But her father, my Grampa Fahren-kopf, lived with us for awhile before he died, and he grew dahlias and vegetables behind our house. He was my inspiration."

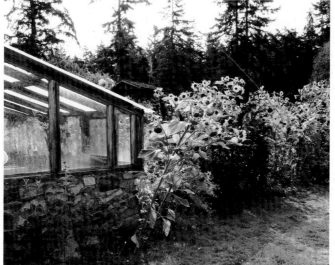

Given the rows upon rows of peas, beans, summer and winter squash, potatoes, onions, salad greens, cucumbers, and sugar pumpkins, it's hard to believe Irene's assessment of her skills in their cultivation. "I'm not a studied gardener. I've never read one gardening book. It's just not my style. Trial and error is."

She points to six-foot-tall, dark-red, feathery stalks that have gone to seed at the top. "That's orach—it's in the spinach family. When it's about a foot tall, it looks like a carpet of maroon leaves.

That's when they're eatable. They're a nice addition to a salad—they add some color." She pauses as she surveys the vegetables and flowers, many of them taller than she is as the growing season nears its end. "I let my garden plant itself a lot and take away what doesn't work. Sunflowers, kale, chard, arugula, mustard greens, parsley, celery, amaranth, orach—I never plant any of that."

Irene does plant corn, though, and stops now to check her crop. She twists an ear off the stalk and with strong fingers peels the sheath of light-green husk to reveal shimmering strands of corn silk overlying tight rows of cream-colored kernels. Before long, much of this corn will be in the freezer and, together with tomatoes still ripening in her green-house, will grace soups and casseroles she'll make this winter.

Irene has already preserved some of the garden's yield. "I picked seventy pounds of raspberries, and sixty went to raspberry wine. It's nice for gifts and to take to potlucks." Then there are the pie cherries, strawberries, blueberries, and basil. "I have thirteen pounds of pesto in the freezer," she says. Next will come the harvest of the sixty-five trees in her orchard—apple, pear, and plum—and the preserving of their fruit in sauces and jams.

*"I'm not a studied gardener. I've never read one gardening book.
It's just not my style. Trial and error is."*

"I love moving my body. The stretch to pick a berry or an apple is like natural yoga," she says, leaning back and extending her muscled brown arms over her head. "If you're aware, you notice when you need to move in another direction." She bends over, her fingertips touching her bare toes, the nails painted with fluorescent, lime-green polish; then she stands tall again and shakes out her arms.

Over the years, Irene has spent thousands of hours turning rich compost into the beds and planting seeds into the cool, moist soil in the spring; pulling weeds in the summer; and digging potatoes, garlic, and onions in the fall. "I've got hard-working hands, and at the same time, they've cared for a lot of babies, done tender things. They've served me well in all parts of my life that require nurturing." They also took her on a cherished voyage.

"Basically, it was my hands that got me 750 miles in my kayak," she says, referring to the solo paddle she undertook at age forty, traveling from Alaska back to her home in Washington State. "I love the out-of-doors, but as a young, single parent, I had missed getting to be in the wild. When I felt I had fledged my three children, I decided to do this thing for myself, sort of a spiritual journey." And one that honored her family heritage as well. "My mother is part Makah Indian,

and my father is part Alaska Tlingit. I wanted my mind and spirit to connect my mother's land in Washington with my father's land in Alaska." For forty days, her hands, powering her single-person kayak, helped her make that link.

At this time of year, Irene struggles to keep up with gathering the fruits of her labors. "Life is busy, and things can get out of control in the garden. A little rain and a little sun, and it explodes. It can be intimidating." Her philosophy about gardening sounds like good advice for much of life. "To be successful, you have to be diligent, thorough, and you have to love it as well. I'm always gratified by the work. "

For some, self-sufficiency is a phase that goes in and out of style. For Irene, it has been a constant. "I've tried to live true to myself," she says. "I like the concept of living fearlessly and ecstatically. Years ago, I made up this saying that I still believe today:

To sing is to make love to the sky
To dance is to make love to the earth."

As long as her hands and the rest of her body allow, Irene will be singing and dancing in her garden.

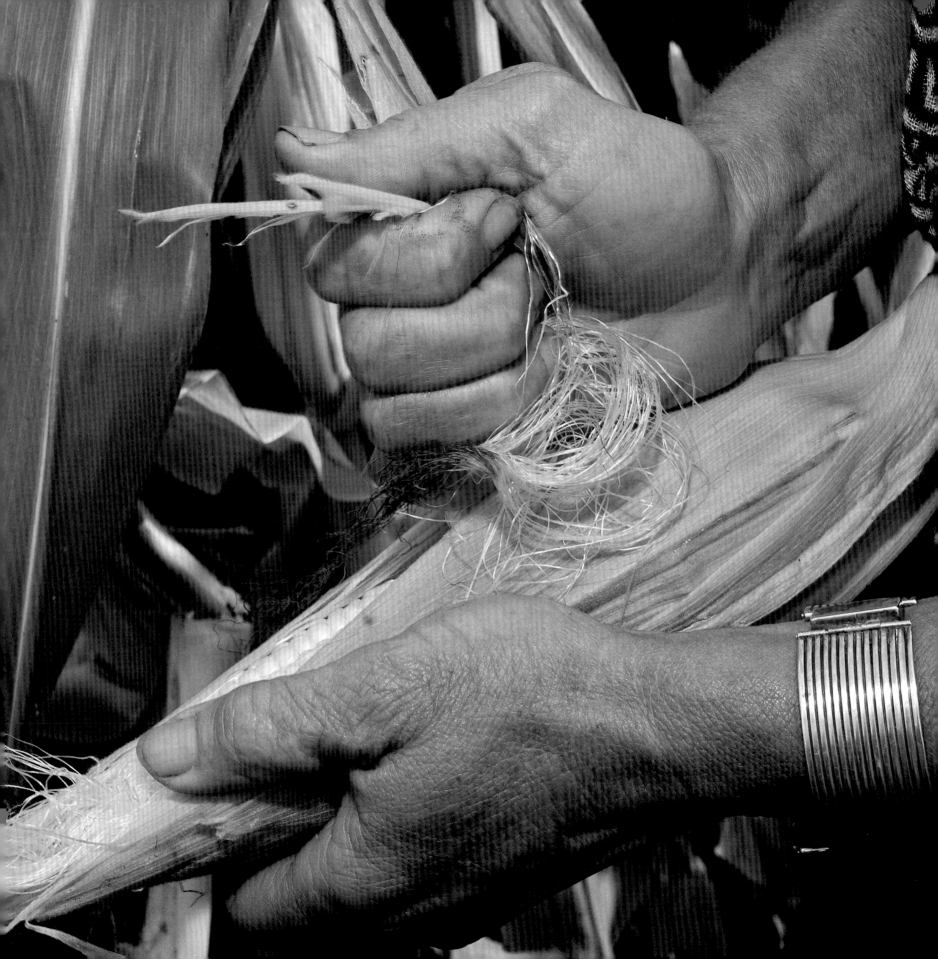

Like an opera singer, Suzanne Whalen warms up every morning before going to work. Instead of her vocal chords, however, it's her fingers, hands, arms, and shoulders she limbers up and stretches.

Suzanne sits in front of a classroom of energetic middle school students, including three who are deaf. Her long fingers curl, straighten, clench into fists, form the shapes of letters, and create images as she interprets between the deaf students and their hearing teachers and classmates. Sometimes her hands are near her face; sometimes they dance in front of her plain black sweater. Her eyebrows raise and lower; she grins, frowns, mugs emotions, and occasionally mouths words silently to augment the concepts, words, and phrases her hands communicate.

Because she is often the only one who can converse with the deaf preschool, elementary, and middle school students she interprets for, Suzanne's job description includes other tasks, such as reading with the younger ones, tutoring in math or English, and riding the school bus three times a week. During recess, some of the elementary students cluster around her, their hands a blur of motion as they tell her about birthday parties, family outings, and day-to-day news that they can share only with another person who signs.

"I really love the interaction with the kids," Suzanne says, at the end of a long day of work with students who have a range of hearing loss and language skills. Her pale, elegant hands drift to the middle of her chest. "The preschoolers melt my heart when they sign with their little tiny hands. Sometimes I don't understand their signs because they're still learning."

The children have gone home, but Suzanne's hands are still in motion, automatically signing as she talks about her work. "In the classroom, I shadow the teacher. The teacher teaches," she says, shaping both hands like flattened circles next to her temples, "and I interpret." Her hands emphasize the different roles as she shifts them to mid-chest and brings the circle shapes together so her thumbs and forefingers meet. "Hearing people learn a lot from peripheral and background discussion, so, as much as possible, I also sign to let the deaf students know exactly what is being said all around them."

Even though she usually sits in front of the class, Suzanne's goal is to be invisible. "A good interpreter blends in," she says. "I don't wear nail polish, jewelry, or anything distracting—no big hair or big colors. My style is pretty classic, so normally I'm not very flashy anyway. I know I'm doing my job if the hearing students don't notice I'm there."

Suzanne was a middle school student herself when she first encountered sign language. "I babysat for a family with a deaf son. I loved that little boy, and I always thought I'd like to learn sign language," she remembers. "But his family moved away, and I got interested in other things."

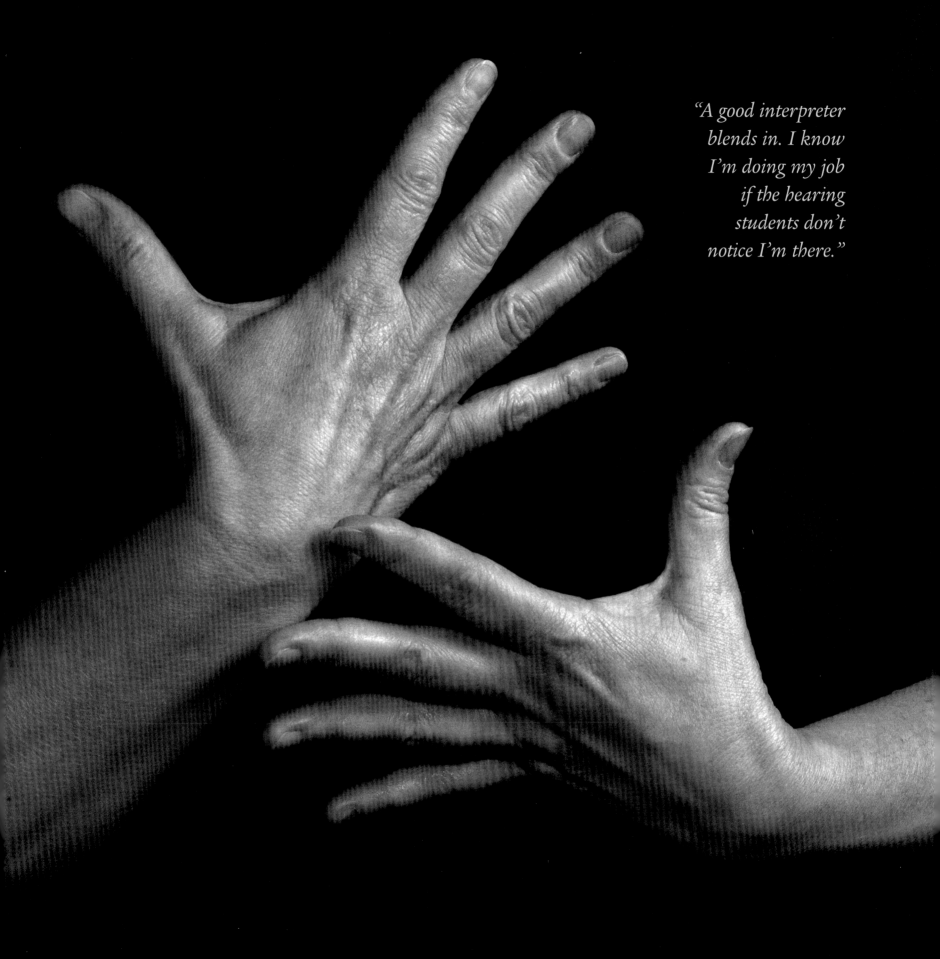

"A good interpreter blends in. I know I'm doing my job if the hearing students don't notice I'm there."

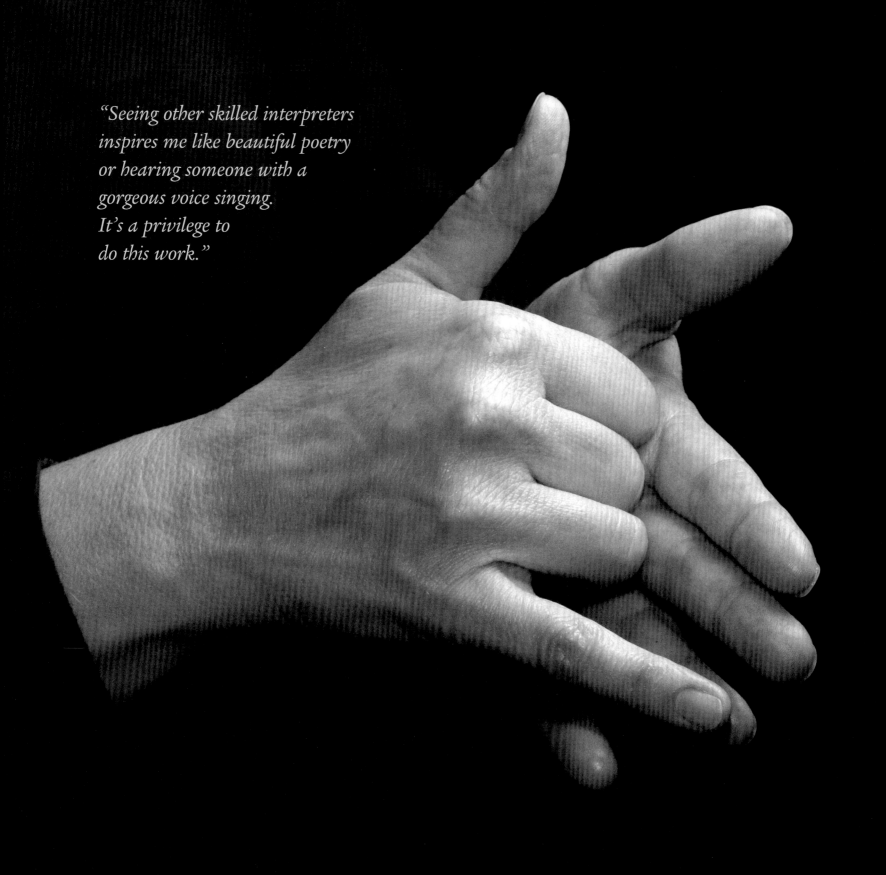

"Seeing other skilled interpreters
inspires me like beautiful poetry
or hearing someone with a
gorgeous voice singing.
It's a privilege to
do this work."

Twenty years passed before she thought about sign language again.

"In 1988 I started going to a twelve-step program, and my home group had a sign language interpreter every Wednesday. I never knew that interpreting was a profession. On my first anniversary in the program, I quit my job as an office manager and went back to school to learn sign language and to enroll in an interpreter training program. I was thirty-five years old."

After finishing the two-year program, Suzanne worked as an interpreter for a few years, but then left the field. "I was afraid I wasn't good enough," she says, "so I worked in the office of the Deaf Program, and then in public relations at the community college and administrative positions in other organizations."

A friend's death in February 2007 was the impetus for Suzanne's return to interpreting. "When I was in the interpreter training program, I had become good friends with Geoff, one of my teachers, and his wife, who is deaf. When Geoff died suddenly at the age of fifty-one, it stopped me in my tracks," she says. Suzanne admitted to herself she was unhappy in her work and wanted to do something different. "My husband said, 'Go find your professional passion.' I didn't know what it was, so I started doing research and made a list of the things I love to do and the things I hate. Interpreting was on the list of things I love."

Her hands whirl, signing as she speaks about her return to interpreting. "One day while I was shopping, I saw a couple I had known when they were students in the Deaf Program. I started signing to them, and they remembered me. The woman was working as an instructional assistant in the schools and told me they needed interpreters. She convinced me that my signing was good enough, so I applied. I started as an educational interpreter in May 2007."

This time around, Suzanne is more confident of her signing skills and more accepting of her ongoing development. "When I went back to interpreting, I was amazed at how the language was still there. I'm still learning, and some days are harder than others because I expect so much of myself. But now I feel like I have Geoff on my shoulder." Her clear, green eyes cloud with tears. She pauses and runs her fingers through her long, wavy hair. "I don't like not knowing exactly how to sign something, but I've learned that I'll never, never, never be perfect. I'll continue to learn sign language forever."

In the past, Suzanne viewed work as a way to make money and to survive. "I feel very different now," she says. "Seeing other skilled interpreters inspires me like beautiful poetry or someone with a gorgeous singing voice. It's a privilege to do this work."

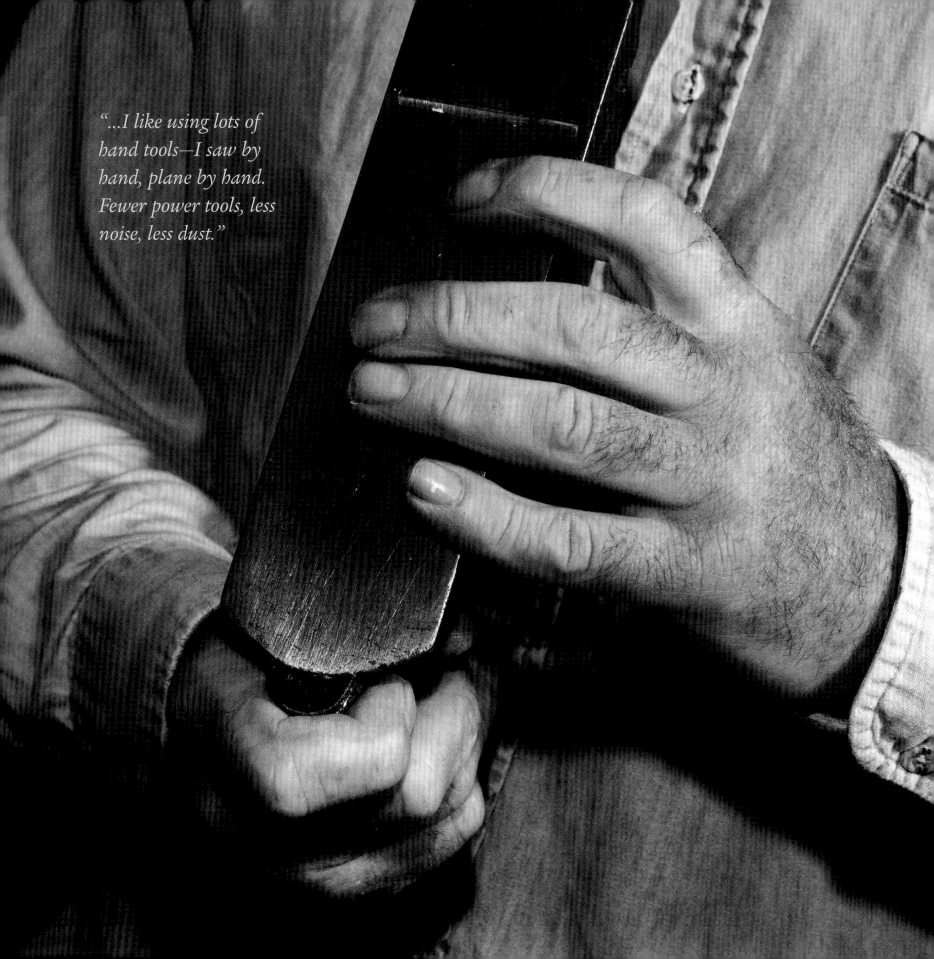

"...I like using lots of hand tools—I saw by hand, plane by hand. Fewer power tools, less noise, less dust."

Keeping up with Steven Brouwer is a challenge as he dashes from station to station in his boat building shop, kicking up bits of sawdust with his scuffed leather boots. Wood dust coats his jeans, graying hair, and reading glasses. He talks about boats in staccato bursts of thought and emotion. "My waking dreams are often about boats," Steven says. "My hands are just an extension of my creative mind."

At this moment, those hands clutch a long, narrow rectangle of Alaskan yellow cedar that Steven is shaping for the back of a bench. His eyes, however, are on the skeleton of a thirty-two-foot Bristol Channel Cutter. The boat's backbone, given to him by another builder who couldn't finish it, takes up nearly half of Steven's shop and occupies many of his thoughts. Over the next year or so, he'll build the boat's hull and interior following the set of plans drawn by the late Lyle Hess. Steven takes a break from today's woodworking task to unroll the sheets of white paper and review Hess's drawings and instructions.

"I'm a laborer," Steven says. "I use my hands. I like the doing part—the hands are what do it." He's been doing the doing part most of his life. "I had a bunch of brothers, and we built stuff like forts, boats, downhill racers. My stepfather was a do-it-yourselfer, and we were encouraged and allowed to build and do things with tools and wood." Some of those tools belonged to Steven's step-grandfather, a carpenter. "He had an incredible collection of tools. When he died, my stepfather got them, and when I was in college, I acquired them. They *are* beautiful."

For now, Steven is using those tools for furniture making. He carries the cedar board to one of his workbenches and smoothes an edge of it with a plane from his grandfather's collection. A burst of cedar scent hangs in the air as shavings curl up on the wood's edge. "As a kid, I felt comfortable with wood. I came to believe that if you want it, you could probably build it. I just wanted to make everything—the house I live in, the bed I sleep in, the boat I sail in."

It would be years, though, before he built a boat to sail in. "I studied civil engineering. It incorporates a lot of disciplines, including environmental sciences. That's what I was interested in, not the structural part. That involved way too much math," he says, stretching a metal tape measure along the cedar and marking inches with a stubby yellow pencil. The pencil goes between his teeth as he trims the marked edge on a band saw, his hands firmly guiding the wood past the blade. He slips the pencil into his denim shirt pocket and inspects the cut.

"After college, I went off to build houses. That got boring real fast," he says. "In 1974, I decided that boats were totally romantic. They're fully functional, self-contained, moving structures that usually are beautiful." He enrolled in a two-year program at the Apprentice Shop in Bath, Maine,

where he learned to build traditional wooden boats. "It turns out that boats are really complicated, and it's all about problem solving. That figuring-out process is what I love."

Steven found another love at the Apprentice Shop—his wife, Molly. "We were both starry-eyed about boats," he remembers. "After boat school, we boatyard-hopped in Maine. I was like a sponge absorbing technique—the things I couldn't learn

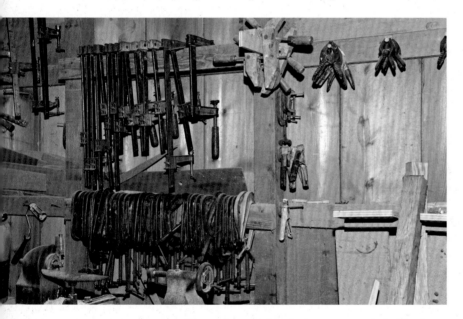

by reading about them. Every yard had these old-timers who had done everything. Most of them shared their secrets, but I also learned by observation because some of those Mainers were fussy old farts and wouldn't tell you."

Some thirty years later, Steven is still building boats as well as boat interiors and furniture. Although Molly's focus has centered on family and the couple's small farm and flock of sheep, she has

assisted Steven on numerous boat projects and remains an avid sailor.

"I'm not a fine woodworker," Steven says. "We're in the age of abrasion. It's all about grinding things to make them shiny and smooth. I'm not fond of sanding," he says, though he does plenty of it with all his projects. "What I care about is how you put it together, the beauty of the form, and the wood itself. It fascinates me to use the grain structure of wood for shapes."

Steven points to long boards—cedar, Honduran mahogany, locust, and walnut—propped against the shop wall. "I've worked with every kind of wood, and I do sense a little bit about it. Wood has personality. Every piece has some character, some flaws, something about it that's unique." He strokes the piece of cedar he'll use for the bench. "I might enjoy the knot, work around the knot. I look at the curve of the grain and work with it rather than oppose it. And I like the sappy part of the wood that stains it."

The grain of the cedar he's working with has an arc he wants to replicate in the bench's backrest. "Steaming helps make wood soft," he says, just before dashing outside his shop to a piece of stovepipe attached to a small water tank heated by propane. "We're boiling water now," he says, plugging one end of the pipe with a plastic bucket to allow the steam to build up inside. He then slides the cedar into the pipe, stuffs an old towel in the other end, and checks his watch. "I want the wood to be relaxed, not under stress, when I bend it."

As the wood steams and hisses, Steven talks about how he approaches his boat building projects. "I start with two cups of coffee and figure out what

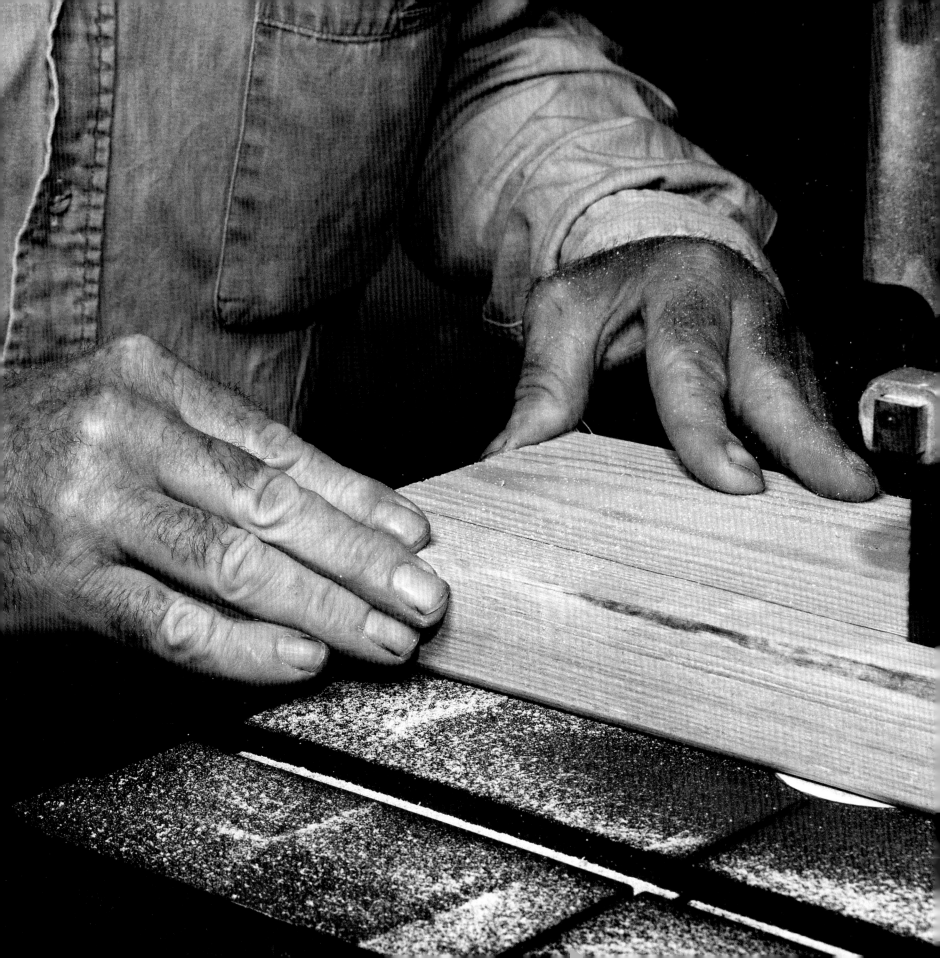

needs to be done that day," he says. "The designer figures out the scale, size, how to make it strong. I seldom deviate from that because that's what makes it work. But the plans don't tell me *how* to do it." He checks his watch as puffs of hot air escape from the improvised steamer.

"For boat interiors, I do a lot of mock-ups using simple plywood or cardboard. Everything has to fit just right in a small space," he says, drawing rectangular shapes in the air with his hands. "You just kind of do it, and if you don't like it, you do it over again."

"People are losing the ability to make things for themselves... We're missing out on that incredible creative process that engages the mind and translates to hands."

Forty-five minutes later, Steven puts on thick canvas gloves. His glasses fog up as he removes the towel plug from one end of the steamer and trots the hot board back inside the shop. Using C-clamps, he shapes the wood onto a jig, a pattern he made that matches the curve he wants for the bench's back. He'll let the wood cool for a few hours.

"I feel best when I solve a building dilemma, when I can create the solution. Then the doing it is secondary." He strips off the gloves and leans against the frame of his dream boat. "I use techniques evolved from boat building for furniture making. Everything is custom. I'm trying to create that one piece, not one thousand identical ones. I'm interested in doing this one. I like using lots of hand tools—I saw by hand, plane by hand. Fewer power tools, less noise, less dust."

Steven had plenty of opportunity to use hand tools, and solve building dilemmas, when he worked on what he considers his biggest accomplishment so far, the *Tern*. He helped his middle son and half a dozen friends build the twenty-four-foot, open expedition boat that they sailed and rowed from Washington's San Juan Islands to Alaska and back.

"People are losing the ability to make things for themselves," Steven says, explaining why he offered to help with the boat in exchange for manual labor on the family farm. "We're missing out on that incredible creative process that engages the mind and translates to hands. If all we can do is type on a computer, that scares me. I can't type worth beans."

The *Tern* was christened on May 1, 2006, Steven's birthday, and began its maiden voyage on June 6. Three months and nearly 2,500 miles later, boat and crew returned home safely and triumphantly, having journeyed to Alaska and back in the vessel they built by hand. Like the Maine boat builders who taught him, Steven had passed on his boat-building secrets to a new generation of starry-eyed problem solvers.

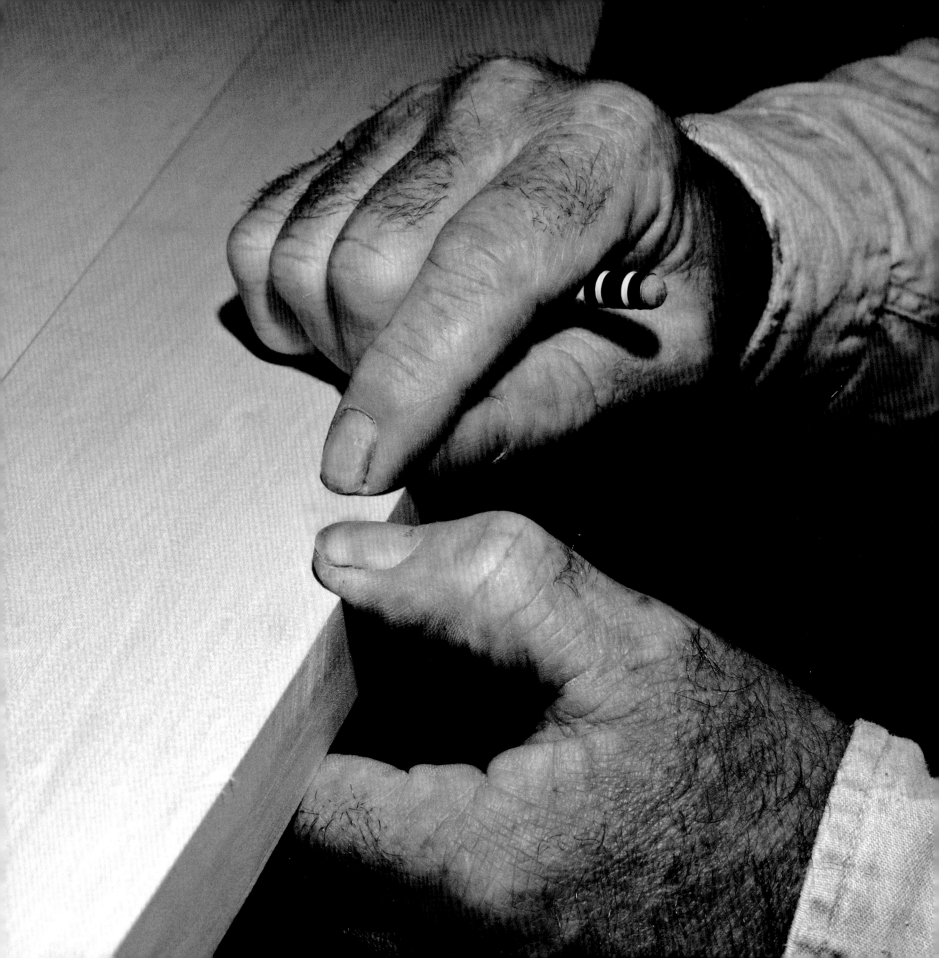

Spinner

Look at Kenny Ferrugiaro's hands, and you would guess (correctly) that he's a carpenter. "You can tell by my hands I work a lot," Kenny says, turning his broad palms up and curling and uncurling his wide fingers. "They're always cracked. There are so many wrinkles. And they're pretty strong."

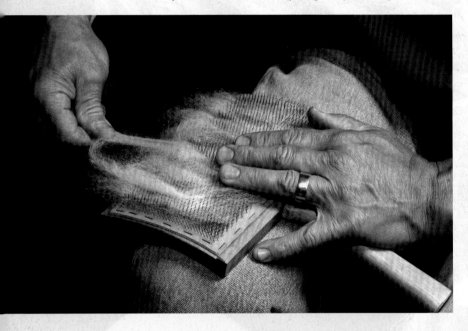

Kenny's hands *are* strong, able to easily grip two-by-fours, swing hammers, and slice a saw through hunks of wood. These hands also occasionally thump the head of an African drum to beat out a rhythm for dancers or jugglers, and once a week they knead and shape dough into rustic loaves of bread.

Those same hands, though, adopt a different motion and rhythm when Kenny sits at his spinning wheel, a tuft of soft carded wool between his fingers. The muscles in his forearms and wrists flex with the careful tension he applies to the fiber as he pulls and coils it into a single strand. "If you looked at wool under a microscope, you'd see little burrs on the fiber; when you twist it in a certain way, it will stay. It's all in the touch," he says.

Spinning wool is not something Kenny learned in the Staten Island neighborhood where he grew up. "I escaped from New York right after high school and hitchhiked to California," he recalls. "I lived in L.A. for sixteen years, but then I realized I was done with cities. I was looking for a more rural life." He found it in the winter of 1998 in a small mountain community in western Washington.

"One guy there was a weaver, a gnarly, no-fuss kind of guy. He learned from his mother in Minnesota." This gnarly weaver passed his craft on to Kenny by teaching him to weave on a table loom. Soon he and Kenny tackled a bigger project. "We did a free-form piece with warp that went from the floor to the loft of the cabin," he remembers." I got a piece of two-by-four, hammered nails in every inch, and bolted it to the floor. Then I tied lengths of hand-spun yarn to the nails and ran them up to a similar piece of wood on the floor of the loft. That made the vertical strands, or the warp." With the weft, more wool wrapped around a wooden

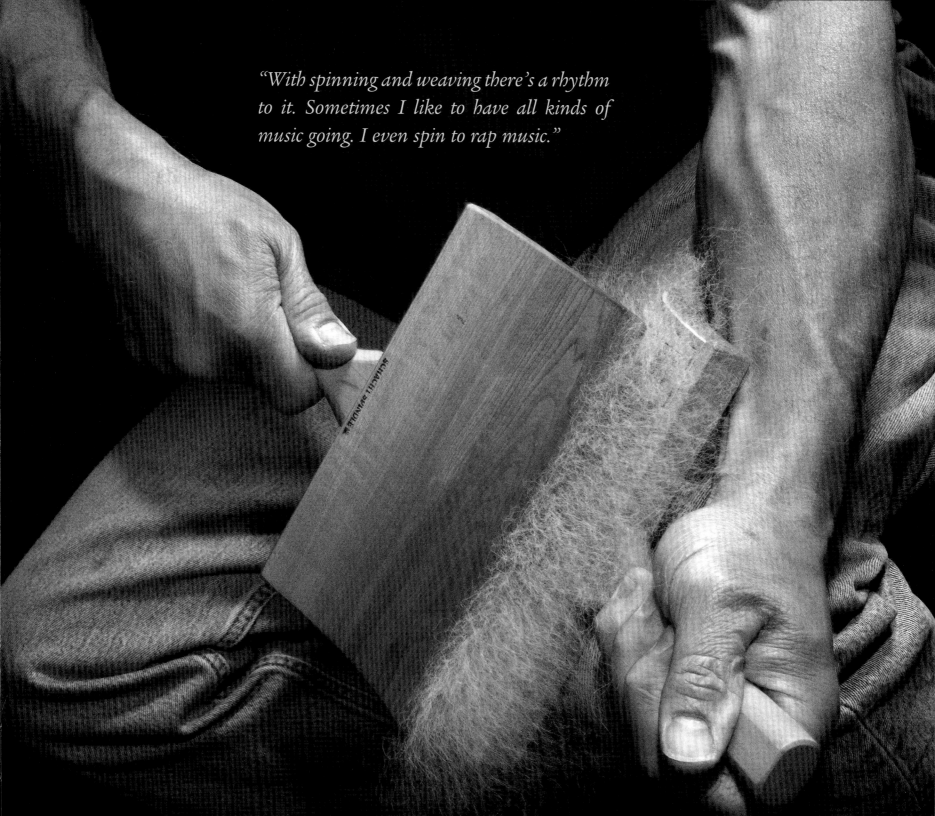

"With spinning and weaving there's a rhythm to it. Sometimes I like to have all kinds of music going. I even spin to rap music."

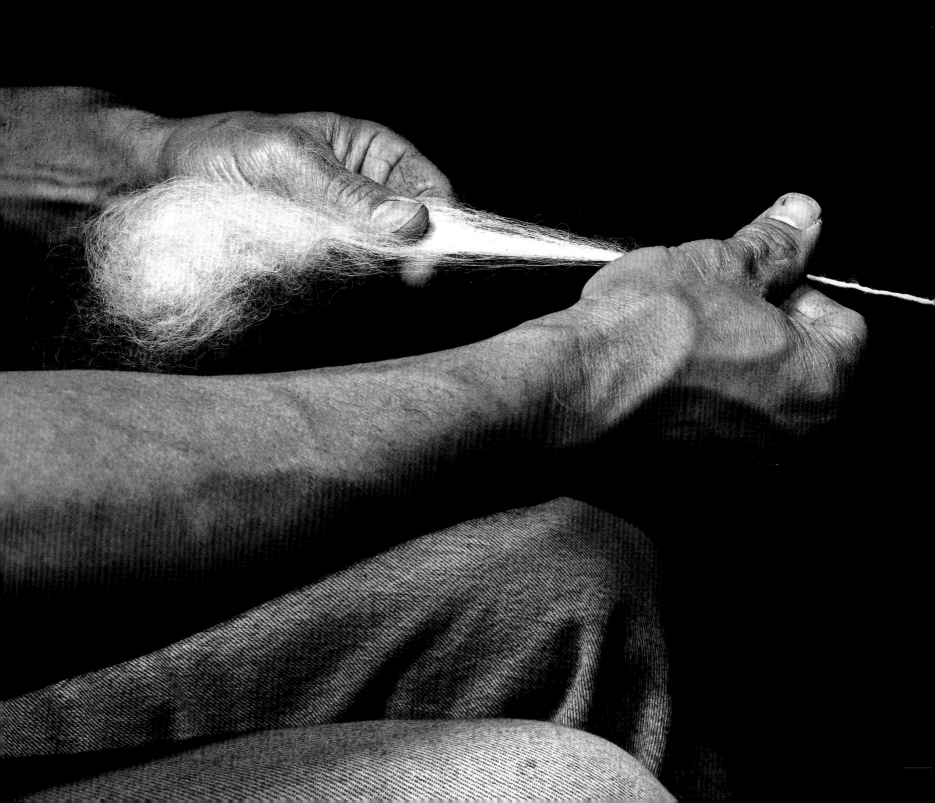

"If you looked at wool under a microscope, you'd see little burrs on the fiber; when you twist it in a certain way, it will stay. It's all in the touch."

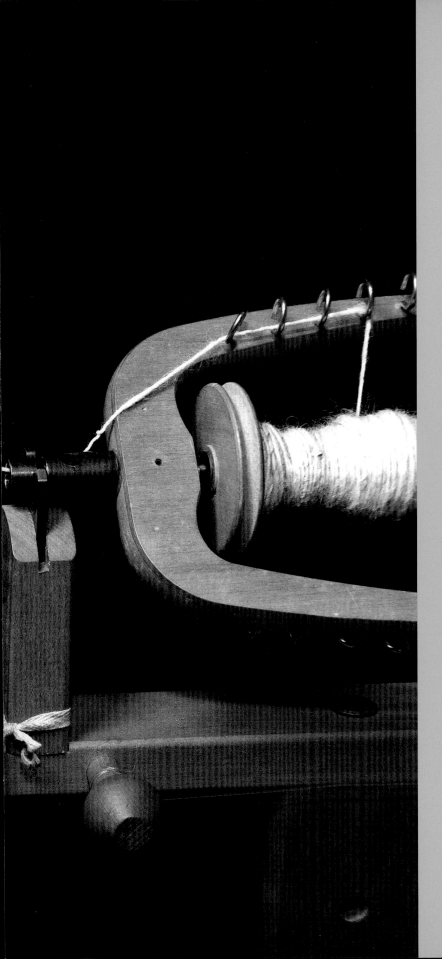

shuttle, Kenny wove over and under the warp threads to create a horizontal pattern. By the time he and his mentor had finished the piece, Kenny was hooked on fiber.

A year later, he started spinning. "I'm always trying to find a way back to things people used to do," Kenny says. "I like natural, more earth-based things." He met kindred spinners in the new rural community he had just moved to, and joined a group of them, all women, at weekly meetings in their homes. "They were happy to have a guy in the group," he says.

He spun with them regularly until more carpentry work forced him to cut back on spinning and weaving. "I view spinning as an art or craft," Kenny says. "When I think of the jobs many people have, I think of them as oppressive, something that takes us away from things we love and people we love. Spinning, though, is just pure love."

Kenny took spinning classes to learn how to twist the wool strands to make them strong. "Too much twist and they curl back and bunch up," he says. He pulls out paper grocery bags filled with yards of his rustic hand-spun wool wound in loose, elongated coils. He fingers the undyed skeins in shades of ivory, dusty gray, and earthy brown; the oily smell and feel of sheep lanolin lingers on his hands. Someday he'll transform the wool into rugs, sweaters, scarves, hats, and shawls. "I love the antiquity of spinning, of taking something that's raw and making it usable and beautiful," he says. "That's a disappearing art."

Like his hands, Kenny's feet are broad and strong and also get put to work when he spins. "Your feet

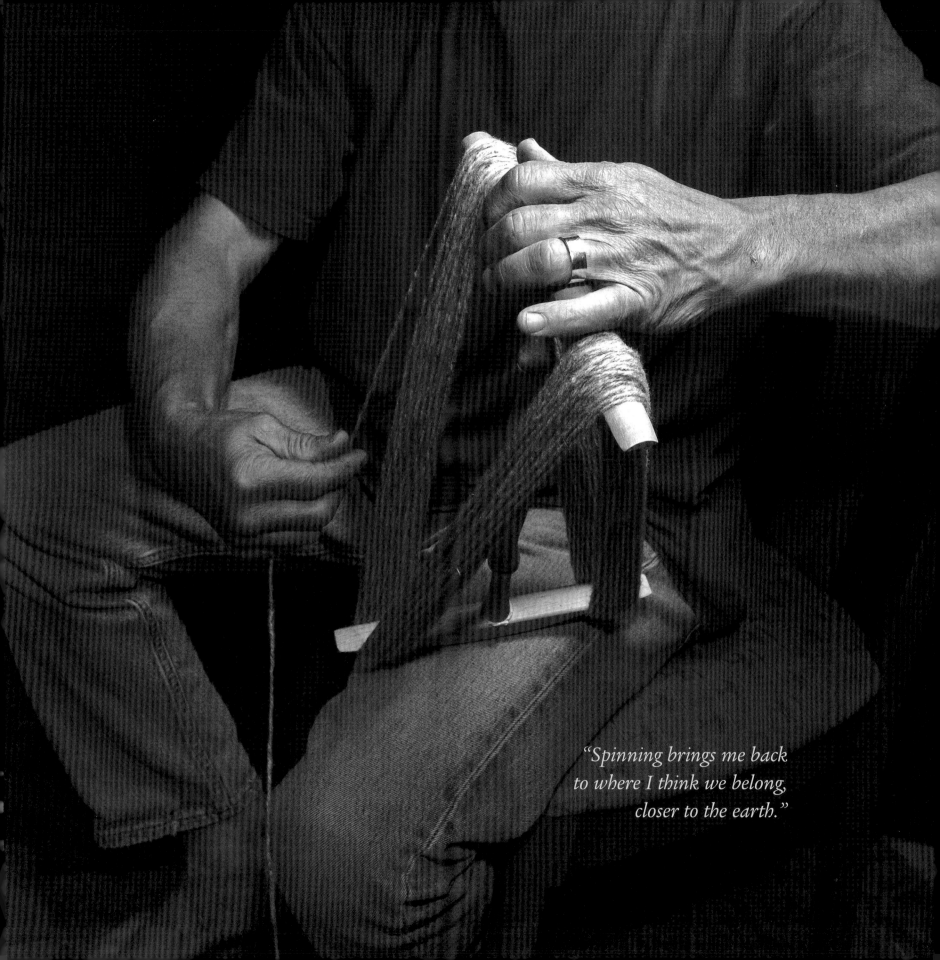

"Spinning brings me back
to where I think we belong,
closer to the earth."

have to coordinate with your hands," he explains, keeping his bare feet on the treadle, the wooden pedal that controls the speed of the spinning wheel. "There are all these little stages...carding the wool to make it fluffier and get it all going in one direction, controlling the speed and tension of the wheel, twisting just the right amount."

And there are other obstacles to transforming clumps of wool into uniform strands of yarn. "Seeds and grass get caught in the wool, and no matter how much you clean it, you've always got some. That can mess up the flow of the spinning. But when it's working and you're in a good flow with it, it just feels really good."

After working all day on a construction site, Kenny finds that the twisting and turning of fiber helps him unwind. "With spinning and weaving there's a rhythm to it. Sometimes it's nice to be quiet while I spin. But sometimes I like to have all kinds of music going. I even spin to rap music."

For his first hand-woven rug, Kenny used wool from a friend's Navajo-Churro sheep. This old breed, introduced to the Southwest by Spanish explorers more than five hundred years ago, had dwindled to just four hundred animals by the 1970s. Saved from extinction through a preservation movement by breeders and the Navajo, the sheep is valued by weavers for its double coat of wool and hair. Kenny stands on the brown border of his three-foot by four-foot rug, scrutinizing its pattern of varied stripes of gray, brown, and off-white. "I'm most proud of this rug even though there are a lot of mistakes," he says. "I'd love to do it again with a native Navajo weaver to teach me."

He's also proud he persevered for the year it took to complete the piece. "I managed to stick with it," he says. Sticking with it is something Kenny believes is important. "Be extremely patient," he advises. "Spinning is an old thing, and you don't want to get mad at these old spirits you're asking for help."

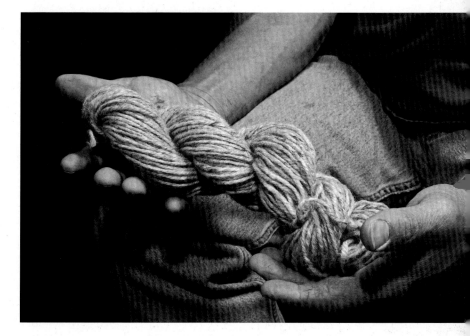

Most of Kenny's spinning has provided yarn for smaller hand-woven projects such as scarves for his mother, father, aunts, and niece. "I like making something for somebody else," he says. "I think of it as giving them a hug from afar."

It's that contact with something deep and old that captivates Kenny. "Spinning brings me back to where I think we belong, closer to the earth."

Terri Drahn helps her eighty-three-year-old patient lie down on the treatment table and places both hands on the woman's swollen right knee. Gently, but firmly, she guides the limb through a series of motions. "Now, bend your knee," she coaxes. "Good. It's good for it to do that." With her hands, sturdy forearms, and lean upper body, Terri applies resistance as her patient pushes back. "Good hamstring," she says. After several rounds of bending and straightening the knee, she offers more encouraging words. "Oh, that's much better than when you first started treatment."

Terri escorts the patient back to the clinic's waiting area and then returns to the small, windowless room where she works. The scent of antiseptic lingers in the air after she wipes down the blue vinyl pad that patients lie on for treatments. She organizes the bright-green, orange, and yellow balls she'll use for balance exercises with her next patient.

"I think there's a lot of knowledge in the hands, and the power of touch has always been important to me," she says, flexing the long, slender fingers of her right hand. Her left hand is dwarfed and has only the thumb and little finger, an unexplained anomaly she was born with. "Asymmetry is a big piece of the story my hands tell," she says. "Because my right hand is so dominant, sometimes I've felt that my whole body is uneven."

Terri was first exposed to physical therapy when she was ten and accompanied her older sister on home health therapy visits. She imagined herself in her sister's profession. "She's a great therapist and healer, and her work seemed very satisfying," she remembers. "On some level, I understood that the people I would work with would be temporarily or permanently differently abled," she says, choosing her words with care. "I thought my difference could be useful, that I could be sensitive to that with others and help them move through their own differences."

Terri has made that same journey herself over many years. "In my family, I was treated just like my five older siblings. My hand was a non-issue. I was competitive in sports and really wanted to be good at everything—tennis, volleyball—and I *was* good." Still, she sometimes worried about being rejected because of her hand. "When I applied to physical

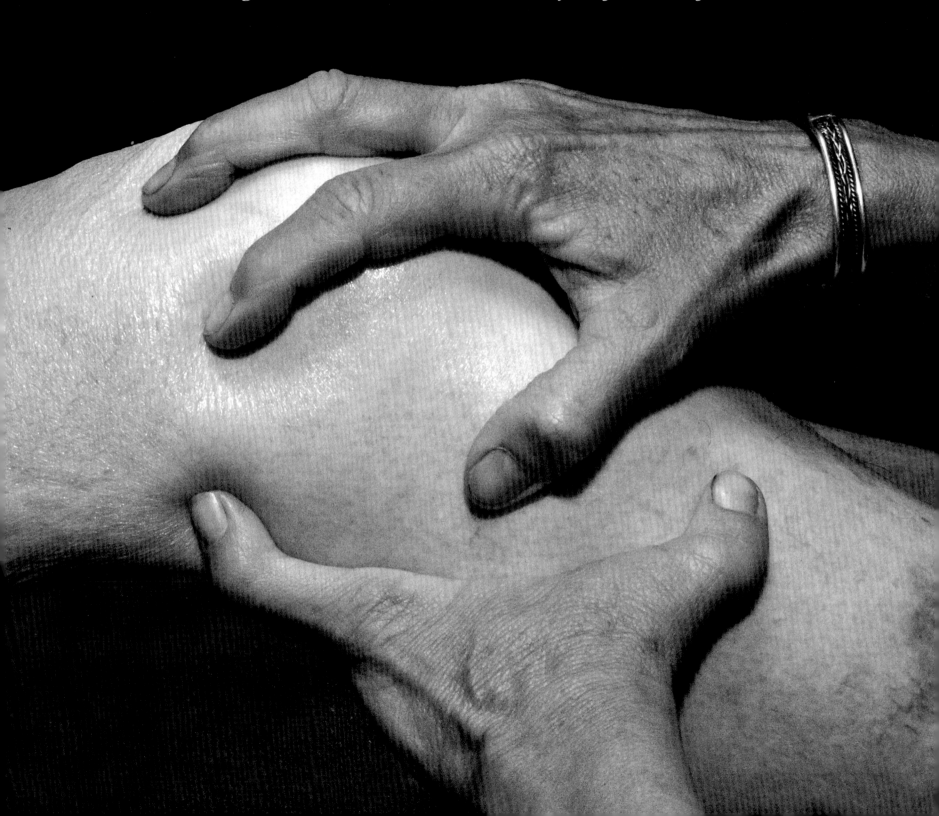

"Asymmetry is a big piece of the story my hands tell," she says. "Because my right hand is so dominant, sometimes I've felt my whole body is uneven."

therapy school, I wasn't sure I could do certain techniques. But I was able to do everything other students did."

After receiving her bachelor's degree, Terri joined the Peace Corps and met her husband, Dan, during their training in San Francisco. They ended up in the same in-country group in Thailand, where Dan worked as a civil engineer, and Terri, as a physical therapist. "I was concerned about being shunned," she recalls, "or that the Thai people would think I was a bad person and my hand was my punishment. The closest translation in Thai for my hand is 'a hand that doesn't work.' I thought, 'That's not true—it *does* work.' And it did. It turned out my hand wasn't a problem for the people I cared for there."

Surprisingly, one of the few occasions Terri was told she couldn't do something because of her hand occurred when she went to Cambodia to work with an organization that made artificial arms and legs from local materials. "I wanted to learn to do this," she says, "but the man who was making the limbs freaked out when he saw my hand." Because she spoke Thai, she ended up translating for other therapists. "It was so ironic," Terri says, "because my philosophy in physical therapy has always been that usually there's a way to do what you need to do."

In her late twenties, Terri recognized she had more work to do regarding her own body. "A lot of times in childhood, my right hand was a cover for the left," she says. "As an adult, I realized I was keeping energy in with this hiding, so I went to the Institute for Transformational Movement. We used exaggerated movement to express anger, joy,

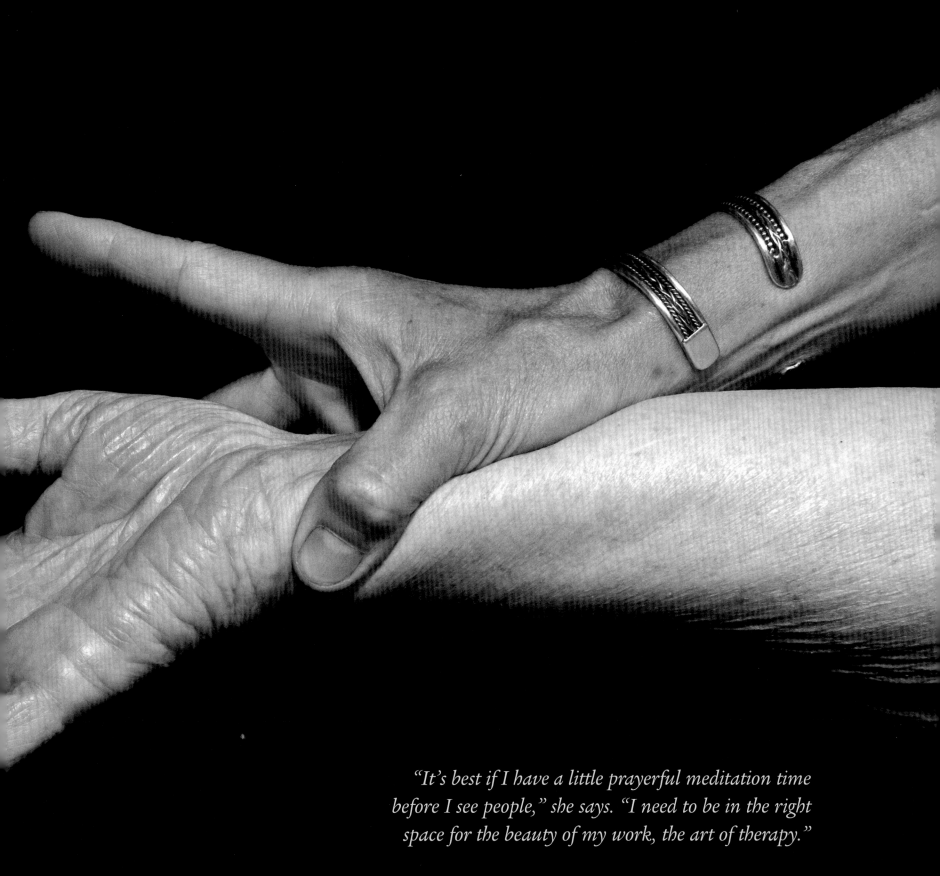

"It's best if I have a little prayerful meditation time before I see people," she says. "I need to be in the right space for the beauty of my work, the art of therapy."

and sadness. It was heart-and-soul work that was difficult to put into words but that I could express physically. It's been an ongoing process, and I've come to think of my left hand as a strength, not a hindrance."

This transformation motivated Terri to teach movement classes with children, including her own three. "I typically wait for kids to say something about my hand," she says, "and usually someone asks what happened. I say, 'Nothing really happened. It was the way my hand grew when I was being formed.' It ends up being a great conversation with all of us looking at my hands and theirs and talking about differences." She smiles as she studies her hands. "If someone says my hand is weird, I suggest saying instead that it's different. It always helps me go one step further with my own acceptance."

Terri's hands and touch have helped people of all ages and with varied conditions. She's worked at a large general hospital as well as a residential rehabilitation center where she provided therapy for people who had head injuries. "I learned what that was like for everyone involved," she says. "I developed strong bonds with patients and families because most people had PT two times

a day for a month or two. I saw them go through the stages of accepting a permanent disability. It was amazing to witness."

Now she practices in a rural health clinic, and relationships with her patients continue to gratify her. "I think of my work as helping people heal and move and feel more vibrant in their lives. It's best if I have a little prayerful meditation time before I see people," she says. "I need to be in the right space for the beauty of my work, the art of therapy." It's disappointing when she realizes that someone's condition won't improve. "I always think there must be *something* that will help, so it's hard to tell people they're not going to get any better and that our work is about maintaining what they have." Some of what happens in Terri's work is a result of her knowledge and skills. Some is more of a mystery. "My profession allows me to deal with people in a real way. I think that's because I physically touch them," she says. "Memories are hidden away in our muscles, and the stretching evokes them. It's amazing what people entrust me with during therapy, and I think that is part of their healing. That's a sacred space to be with people."

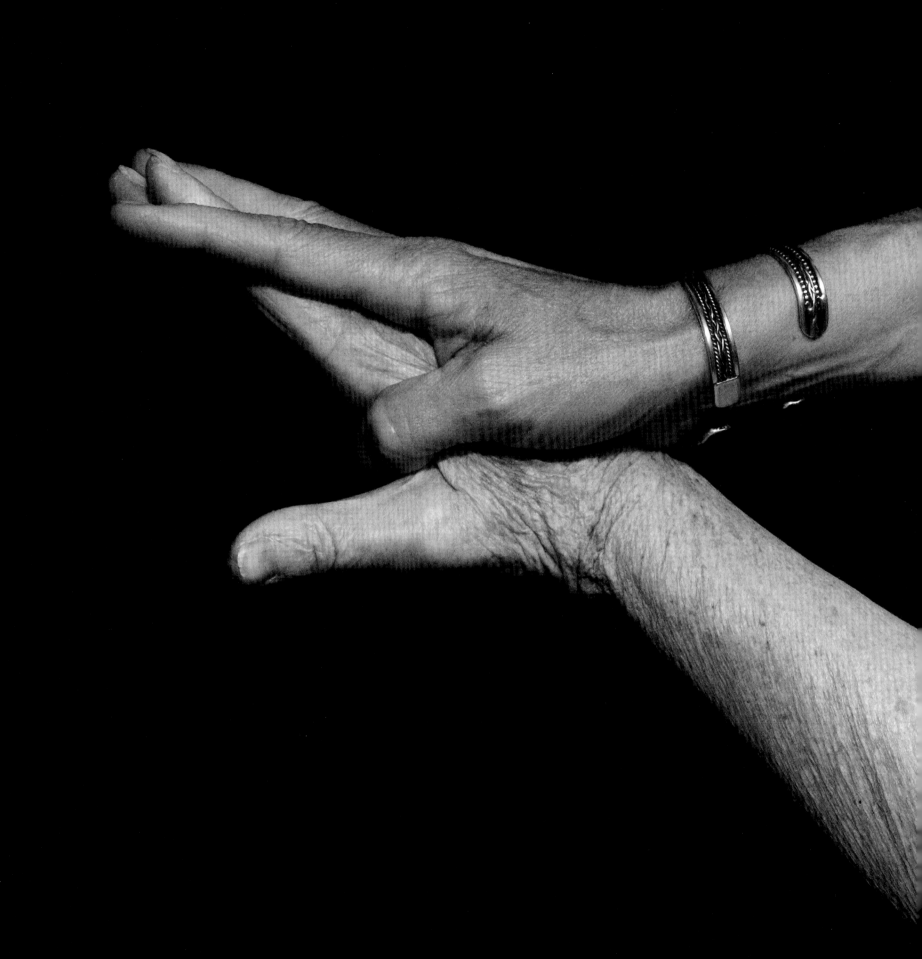

Within the Familiarity of Human Hands

Within the familiarity of our human hands
A freedom is born
Where heart and body, mind and soul
all reach out and work together
beyond places of knowing
to meet
where heaven and earth entwine
Fingers extending
 a feathered action taking flight
tips of wings that touch
becoming the whole of humanity
even without sensing it

Living prayers of hope for the future
Hands are a winged thing

Alysia Tromblay

Healing

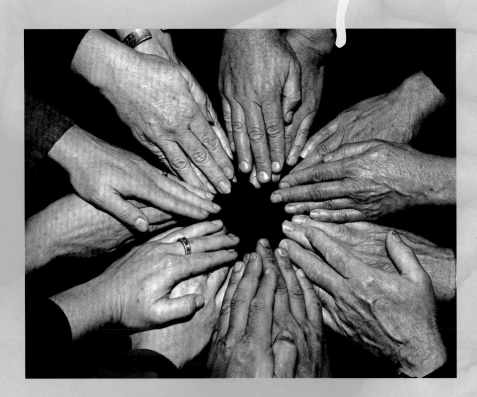

"There's a lot of mystery in this hands-on
energy work. It's really an intuitive art
to touch the body in a very still way to
promote healing, wholeness, and balance.
It's like being held and nourished on a
cellular level."

Reiki practitioner
Wendy Westervelt

"Maybe the way to change the world the most is to change people by helping them feel better."

Acupuncturist
Christopher Steckler

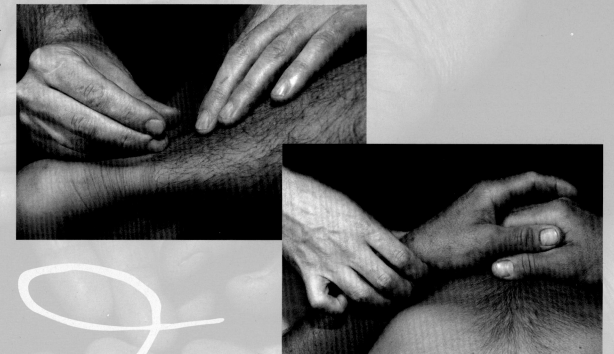

Hands

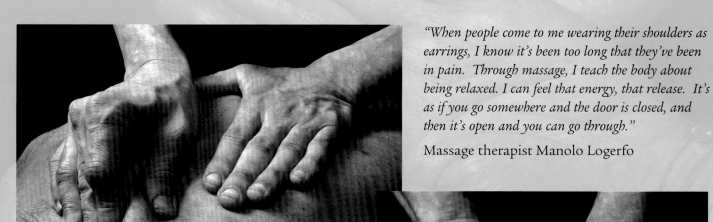

"When people come to me wearing their shoulders as earrings, I know it's been too long that they've been in pain. Through massage, I teach the body about being relaxed. I can feel that energy, that release. It's as if you go somewhere and the door is closed, and then it's open and you can go through."

Massage therapist Manolo Logerfo

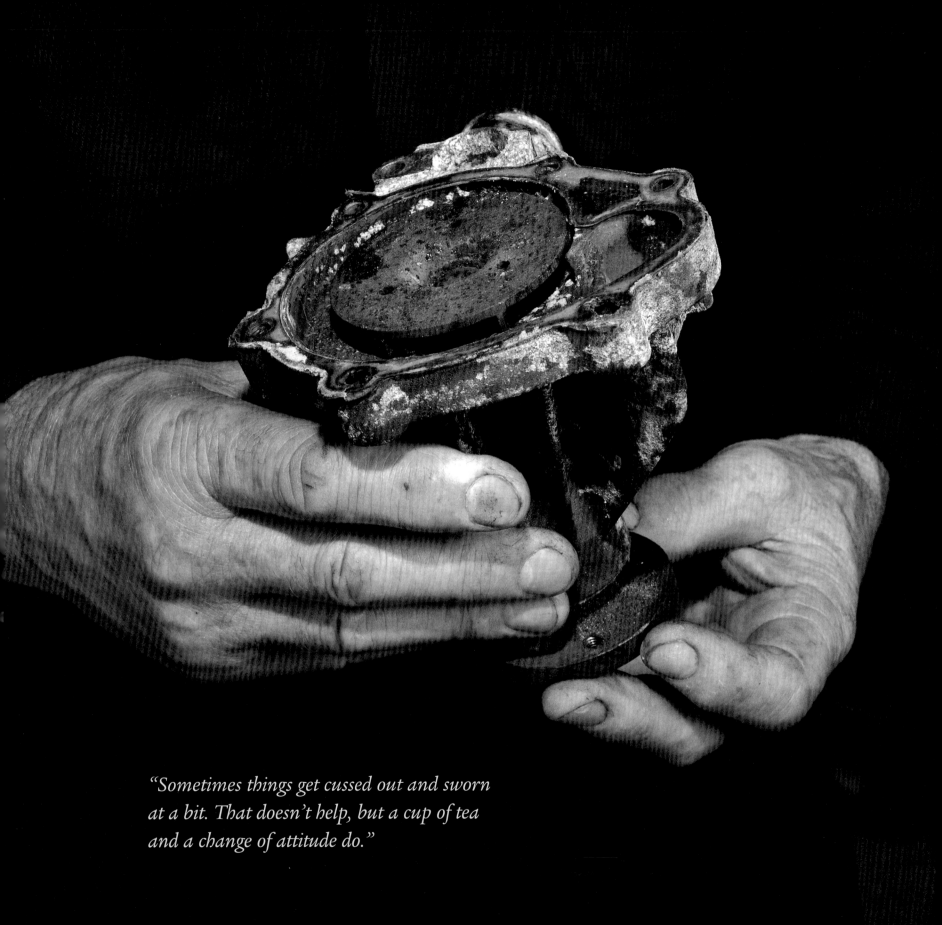

"Sometimes things get cussed out and sworn
at a bit. That doesn't help, but a cup of tea
and a change of attitude do."

Rhythm Auto Repair is the name painted on the roadside black-and-white checked mailbox that marks the turn for Alwyn Jones's shop. Many a car or truck has coughed and sputtered its way up the winding gravel driveway and past the abandoned vehicles screened by firs and overgrown grass. Despite the camouflage, it's not hard to spot a rusty GMC pick-up, a leaf-covered 1971 Chrysler Imperial with ten-year-old license plates and moss growing around the window rims, and a Dodge Power Wagon boom truck, faded red showing through its worn yellow paint.

Cars with current license plates hug the shoulder of the lane: a yellow Volvo sedan with a black vinyl roof, a black 1977 Ford Ranger pick-up with a "For Sale" sign in the rear window. A smiling customer drives away in her purring, newer Volvo station wagon. She passes four other Volvos of various vintages awaiting repairs, as well as a pale blue Studebaker truck, a classic VW bus, and a Plymouth minivan on a trailer. Clearly, there's no lack of ailing vehicles in this small town.

"There's a maintenance rhythm to car repairs," Alwyn says, explaining the name of his business. "The cars keep coming back. There can be lulls when I don't have much work, but they don't usually last long before I get a call about a no-start or some other problem." He pulls on a crisp pair of black coveralls and studies the brown 1982 Volvo station wagon parked in the single stall of his shop.

If he were in his native New Zealand, Alwyn would be gathering his "spanners" and checking under the "bonnet." But after more than twenty-five years in the U.S., he reaches for his wrenches and raises the car's hood. "This engine has over 200,000 miles on it," he says, as his right foot pumps a hydraulic jack to raise the car. He slides safety stands under the body for additional support. "You never get under there with just a jack because the car will come down and kill you."

Alwyn squats next to each tire, pries off the hubcaps, and lets them clank onto the cement floor. He grips a whirring air gun in his right hand. "I use air tools whenever I can because they're quick and cause less wear and tear on my body," he says, loosening the tires' lug nuts and methodically placing them inside each hubcap.

Next, he removes all four tires to expose the brakes. "Brake fluid can be nasty stuff," Alwyn says, shimmying his large hands into blue surgical gloves. A pump hums and a petroleum smell saturates the air as Alwyn flushes two pints of thick black liquid out of the brake fluid reservoir into a barrel. He shines a flashlight onto the brake hoses. "They're old, but not cracked," he says. He refills the reservoir with fresh fluid, then grips the brake drum and spins it. "Looks good."

Since 1986 Alwyn has been repairing cars and trucks here in the combination shop and house that he built from trees on his land. After work, he heads up a short flight of stairs, and he's home. "It's nice having the shop right here. I can be doing

things at home and be at work in an instant if someone drives up. I can always tell when a customer pulls in," he says, scratching the ears of his fourteen-year-old Australian shepherd/springer spaniel mix. "Ringo hears the car, barks, and then runs out to greet it."

Alwyn's beard and short brown hair are flecked with gray. "I'm the oldest mechanic in town right now," he says. Framed ASE Master Automotive Technician certificates hang on the wall leading upstairs. "I use both terms—mechanic and auto technician—to describe myself, because even though I still do

"There's a maintenance rhythm to car repairs. The cars keep coming back. There can be lulls when I don't have much work, but they don't usually last long before I get a call about a no-start or some other problem."

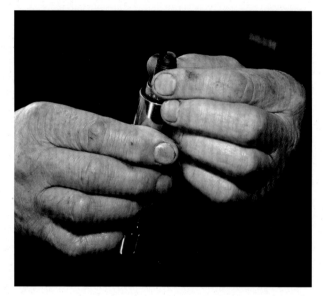

milling machines to make metal into shapes. It was a good basis for automotives."

For the first two years of his apprenticeship, he worked at the maintenance workshop at Tauranga Harbor Board, an import-export wharf. Then he transferred to a factory in Auckland that manufactured every kind of bottle used in New Zealand. There he assembled and repaired bottle-blowing machines.

He put his repair skills to the test in 1973, when he and a friend went to Europe and bought a used London double-decker bus. "We made it

mechanical work, much of what I do is diagnose electrical problems. All the changes in cars keep my brain sharp," he says. "Sometimes things get cussed out and sworn at a bit. That doesn't help, but a cup of tea and a change of attitude do."

The youngest of eight children, Alwyn grew up in the small town of Tepuke, New Zealand. "Everybody in my family was a farmer or a carpenter. As a kid I had always been mechanically inclined, and I wanted to be a mechanic. But my brother talked me into doing an apprenticeship in machining after high school. I learned to weld and use lathes and

into a live-on bus, where fifteen passengers could cook, sleep, and take showers. We drove it all over Europe and from Greece to New Delhi." Once, the bus broke down in the middle of the night beside Mt. Olympus, and the police pushed it off to the side of the road. "The gear had broken off the cam shaft. That's usually disastrous," he says. "We had to pull the engine, straighten the push rods, have new valves made, and put it all together again. We had the bus back on the road in three days."

That experience didn't deter Alwyn. "A Swiss friend had the money to buy a thirty-four-passenger

touring bus in Kabul, and I had the expertise to run it. We drove it all over India and Europe without any breakdowns. It just blew tires sometimes, and that was difficult because they were hard to get in India." When he came to the U.S. in 1981, Alwyn had all the qualifications to work with the budget travel company, Green Tortoise, driving (and fixing) its touring buses all around this country and Mexico.

Alwyn continues to work his way around the Volvo, using both hands to check the battery voltage and remove spark plugs. "Water pumps just wear out at around 120,000 miles," he says, poking around the engine. "This one made a horrible rumbling sound. It was corroded and leaking, so I replaced it with a nice shiny one."

He plops down on the "red creeper," a worn red plastic pad on a wheeled wooden frame and scoots under the car's front end. Wrenches clank as he tightens and adjusts parts that owners seldom see. A few minutes later, he slides out, stands up, and strips off his gloves. "This work is hard on my hands. I took a chunk off my right thumb yesterday on the sharp corner of some part. It's tender today," he says, gingerly rubbing the wound.

A red Mickey Mouse clock on a fir post ticks away the minutes. Alwyn returns his tools to two metal chests where he's meticulously organized his screwdrivers, pliers, heavy-duty socket wrenches, and the German wrenches he bought during his

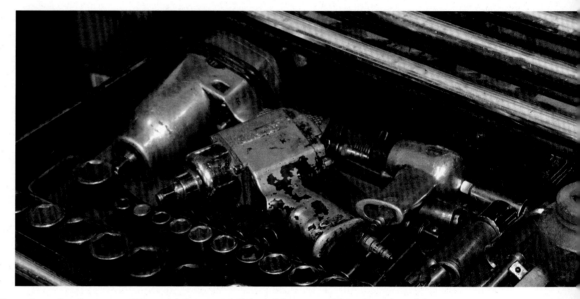

apprenticeship. "These beautiful offset wrenches are thinner, so they fit in places better," he says, splaying four of varying sizes across his broad, outstretched palm.

He goes back to the Volvo, replaces the tires, removes the safety stands, and lowers the car to the shop floor. His final task will be in the driver's seat.

"I test-drive everything," he says. "I can't take risks with customers' vehicles. I check and double-check to make sure lug nuts are torqued on tight and everything is safe."

The engine hums as Alwyn grips the steering wheel. "As a machinist, I often watched the clock and thought the production work was boring. With mechanics, there aren't enough hours in the day—there's always one challenge after another."

Diana Bower's hands tell of fifty years of using ancient techniques to create words and images. She's carved more than a hundred linoleum blocks, spending thousands of hours working with X-Acto and gouging knives. Many of her four-inch by six-inch blocks convey pastoral scenes. Others are half that size, including a series of six she carved in intricate detail in 1981 to depict the jail cell of a fellow nuclear weapons resister. "My hands never recovered from those," she says, flexing and straightening her fingers.

Although she no longer cuts linoleum blocks, Diana still enjoys operating her Vandercook Simple Precision SP15 proof press. Letter by letter, she spells out blessings and beloved quotes, places them and her hand-cut blocks on the press, and prints bold, inspiring images.

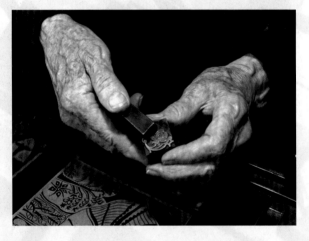

"Let's get a beautiful, big piece of type." Diana lovingly runs her fingers over letters stacked in a wooden drawer, one of a dozen filled with cast-lead alphabets. "The word is growing, isn't it?" she says, adding letters to the composing stick, the frame that secures the letters before she puts them on the press. "I have a lifetime collection of type. Each piece is a precise sculpture made of lead. You have

to handle them carefully. They're heavy, but they can be hurt."

Diana slides a thin sliver of lead between some of the letters so they are spaced properly for the reader's eye, and then studies the phrase written in reverse: "May Our Actions Bless This Earth With Peace," a blessing given to her by her son, Dan. Above the type she centers a linoleum block, carved with a scene of rolling farmland and trees. "One of the most important lessons I've learned as a printer is one word." Her green eyes sparkle as she sings out, "Proofread!"

She's well known for these prints, called broadsides, which combine her blocks with words to convey information as well as her opinions. Some broadsides include as many as eight images and several lines of hand-set type. "I can get terribly depressed and worried about the world situation," she says. "If I can do something productive, like make something with my hands, it's good for my mind and spirit."

Diana turns to a shelf behind her and smears thick black ink onto a square of glass, then works the ink to a fine film with a rubber roller. Then she returns to the press to roll a thin layer of ink

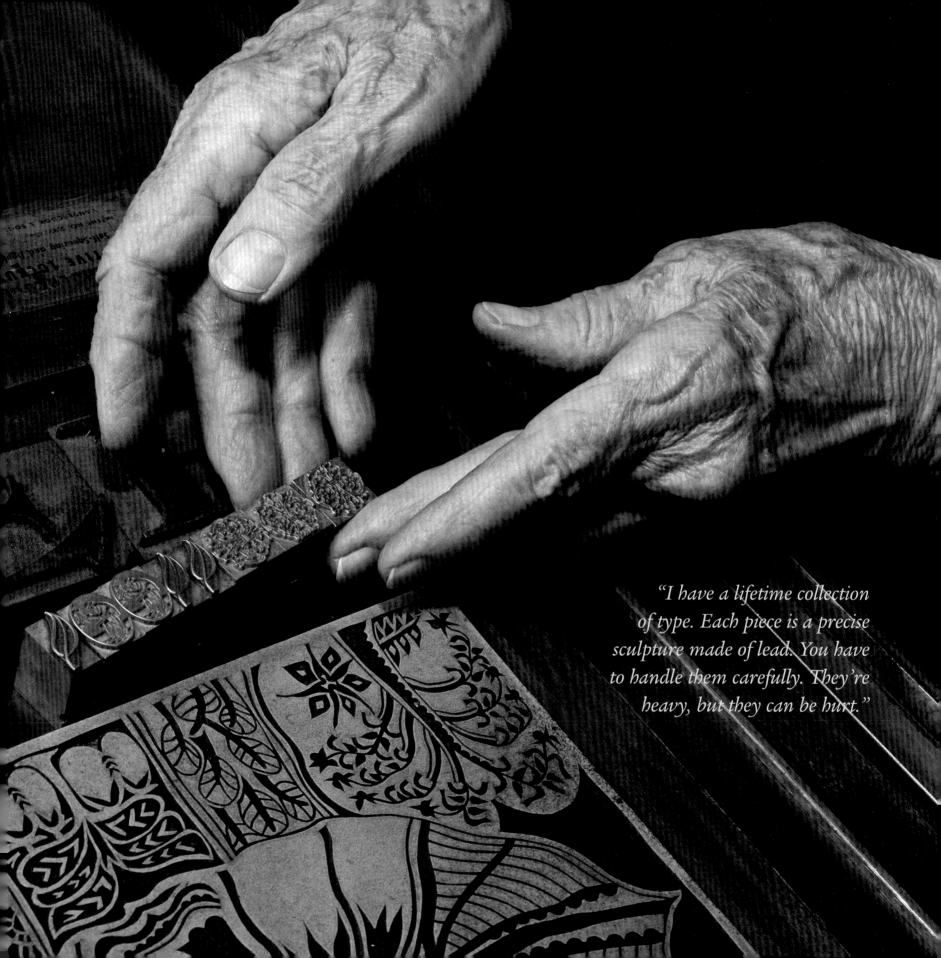

"*I have a lifetime collection of type. Each piece is a precise sculpture made of lead. You have to handle them carefully. They're heavy, but they can be hurt.*"

on the letters and block. "Both my children, Holly and Dan, have had a profound influence on my life," she says. "Their generosity and views about the world teach me so much. They taught me that inaction is a fruitless path. You have to take action. My political posters and upbeat broadsides are something I can do."

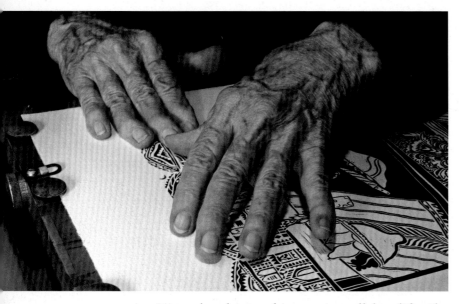

Diana has been taking action all her life. She lived much of her youth in small towns in New York State and credits her high school art teacher with guiding her into her life's work. "I had always loved art—watercolors, costume design—and my art teacher said, 'You've got to go to Yale. It's the best art school I know of.' But my father wanted me to go to Vassar. I was accepted to both, so Papa let me choose." Soon she was trying to get his permission for another dream.

"When I started at Yale, the art school followed the Beaux Arts tradition of life drawing and portraiture in dark studios. It was grim. I told my papa I had to go to Europe. He said no and I argued and argued with him. Then I made a bargain with him that if I earned my passage, I could go. I did that by working in the village diner."

After seven months of soaking up art in Scotland, England, Paris, and Florence, Diana returned to Yale. "The art school had been transformed. Everything had been painted white, and Josef Albers had established a graphic arts department with brilliant young instructors. They were so inspired. And they smiled and laughed and got us to do great work. They had a wonderful letterpress, and that's when I fell in love with type. It was like coming into my own."

The job in the diner had provided Diana with more than her funds for Europe. It was also where she met Ted Bower. "He was an architect building Frank Lloyd Wright homes and his own designs. He was quiet, handsome, and intriguing. I gave him extra butter," she says, her eyes twinkling behind the big, red-framed glasses she wears when she's working. They were married in 1953 and headed to India, where she and Ted worked on architecture designs for schools.

Their next home was Seattle, where Diana was befriended by a family of Japanese-American printers. "Their baby would sleep in a cardboard box under a press," she remembers, "and it was as if they had adopted me. Their print shop had lots and lots of type, and they gave me my own little corner. They were incredibly kind and taught me a lot. I started setting type more and more, and I loved it."

Diana's skill as a printer grew even more when she began working with Rachel da Silva, cofounder of Seal Press, Seattle's first feminist publishing house. "Rachel was an accomplished letterpress printer and teacher, and we shared an old Chandler and Price platen press we kept in my basement. We worked together very well, and had fun at it."

Soon Diana became sought after for book design for the University of Washington Press. "I also had many years of making blocks and printing invitations," Diana says, pulling out announcements and posters that she handset for civil rights and peace efforts. She recalls the days when she protested nuclear weapons and the time she was tried in federal court for civil disobedience.

In 1981 Diana bought property in the rural community where her daughter runs Holly B's Bakery. Now, she and Ted live there, and in her studio, a refurbished 1910 farmhouse, Diana continues her letterpress work. A wood stove warms two small rooms, and a classical music radio station plays quietly in the background. The studio's wood floors are painted pale blue and covered with tapestry and rag rugs. Cornflower-blue trim accents floor-to-ceiling windows and French doors. A bright-blue enamel ceiling lamp hangs over the bed of the press. "What a joy it is to work in this room when the sunlight comes in through the glass," she says.

One wall of the press room is lined with four-foot-high shelves. On top are round metal tins of

MAY OUR
ACTIONS
BLESS ⚬⚬ THIS
EARTH
WITH
PEACE

inks in black, red, blue, and yellow plus glass jars and pottery vessels packed with pens, pencils, and brushes. Shallow drawers below are divided into squares and rectangles, to organize the type alphabetically and protect her carved blocks. Some cases hold the little symbols known in hand-set type lingo as dingbats or printers' flowers. "I put them between words or use them to create a mood." Diana pulls open one drawer of Garamond type she acquired when a university closed its print shop. "One can get a lot of happiness out of type," she says. "As you can see, I love it."

Flat shelves beneath Diana's press hold stacks of pristine Arches cover paper. She slips a cream-colored sheet under grippers at the top edge of the cylinder, a heavy drum in the middle of the press. She turns a crank to roll the cylinder over the inked letters and block. "You have to slowly roll all the way to the end of the bed," she explains, the pace of her words matching that of her footsteps as she walks the six-foot length of the press. When the roller reaches the end, she just as methodically peels the paper off, admires the print, sets it aside, and repeats the process. Diana always makes a series of prints to get the perfection she strives for. "I enjoy retrieving the image at the end of the rolling cycle. When there's a really crisp print, I love that. The interim satisfaction of printing is that as soon as you print one, you put it on the table to dry. Then you see the rows of prints growing."

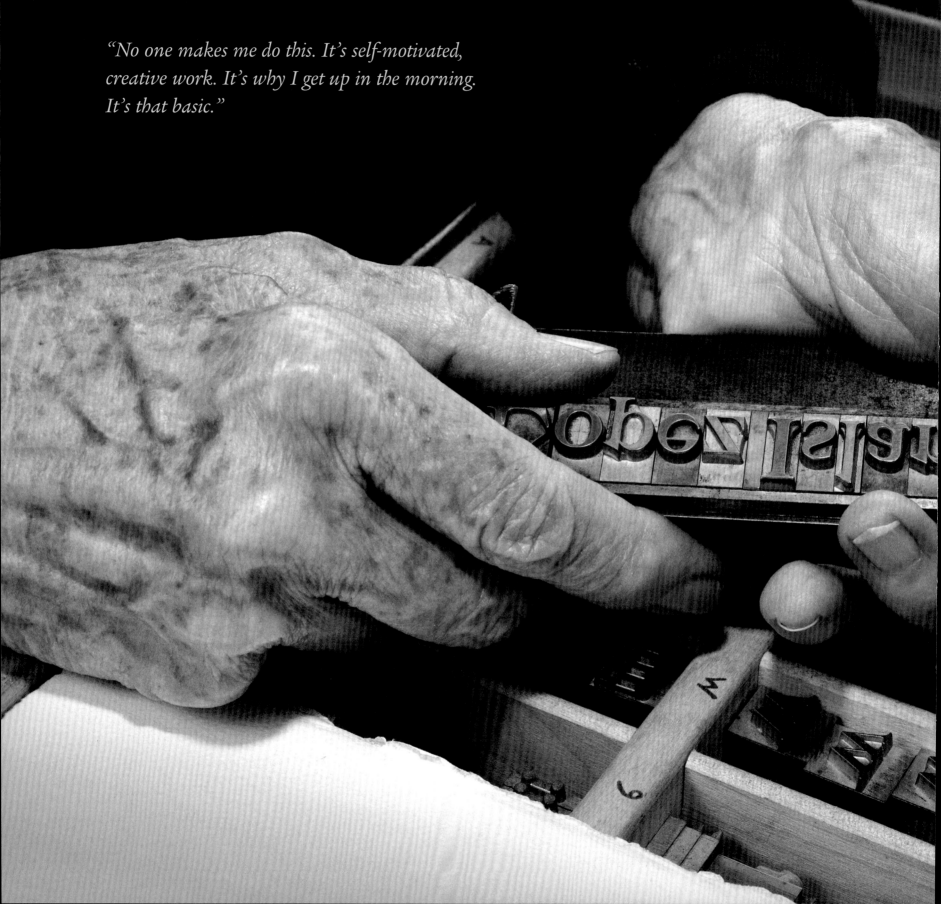

"No one makes me do this. It's self-motivated, creative work. It's why I get up in the morning. It's that basic."

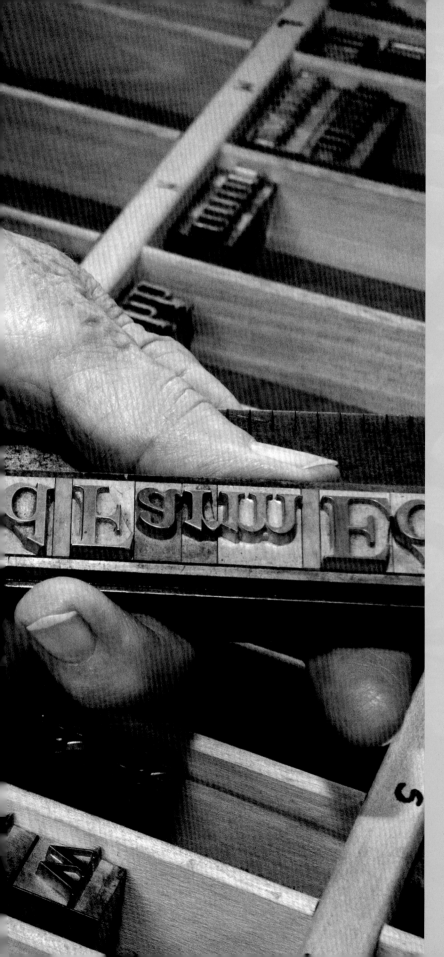

For many of her broadsides, the printing is only part of the process. Often she later cuts out bits and pieces of other prints, maps, or photos and glues them to a broadside to create collages. Sometimes she watercolors vibrant hues inside the black borders of the images. "It's such a great joy to put color on a print. The painting takes less effort than carving and setting type, but I still have to get up a lot of steam to do it."

Diana continues to use her art to promote peace and express her views. "When I can be present to watch people react to my work, there's often a lovely moment of connection. Sometimes they put their hands over their hearts, or they'll read the words and catch their breath a little. A broadside that combines the peaceful and pastoral quality of my home with a blessing that conveys encouragement and love—that's what gives me the most pleasure."

Her least favorite part of printing is cleanup. "Especially the ink on my glass palettes. It takes a long time to get the black goo off. I have to use paint thinner," she says, scrunching up her nose at the mention of the pungent chemical. "I don't mind cleaning the blocks and type so much, though, because I run paper through the press until almost all the ink is off of them. And I get nice shadow prints in the process."

Diana moves gracefully around her studio, readily able to put her hands on type and blocks or pull out favorite prints. "I love work that sustains life," she says. And this work, this old craft that dates back to the fifteenth century, sustains her. "No one makes me do this. It's self-motivated, creative work. It's why I get up in the morning. It's that basic."

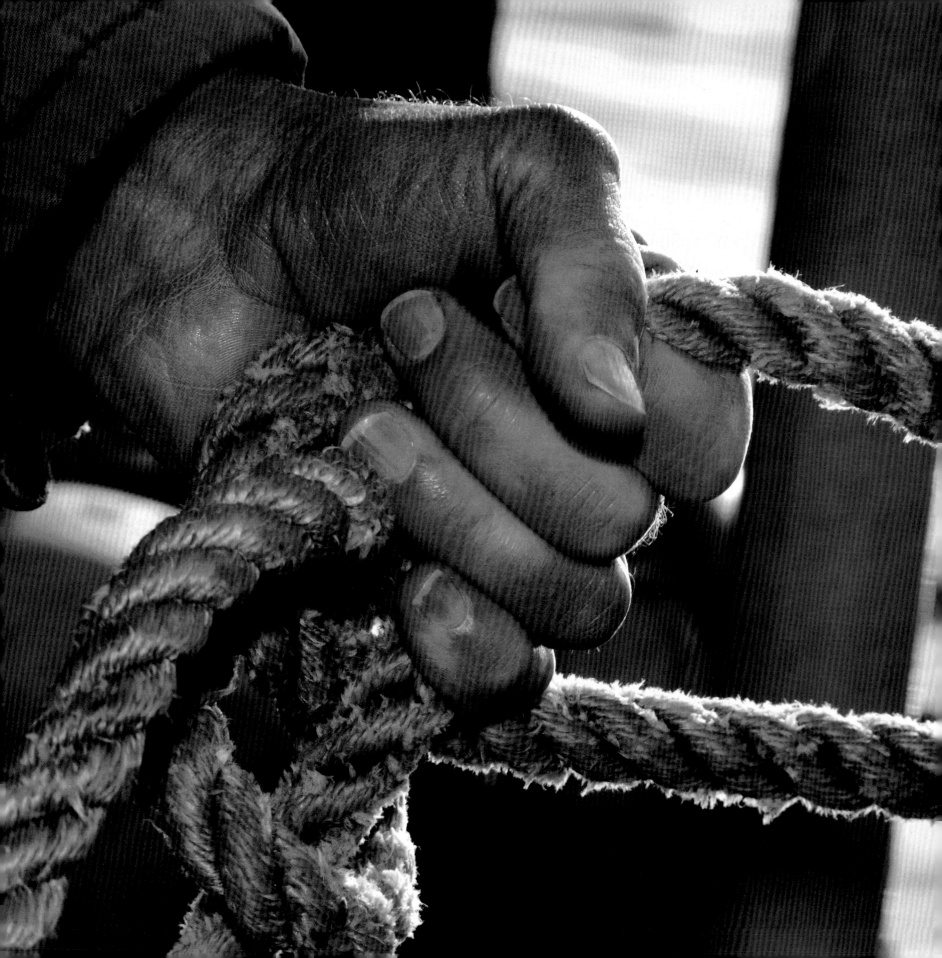

Looking at Jack Giard's hands, it's hard to believe they've been hauling in fish nets for fifty years. "I guess I got my mother's hands," he says, holding them up and spreading his long, slender fingers. A third-generation logger, lumber yard owner, and fisherman, Jack started reef net fishing the summer after he graduated from high school. Every July through October since then, he's caught wild salmon with reef nets off the western shores of Northwest Washington.

Reef net fishing, a historical Pacific Northwest method practiced for centuries by Native American tribes, may be the oldest way to harvest fish in the United States. Its "gear" includes two boats anchored seventy feet apart with a fifty-foot square net submerged thirty feet underwater between them. A large, scoop-shaped mesh net, called a bunt, is sewn into the back end of the square net. Two lines of nylon, called leads (each of them two hundred feet long), are attached to the net below and the bow of the boats above. The leads stretch out from each boat in a funnel shape to guide the fish into the bunt. Plastic streamers, or salt grass that grows along the shoreline, are woven into the lines; they wave in the tidal current that passes through, simulating a reef.

Centuries ago, Native Americans wove nets and lead lines from dried willow and cedar bark and moored their cedar canoes with boulders. Although Jack's nets and lines are rayon and nylon, and electric winches lift the net and four-thousand-pound cement blocks anchor his boats, his technique is much the same as in those early days.

"The salmon can't see the net and swim into it thinking they've gone over a reef and are headed into deeper water," Jack explains, poised on the sixteen-foot-high tower in the bow of his boat, scanning the water for a school of fish. His three crew members—one on the other boat's tower and one on each boat's deck—wait patiently for the fish

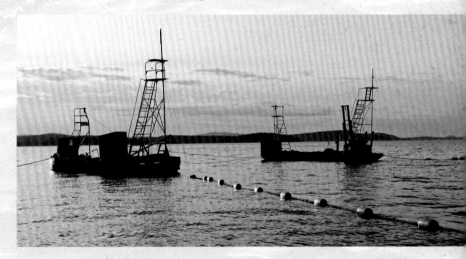

to swim into the net. "It's not a sure thing they'll go into the net," Jack says. "They're traveling at about six miles per hour on the way in. They might get scared and turn around or go through the spaces between the lines in the leads. There aren't

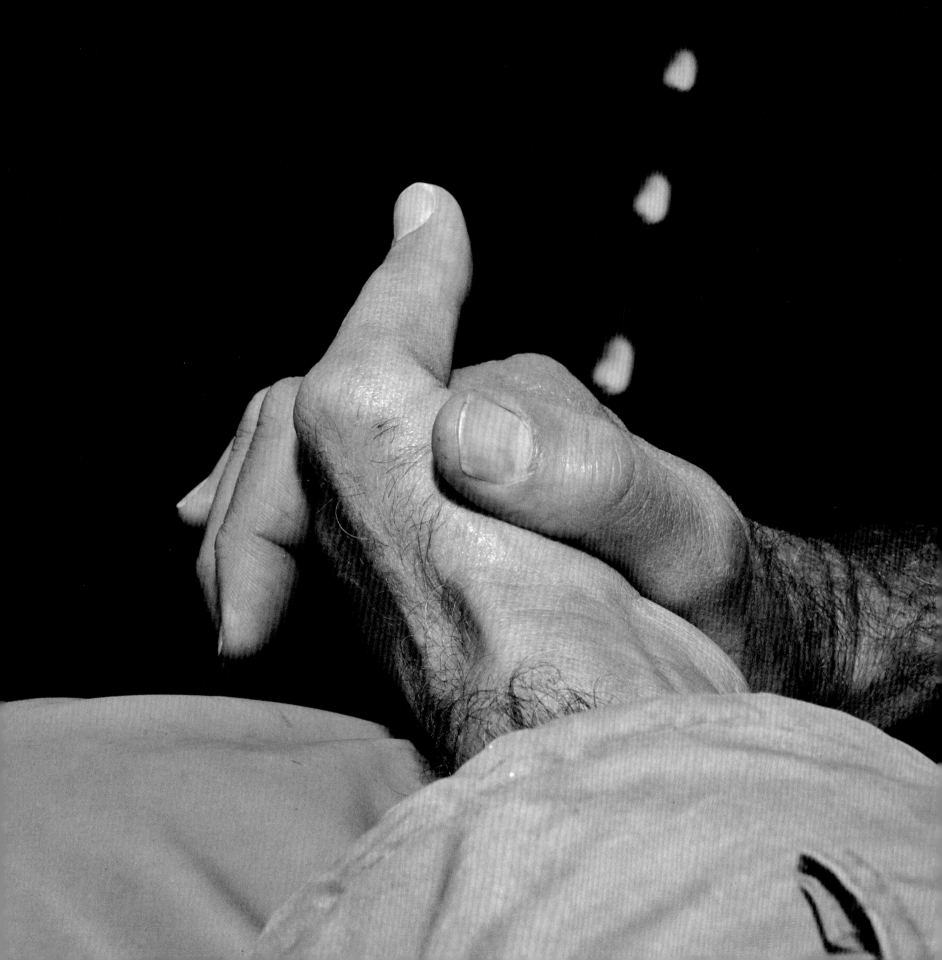

any sides on the net to stop them, and we've only got about ten seconds to get the bunt pulled up around them."

Jack squints his clear, blue eyes and stares across the green water reflected in his bifocals. Saltwater dots his yellow vinyl raincoat, rain pants, and black rubber boots. He rubs his reddened hands together. "Your hands get cold, especially in the fall. Of course, the water is always cold—about fifty degrees. Some guys wear rubber gloves, but I don't because they get caught in the net. I don't want to get pulled off the boat by my gloves." He leans forward slightly, then straightens. "Here they come. Let's pull!" he shouts. He punches the button for the electric winch that hauls the net up in six seconds, and then swings his six-foot-three frame down the tower's ladder.

The work is punctuated by grunts from Jack and his crew. Hand-over-hand they drag the net over the edge of the boat. When fishing is good, there are anywhere from twenty-five to seventy-five fish in a school; more than a hundred isn't unusual. "This part can be back-breaking," Jack says, his breaths steaming his glasses. "If you have a hundred and fifty sockeye in your net, that's about nine hundred pounds. The boat will take half of that weight, and we take the rest." The boat creaks and sways as the four men haul in unison, tightening and releasing their grasps on the net loaded with salmon.

Frigid saltwater bathes the silvery, pink-tinged coho and chum as they spill over the threshold into the seven-foot-square tank under the boat's deck. "With reef netting you get the best-quality

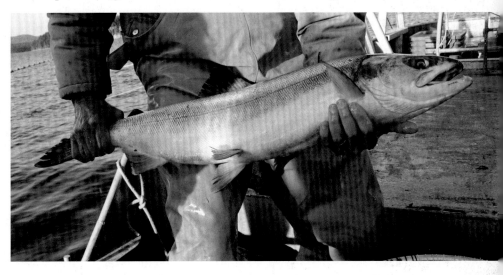

fish because they haven't been damaged as they're caught," Jack says, "and they just swim around in the live tank until we deliver them to our market." When the net is empty, Jack and his crew feed it back into the water, ready for the next school of fish. The entire process takes just three minutes.

"I like the excitement of fishing," Jack says, perched again in the tower. "These fish have a good chance of beating you, especially in dark weather. If you don't see the school coming, you miss 'em. And if you see them and wait too long, you miss 'em. It's sort of like sitting at a card table and getting dealt seven cards. We sit in the same spot every day and wait for the fish to come to us."

Jack's hands are relaxed now, resting in his lap as if in prayer. His gaze remains on the water, and his chest expands with a big inhalation of briny air. "I don't like killing anything if I'm not going to use it, and I love to eat fish," he says. "Smoked pink salmon and barbecued sockeye are my favorites."

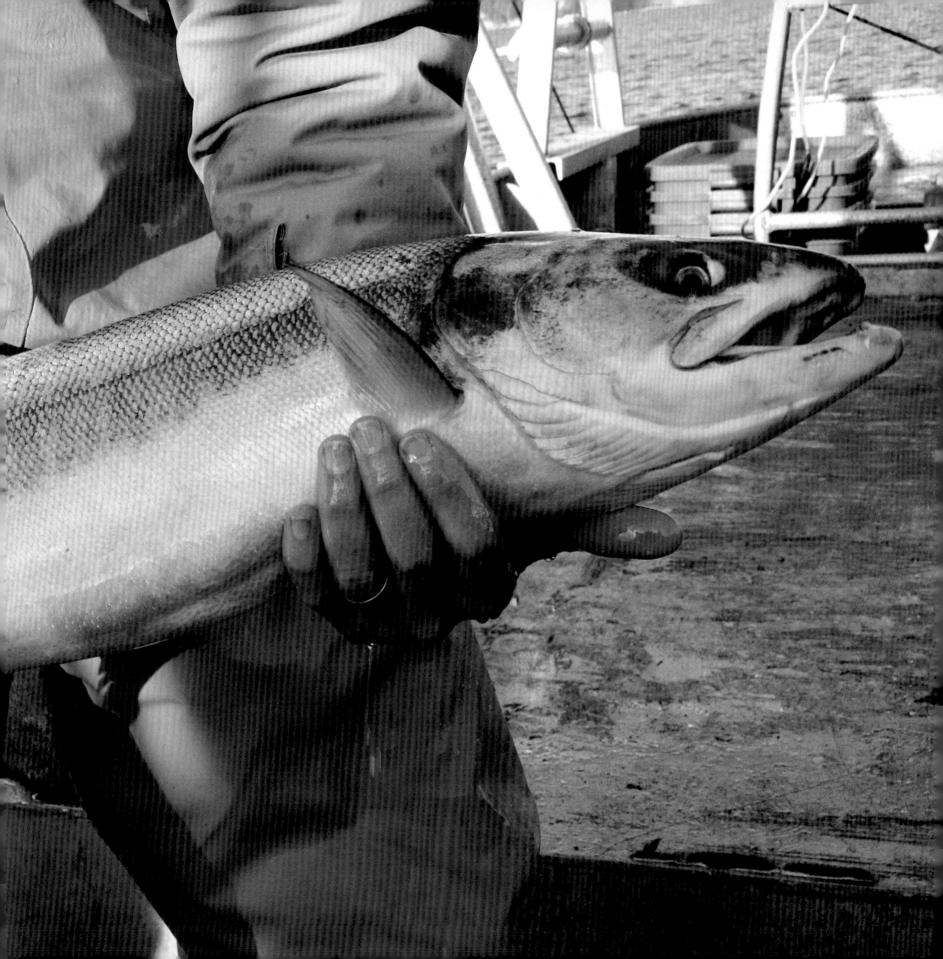

The boat rocks gently on the calm water this autumn day, but it's not always so peaceful. "When the weather gets too rough, I come in," Jack says. "Strong currents along with heavy seas can tear the gear to pieces, and heavy winds out here can create ten-foot-high waves. You have to use your head. I've seen my boats upside down several times. I'm just thankful to God for every year I can fish."

Jack is committed to preserving this work he loves and the Canadian and U.S. salmon resources he harvests. For eleven years, he's represented the U.S. nontribal fishing industry on the Fraser River Panel of the Pacific Salmon Commission, an international group that manages the American and Canadian harvest of sockeye and pink salmon bound for Canada's Fraser River. A large portion of this resource migrates through and is harvested in the waters around Washington's San Juan Islands.

"When I started reef netting, there were about a hundred reef-net gears in northern Puget Sound. Now"—Jack mutters names as he counts on his fingers— "there are eleven gears left." Recent treaty changes with Canada have lowered the U.S. entitlement on Fraser River harvest, and much of the

"Your hands get cold, especially in the fall. Some guys wear rubber gloves, but I don't because they get caught in the net. I don't want to get pulled off the boat by my gloves."

nontribal fishing fleet was reduced by buy-back monies allocated in the new treaty agreements.

"Reef netting is the most environmentally friendly, fuel-efficient way to fish," he says. "We're not out in big boats spending thousands of dollars on diesel fuel. In two weeks, I maybe use five gallons of gas in my outboard motor getting from the shore to my fishing boats."

Jack cherishes being aboard his boats. "There isn't anything I dislike about fishing," he says. "I like being out in this peaceful, quiet area, watching other people in boats and looking at sea lions, seals, flounders, and whatever else goes past my gear. And when I see those pristine fish and realize what they went through to hatch out in the Fraser River and get past all those predators swimming to the Bering Sea, and then turned around and came back to the same river, the same tributary..."

His voice trails off as he looks out across the gently rippling water. "One of the most important lessons I've learned as a reef net fisherman is patience," he says. "You can't be quick to give up because you never know when the fish will come."

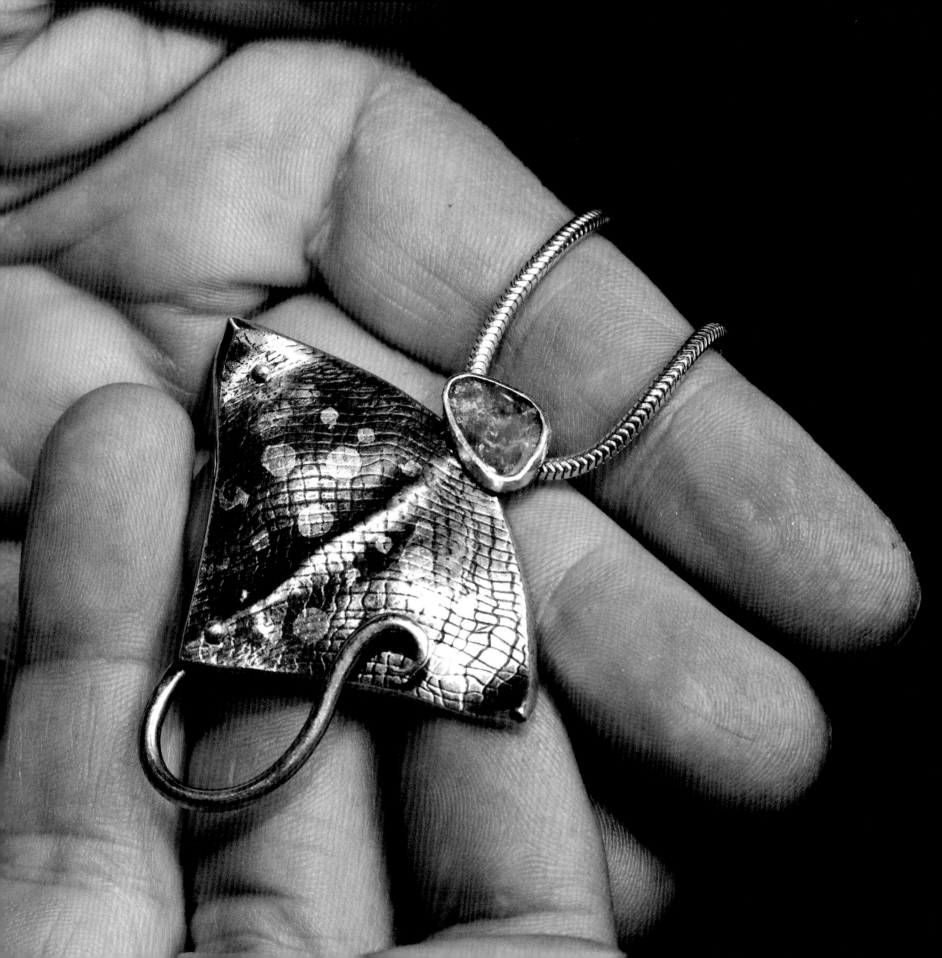

Tina Finneran's sturdy hands cradle a necklace of gold, silver, and opals. It looks much like the photo she has of a Spotted Eagle Ray, a type of shark she often saw while she was living in the South Pacific. "They don't have bones, and they're often five to six feet across. They're really gentle," she says, fingering the cartilage-like ridge on her rendition of the sea creature. It's one of her favorite designs.

"I'm a studio jeweler as opposed to a fine jeweler. I don't use a lot of diamonds and precious gems," Tina says. A canvas apron covers her magenta turtleneck and blue jeans; her yellow plastic clogs have splashes of tropical green. "I've gone to a few workshops, but I'm largely self-taught," she says. "I combine beach stones, fossils—things you wouldn't expect—with silver, gold, copper, and brass. There's something really satisfying about seeing a rock on the beach and then in a pendant. It's like it's framed, and you can wear it. It's not high-end fancy jewelry, but I think it's meaningful."

Tina slides the necklace onto a swatch of black velvet and picks up rectangles of patterned silver. One has a crosshatch texture that she created by pressing gauze on heated silver and running it through a rolling mill. Another is etched with a Chinese cloud pattern. Some are imprinted with a few words from the first page of *Moby Dick* or a Sanskrit sutra. Eventually, Tina will cut, solder, and polish the strips of silver to fashion earrings and necklaces. "These words and symbols are very subtle in the background, which I think adds some mystery. They touch the subconscious even if people don't know what they mean," she says.

It's no surprise that Tina is inspired by sea creatures and seafaring novels. In the late 1970s she sailed to Hawaii with five friends; they anchored in a bay in Kona. "I spent my days on the beach swimming and surfing and my nights working in a restaurant. I met my husband, Shane, in that community of young people in funky boats. Unlike the other guys, he wore a plaid flannel shirt and seemed very Northwest," she recalls, flashing a big smile.

Shane's "funky boat" was a thirty-year-old, thirty-foot classic wooden vessel with a bucket for a toilet, no electricity, and kerosene lanterns for light. In 1981 he invited Tina to sail it with him to Palmyra, a thousand miles south of Hawaii. They got married in Fiji and continued sailing around the South Pacific for five years. "We lived very simply

"Being able to make a living doing what I love and what inspires me is a blessing."

on the boat and worked for awhile in different places," Tina remembers. "We stayed in Tonga for two years, working for a guy who was remodeling his hotel. I also repaired sails with the 1927 Singer sewing machine I had brought along."

Tina and Shane sailed next to Australia and then to Guam, where Tina trained as a dive instructor, and they both got captain licenses. When their son,

Ian, was born in 1990, they sold the boat. After having been away for nearly thirteen years, they returned to the mainland U.S.—sort of.

"We bought a van and visited a friend of Shane's on an island in the Pacific Northwest," Tina says. "This felt like the best place for us. We lived in the van with our baby while we cleared land for a house. I did watercolors of sea life while Ian napped." Soon Tina met some glass blowers and learned more about making jewelry by cutting beads for their company.

After their house was built, Tina started designing jewelry with black coral, shells, and coins she had collected in the South Pacific. She sold her work in the gallery of the local artists' cooperative that she joined in 1994. In 1997 the family of three sailed again to the South Pacific for two years. Tina continued to make jewelry and sent it to the gallery back home.

After so many years living on a boat, Tina seems at ease working in the compact shop Shane built behind their house. The walls are painted pale green, and windows on three sides overlook cedars and firs. Tools and machinery occupy every shelf, workbench, and tabletop. In one corner is a hot plate that Tina has modified for heating silver. In another, strips of blue tape attach drill bits, arranged by size, to a wooden post. A stack of rainbow-colored plastic drawers contains shells, stones, freshwater pearls, and beads. "I've had a lot of crappy jobs in the past," Tina says. "Working with my hands is so satisfying because I've got something to show for my effort." Customers at artisans' fairs and the local gallery are satisfied with her work as well, and it has been featured at the Seattle Art Museum's gift shop.

"Being able to make a living doing what I love and what inspires me is a blessing," Tina says over the whine of a disc cutter, shaping two silver spheres the size of quarters. She perches on a stool and wraps wire around the pieces to create a dome-like pendant. Varying sizes of pliers and clippers with blue, green, yellow, and red grips dangle on a wooden rack. Tina reaches for a pair of clippers and snips tiny bits of solder—silver mixed with other metals that melt faster than pure silver—and then

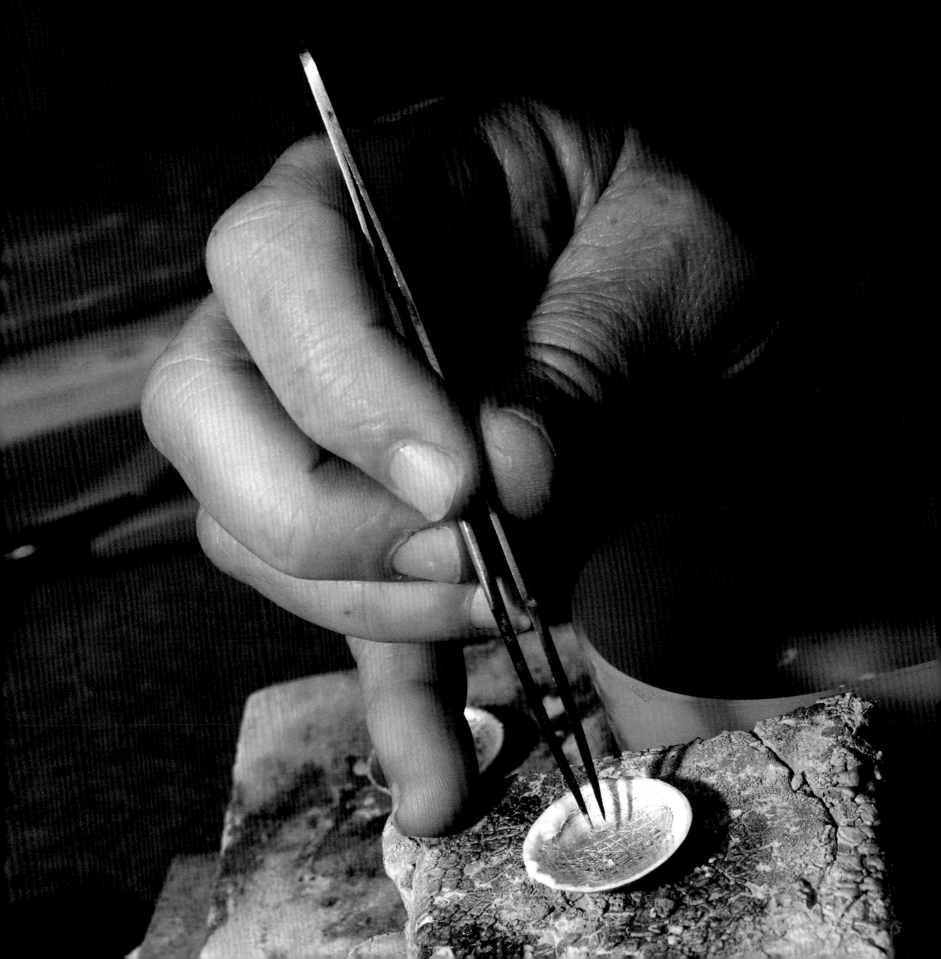

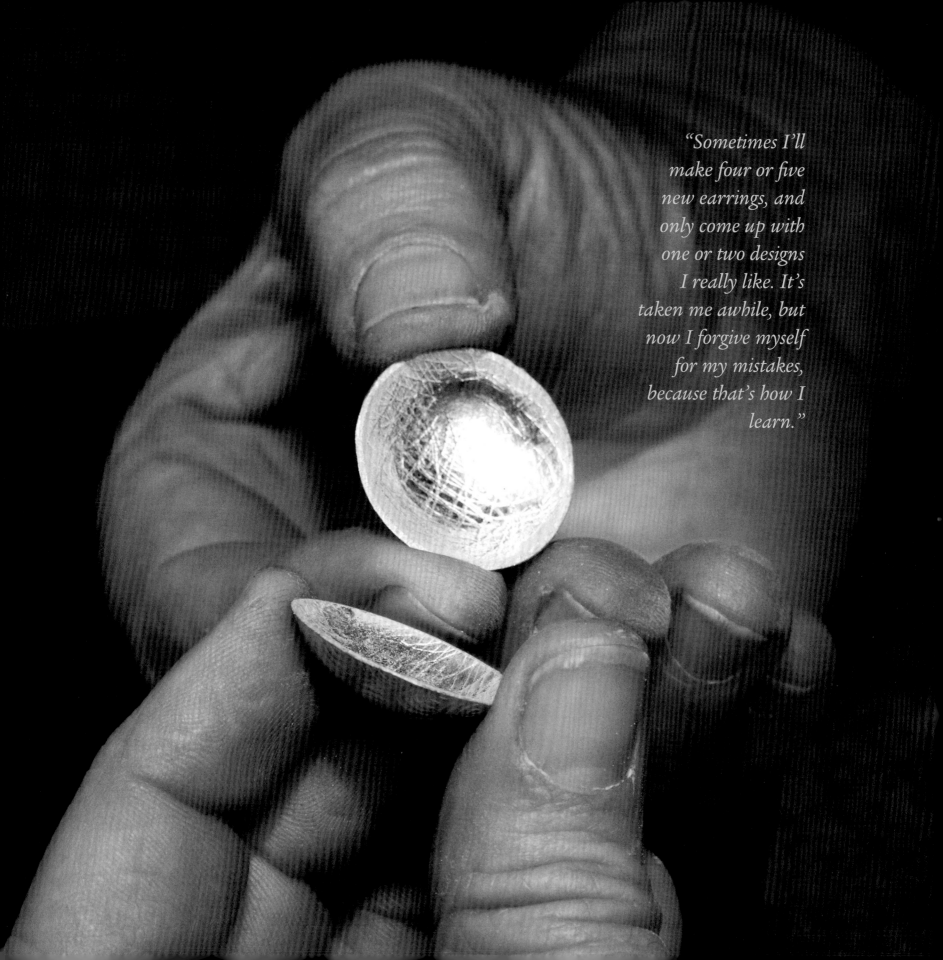

"Sometimes I'll make four or five new earrings, and only come up with one or two designs I really like. It's taken me awhile, but now I forgive myself for my mistakes, because that's how I learn."

replaces the clippers on the rack. "I always put my tools away immediately. I get so excited with what I'm doing that if I didn't, soon I'd have them all out and wouldn't be able to find anything."

Tina slips welder's goggles over her eyes and turns off the overhead light so she can see the color of the metal as she heats it. Her left hand wields a torch, its orange flame fueled by oxygen and propane; tweezers in her right hand pinch up pieces of solder that she places on the rim of the heated dome resting on a stand.

"I've got my flame up big now, so I have to be careful not to melt the pendant. That's how I get a lot of scrap silver. I have a big mayo jar full of it." Her thumb hovers over the torch's regulator. "Let's try a little smaller flame," Tina says, adjusting the knob. "I'm looking for a little fleck of molten silver on the edge. Come on," she urges, coaxing the solder to change color, first to blue, then green. "When the metal gets red, that's the danger zone." The instant the silver goes orange, she switches off the flame and drops the freshly soldered dome into the "pickle," a dish of acid that dissolves the oxides formed on the silver during heating. After rinsing the pendant in a solution of water and soda, Tina dries it, unwraps the temporary wires, and carefully smoothes the edges with an emery board.

Next she shifts to two-inch rectangles of silver for earrings. She'll design these using *Keum-bu*, a Korean technique of applying twenty-four-karat gold leaf to silver. Tina cuts the paper-thin gold into slender strips with manicure scissors. "I want them to resemble eel grass and seaweed, the way it looks down in the dark water when I'm in my kayak and the sun shines on it." She picks up slivers of

gold with tweezers and drops them onto the silver. "This looks chaotic, like I'm just throwing the gold down, but I have a vision. It's the change of the tide and the grasses aren't all going in the same direction."

Tina buffs the gold with agate burnishers and sets the pieces on the hot plate to melt the gold into the silver. Later she'll add wire hoops and will polish the pieces until they glisten. "I like exploring new techniques and trying to figure out how to make a texture or develop a process," she says.

She stops to study the miniature seascape she's just created. "I'm torn sometimes between trying to make money and experimenting," Tina confesses. "Sometimes I'll make four or five new earrings, and only come up with one or two designs I really like. It's taken me awhile, but now I forgive myself for my mistakes, because that's how I learn."

Vibraphonist

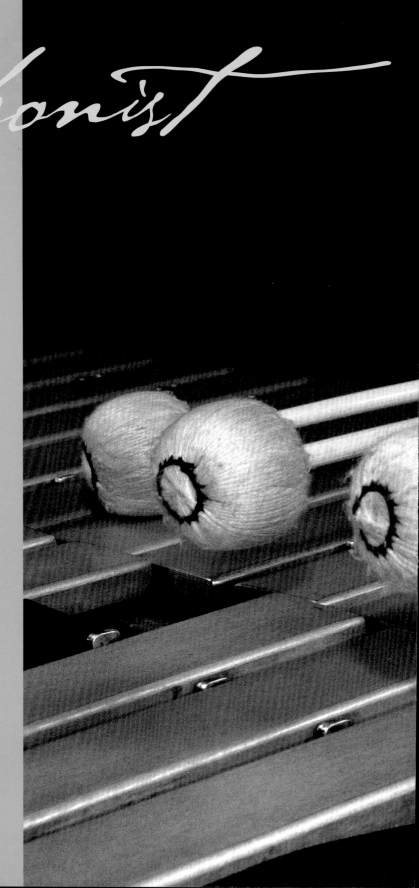

Hawk Arps hunches, all six-foot-four of him, over the vibraphone set up in the combination kitchen/living room/dining room of his small house. His mirrored sunglasses reflect the instrument's silver keys. A bushy brown mustache hides Hawk's upper lip, and strands of graying hair that have escaped from his ponytail, curl behind his ears. His wife, Heather, washes the dishes, swaying to the soulful strains of one of Hawk's original jazz arrangements. "I'm a carpenter by day," he says in a deep voice with a tinge of a drawl left over from his childhood in Texas. "It's skilled labor, and I'm proud my hands know how to do that. But when I'm doing carpentry I don't feel I have a relationship with the cosmos. With music, my hands connect me to all of creation."

Smoke curls up from a smoldering sprig of cedar wedged into a corner of the rectangular keyboard-like surface of the "vibes." The woody scent mingles with the full, round notes echoing from the instrument as Hawk's long arms stretch across its narrow, five-foot span. Each of his broad, calloused hands wields two mallets (rattan sticks with a rubber ball wrapped in yarn on the end). One mallet perches between his thumb and index finger; the other, between the index finger

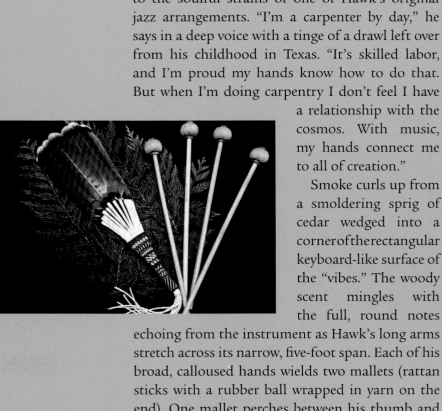

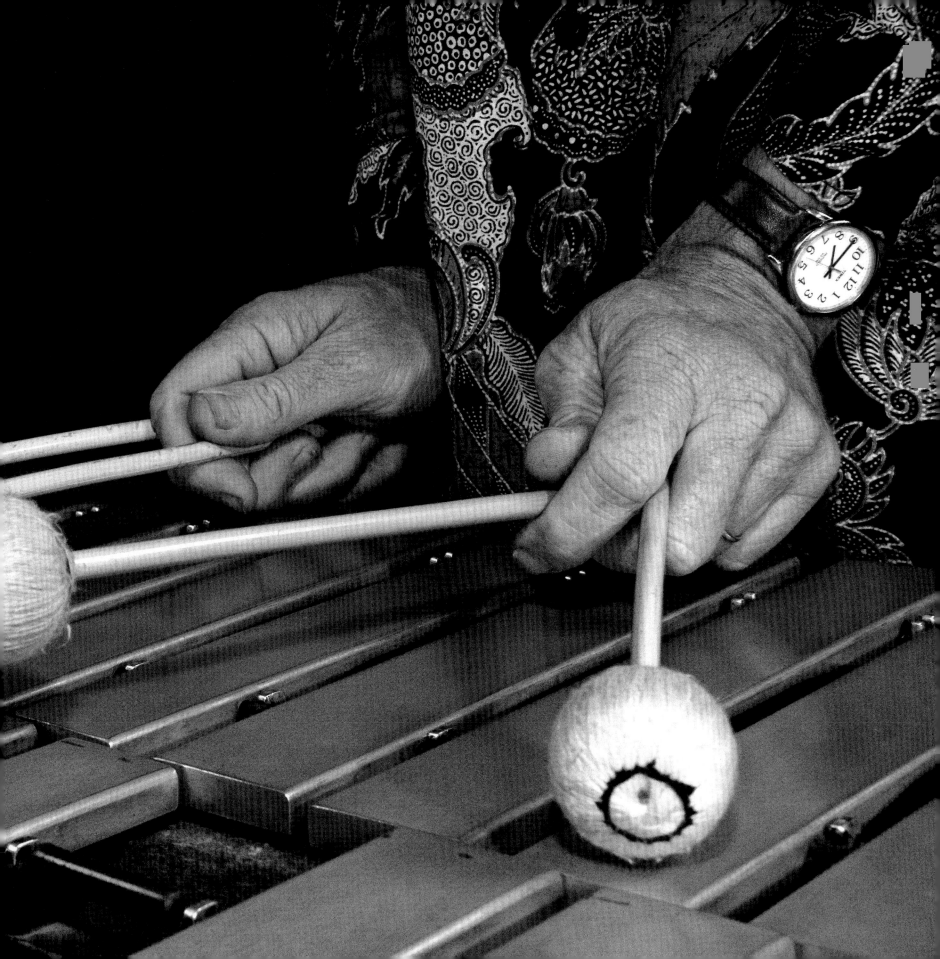

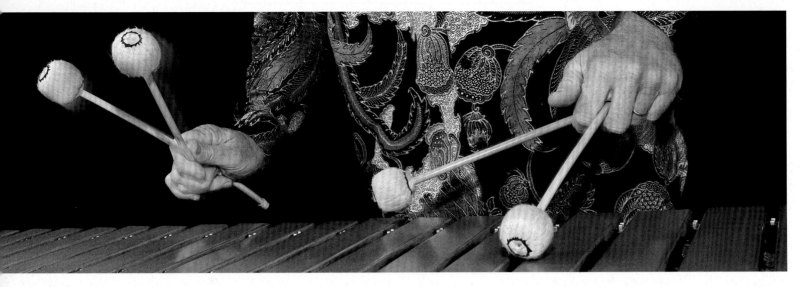

and the middle finger. "It's my own grip," Hawk notes, "and it works for me."

His wrists flex as the mallet heads strike the aluminum-nickel alloy bars. Sound reverberates from the bars down long tubes, called resonators. A motorized bar across the top of the resonators opens and closes flaps, resulting in a vibrato—hence the name vibraphone. Hawk's has a first name, too—Stella.

"Years ago I was at a friend's cabin with some Brazilian exchange students," Hawk recalls. "One of them went out in a boat on the lake late at night. He was yelling his girlfriend's name, Estella, as he looked at the full moon, knowing *she* was looking at the same moon. The passion across continents struck a deep place in me. When I play, I'm trying to express that longing."

Hawk's arms swing as if, like a marionette, they're attached to strings; his head bobs slightly to the rhythm. "I usually play with my eyes open," he says, "but I use my hands to see, and the mallets become extensions of my fingers. I do look at the vibes, but just to make sure I'm in the right place. It's like having your hands on the right keys of a typewriter. The trick is to put them in the right place at the right time."

Hawk has been putting those mallets in the right place at the right time for much of his life. "When I was eight, I went to the Texas State Fair with my mom, and there was a steel drum band. All day I sat on the side of the stage patting my thighs, playing along with the band. That night, my mom noticed I had blood blisters on my thighs, and the next day she took me to the mall and got me a snare drum."

Around the same time, Hawk heard his minister's son playing boogie-woogie on the church piano. "I watched his right hand and realized he was hitting the same notes over and over. He told me it was a blues scale." Hawk went home and tried

that scale in different keys on the piano that his great-grandmother had played in movie houses. "I just did that for about five years and taught myself chords and scales. I never had piano lessons. Later I became a band geek. During middle school, I was the drummer in a garage band. In high school, I played tympani in the concert band and all kinds of percussion in the pep band. The jazz band didn't have a pianist, so the director gave me that music and I played it on the vibe with them, too."

His shift to the vibraphone came after a family crisis. "In 1976 I was on a high school band trip in Central Texas. I got a phone call that my house had burned. I lost all the instruments I had." With the insurance money, he could buy only one instrument. "I ordered a brand-new vibraphone. It's both a piano and a drum—a percussion piano," he says. The delivery truck showed up with it on his seventeenth birthday, and he's been playing that same vibe for thirty years.

"If we had a fire at our house, this is the thing I'd grab," Hawk says as he unrolls a black velvet case his wife made to hold his collection of a dozen sets of mallets. There are only a few mallet makers in the world, and Hawk's were constructed by the granddaughter of the man who made mallets for vibraphone legend Milt Jackson. The mallet heads are of varied sizes and levels of hardness. "I use different mallets to get different tones," he says. "A bigger mallet makes the bar resonate that much stronger." He picks out a set with faded orange yarn heads and knitting needles duct-taped to the sticks to provide extra support. "These have been around," he says. "They're for really loud music."

Despite his passion for music, Hawk studied philosophy, Chinese, and comparative religion at Duke University. "I was searching for answers because the church I had grown up in mainly asked questions. And the comparative religion curriculum allowed me to take a lot of what I wanted, like

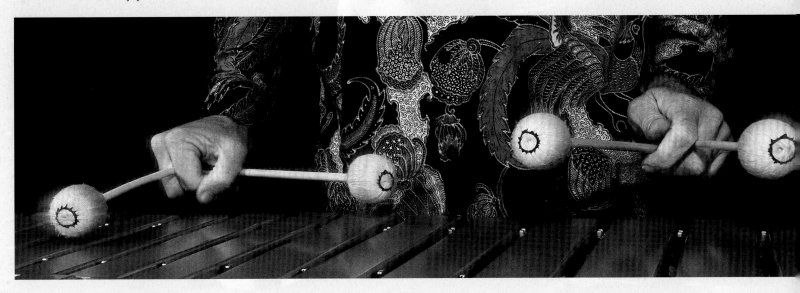

Chinese and jazz history." In his junior year, he was accepted to North Texas State University's music program but decided instead to study abroad in China. While there, he was the drummer in a band that performed in a lounge bar. "We played American rock-and-roll, but I was the only American in the group. The rest were Chinese, Turkish, and Guatemalan. Music was the language we communicated with."

After college, Hawk moved to Seattle to work as a musician, living in his van and playing vibes on the streets. "One night I was basically playing for my dinner when a steel drum band set up and asked me to join them," he remembers. He ended up performing with the band for three years. "I could play bass steel drum, which was much like the tympani I had played in high school, and I was the only one who could write music. I would listen to the music we wanted to play, write the notes, and arrange all the different parts for the steel drums. We toured the west coast and into South America where we had a gig at Carnival in Brazil."

By 1988, Hawk had tired of the transient life. He and his wife moved far from the urban music scene to the rural Puget Sound island where they've raised their two sons. "Living here makes it hard to have music as my livelihood, but moving here is the best thing I ever did. It was a lifestyle choice," he says.

Hawk's left knee raises and lowers in time with the Latin rhythm he's playing. "When you see me

"I'm a carpenter by day. It's skilled labor, and I'm proud my hands know how to do that. But when I'm doing carpentry I don't feel I have a relationship with the cosmos. With music, my hands connect me to all of creation."

stomp, I'm getting carried away by the music. One time I walked all the way around the vibe," he says. On many evenings and weekends, Hawk joins other musician friends to play at local clubs and private events. "When I'm playing vibes, I'm just in my own world. Me and Stella are together doing our thing. I try not to let my mind interfere with what's going on. You have to think when playing vibes, but you don't want to think too much. You injure the groove a little, and then you're playing theory instead of music."

Hawk plays plenty of music on his latest recording, "Vibra Cum Laude." He worked with seven fellow musicians on this collection of twelve songs, ten of them Hawk originals. "It's a testament to who I am and where I am," he says. "There are gifts on this CD—a song for my wife, one for each of my two boys, and some for other people who've been close to me." The album's collage of different rhythmic styles—Caribbean, modern jazz, rhythm and blues, gospel, and contemplative—is more evidence that this religion-major-turned-vibraphonist has found some answers to his questions about life.

"The Greek philosophers said the mechanics of the universe are based in harmony and rhythm," Hawk says, gently tapping the vibraphone keys. "When I make music, it's not about me. It's something grander, a beauty out there to be witnessed through the senses. That's why I play music—to open people to that beauty."

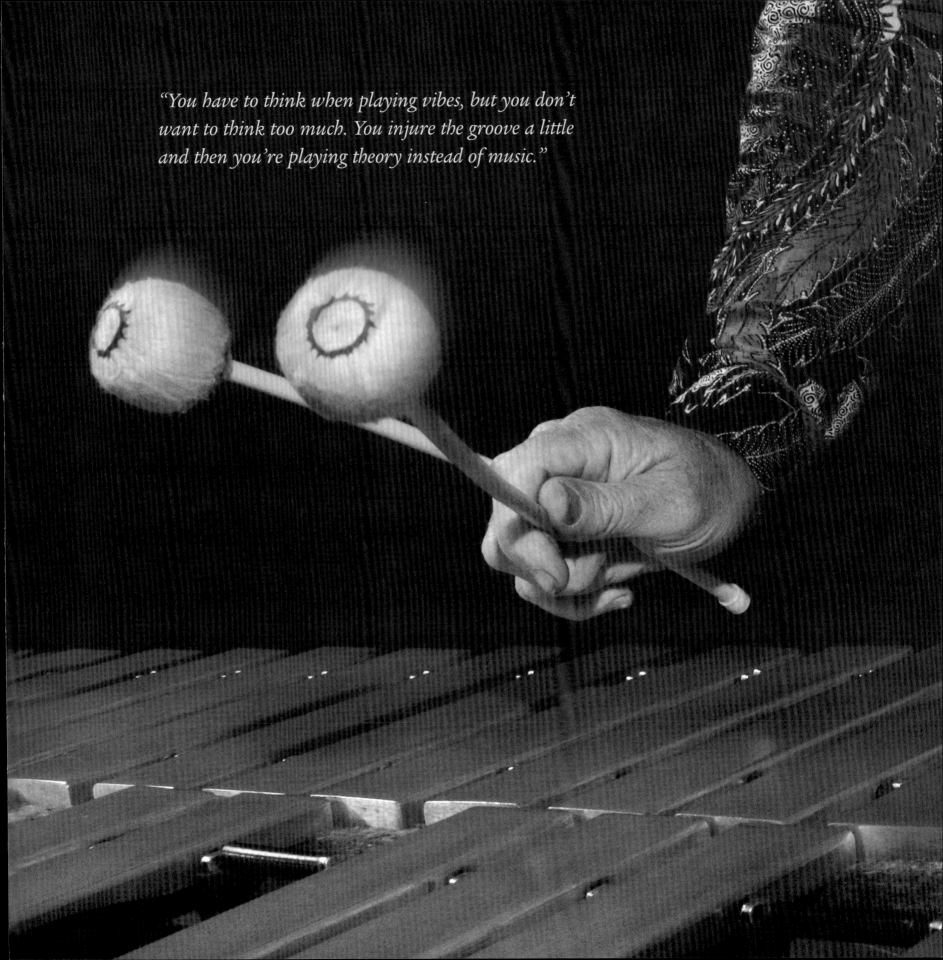

"*You have to think when playing vibes, but you don't want to think too much. You injure the groove a little and then you're playing theory instead of music.*"

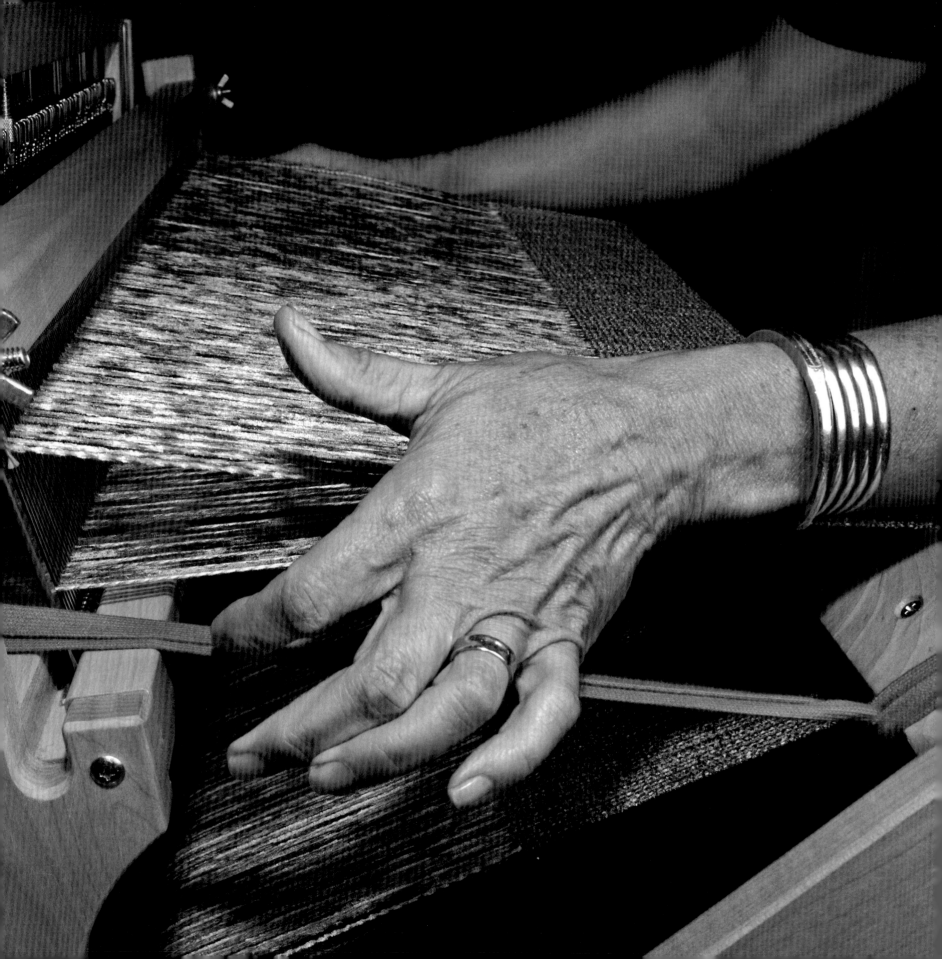

There's a knowing in Sheila Metcalf's hands that doesn't come from textbooks. "I describe myself as a woman in the textile world, and that links me to women all around the world and throughout history. Weaving is the oldest way to make cloth," she says as her hands, secure in their knowledge, efficiently slip the wooden shuttle filled with color and texture from left to right. "There are textiles still around from nine thousand years ago. That's in my awareness whenever I work."

Sheila rests her hands on the taut threads of her loom. Her fingernails are clipped and unpolished. "My hands are authentic, kind of rugged, not fancy," she says. "They work hard. They're really my good friends. I love them and the work they do." As Sheila studies her hands, her brown eyes fill with tears. "I have fingernails like my father's. And, you know, every person who came before you is there in your hands."

A sense of calm and order pervades Sheila's weaving studio. Shelves bear squat spools of wool, cotton, and silk thread organized in a color wheel of blues, yellows, reds, greens, browns, blacks, creams, and whites. Ceramic jars and bowls organize shuttles, needles, and scissors. Hand-woven rugs sprinkle subdued color on the knotty-fir floor. A large floor loom dominates half of the studio; the other half is taken up by two smaller ones. "The tools for weaving haven't changed that much," Sheila notes. "They're really pretty simple, and I love understanding how they work."

Sheila's initial exposure to textiles was through knitting and spinning, activities she pursued casually throughout her thirty-three-year career as a flight attendant. As she neared retirement, she took a weaving course because, "I thought I might like to weave in my next phase of life," she says. With retirement came a move to a rural community and the farmhouse she and her husband renovated. "A couple of years after the move," she says, "we built this studio, and weaving became my passion."

She started with scarves. "Learning to weave is so much trial and error. The more things you try, the more you evolve into what you like and what works. I like to make soft, drapey garments, and I use a wide variety of fibers—rayon and cotton

chenille, silk, alpaca and mohair wools, cottons, and linens."

Sheila runs her hand across the mauve wool fibers that make up the warp for one of her current projects. "Some aspects of weaving give me a place to be spontaneous and daring. With others I need to be careful and do what I know works." The most

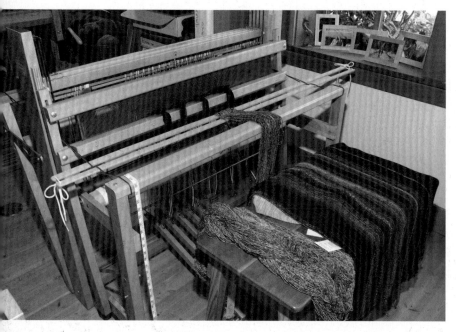

creative stages of weaving often happen long before a single strand of fiber goes onto the loom. "First you think about what you're going to make. I love designing my next project," she says.

Then there's the dyeing of the fibers. "I like being impulsive in the dyeing process—that seems to work. It's exciting and mysterious." Velvety chenilles and earthy wools take on hues of gold, rust, the sea, and the sky when Sheila dips and paints them with colors that would make Monet envious.

She starts with commercial dyes in primary colors of scarlet, brilliant blue, and golden yellow, and mixes them to create her own unique hues of burgundy, eggplant, raisin, teal, periwinkle, pumpkin, and rich brown. "And chartreuse," she adds. "That's become my signature color." Often Sheila soaks the fibers in the pigment, but sometimes she applies the dye using squirt bottles or brushes. Then she lets the colored fibers "batch" or set, some with heat, others with cold. Finally, she washes them. "Everything is done by hand and done carefully to keep the ten or so yards of threads organized." Impulsive, perhaps, but still a painstaking process.

At other times, Sheila weaves with unaltered hues. "All wools are fun to use in natural colors. I especially like the grays and nutmegs of alpaca, the natural whites of linen and cotton, and a creamy-gold natural silk created from what the silkworms eat in the wild."

For Sheila, color is central to her creations. "Wherever I am, I notice color— on rocks or pebbles on a beach, in a sign on a bus, or in magazines. Sometimes I'll actually stop and say, 'Wow, what makes that work?' I also collect postcards of my favorite paintings in museums. I have quite a stockpile, and I often use them as inspiration when I'm painting a warp. They jog me into new color combinations."

The process of warping the loom—stringing it with eight to ten yards of fiber—requires precision. "On a typical project, I put 370 warp threads on the loom. When I get to this point, I'm relieved. There's a saying among weavers—'You never want your looms naked.' It takes so much time to get a loom

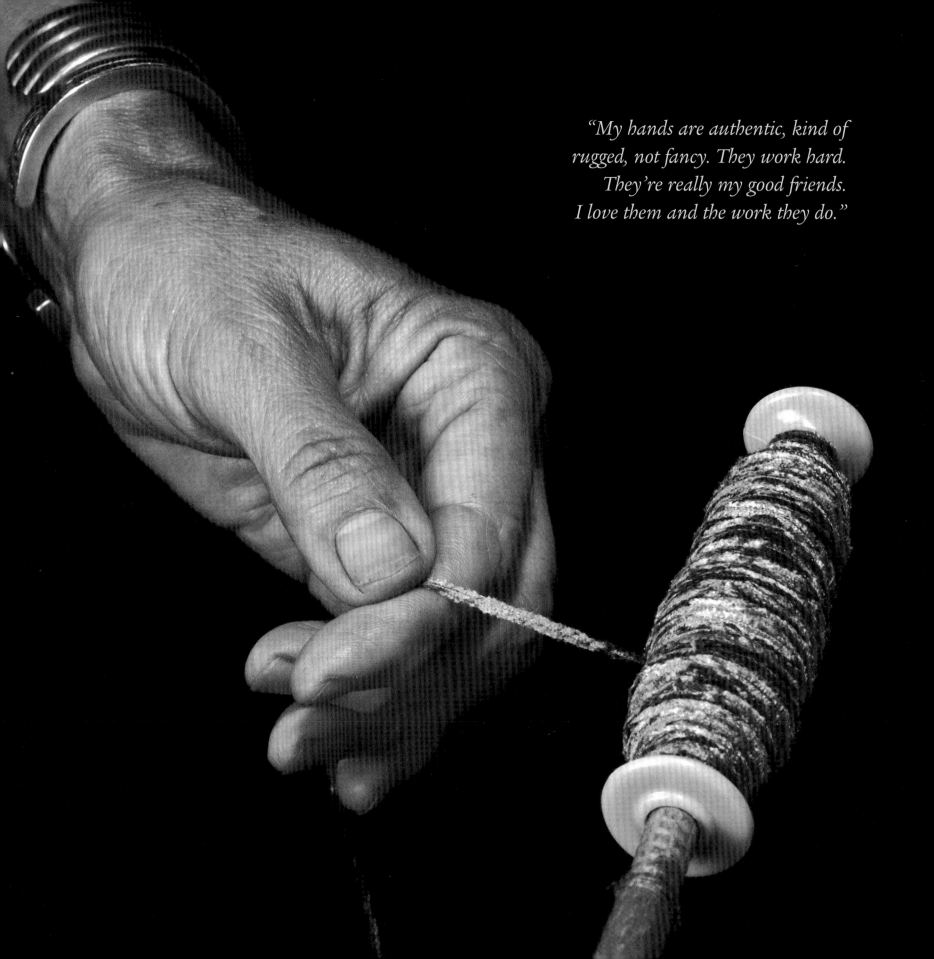

"My hands are authentic, kind of rugged, not fancy. They work hard. They're really my good friends. I love them and the work they do."

ready, and that can stop you from getting started. That's why I usually have three looms warped all the time. I want to walk into my studio and always have something ready to work on."

Once the loom is warped, she winds weft threads around a wooden shuttle and begins to weave. "It's very exciting because during the designing and the

warping, I can guess how it will be, but then I finally get to see the pattern in those first few inches of weaving."

It's often weeks before Sheila finishes weaving and cuts the fabric off the loom. Depending on the piece's design, she sews the dangling ends or coils them with a hand-held fringe-twister. "The fabric is very stiff when it comes off the loom," she says. "Until I wash it by hand, I don't really know what it's like."

Some of her hand-woven fabrics are cut, pieced, and sewn into large shawls called ruanas or small capes that she calls ponchitas. Sheila fashions others into delicately tailored jackets lined with hand-painted silk. Then there is one final step. "Once, a title came to me for a piece, and I thought, 'I'm going to name you.' Now I do that with all my garments. Sometimes I have naming sessions with a group of friends. We come up with things like 'In the Rose Garden' or 'Rhapsody in Raku.' We named a burgundy-wine-colored ruana 'Qué Sera, Syrah.' The name just finishes it."

Morning light brightens the off-white walls and golden fir trim in Sheila's studio. She gently drapes shawls over a wooden rod and straightens ruanas on hangers displayed on a coat rack. "I'm not as confident as I may appear," she claims. "I think people have a sense I have it all together here in my studio." She pauses. "Often, I don't. I have to trust that even though a project might seem daunting, the finish will come if I just continue the process. Weaving teaches me patience. I don't think I've really learned it, but I get to practice it a lot."

Sheila looks again at her hands, remembering all those who have come before her and the relationships she has cultivated in travels to places with ancient weaving traditions: India, Laos, Guatemala, and Hungary, the land of her heritage. "My hands at work are one of the greatest pleasures in my life," she says, "and I'm most proud that I've developed a weaving business. I'm grateful that people value what I do. Every time I sell a piece, I feel connected and touched." Purchasers feel the same, enfolded in the loving embrace of Sheila's hand-woven garments.

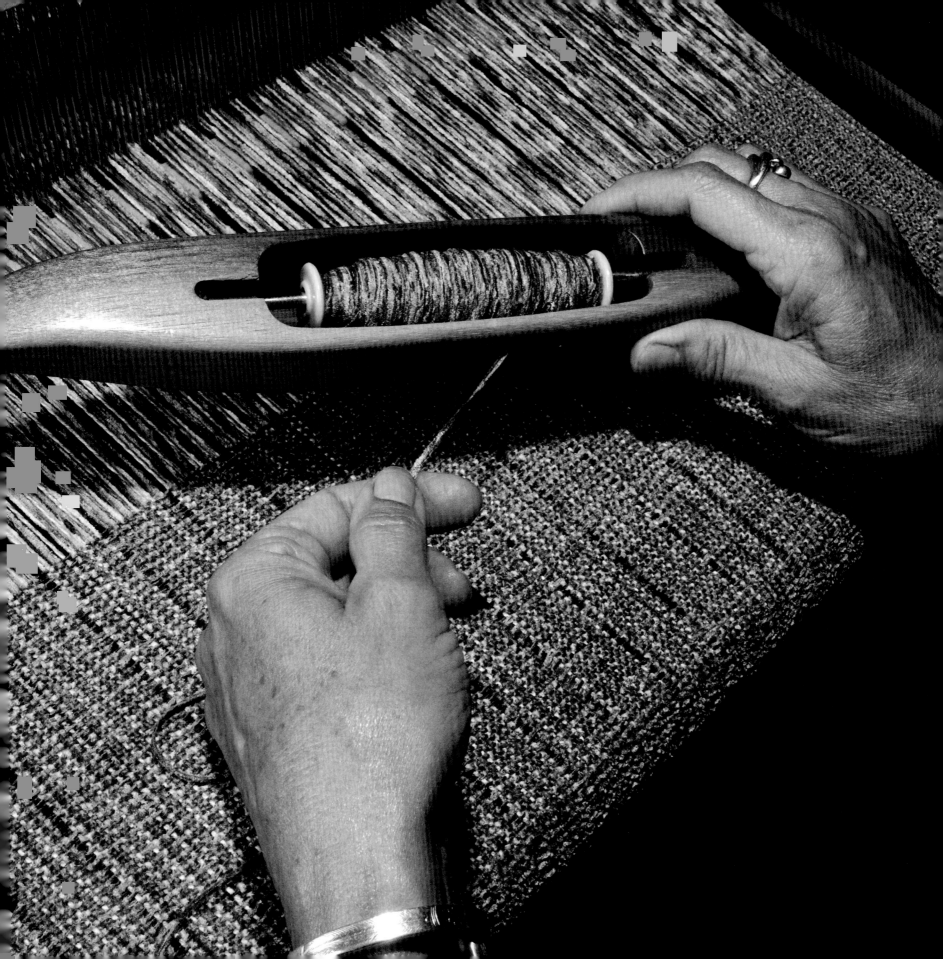

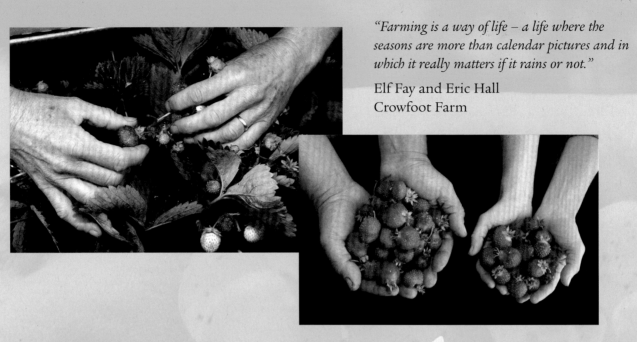

"Farming is a way of life – a life where the seasons are more than calendar pictures and in which it really matters if it rains or not."

Elf Fay and Eric Hall
Crowfoot Farm

Farming

"Our dream is the community will feed itself. The only question people will ask about their food is which of their neighbors' farms it came from. We believe we're the future."

Elizabeth Simpson &
Henning Sehmsdorf
S & S Homestead Farm

"Growing grapes is an ancient human task. Weather ultimately determines the size of harvest, but the labor of human hands can help nudge this event in the right direction."

Brent Charnley
Lopez Island
Vineyards

Hands

"Farming has taught us to be humble. We're still learning it's all about this thing about death, and not just the animals. There is a singularity of spirit all living things share. We want to be really reverent about it and to be able to respect this place with all these living things."

Dave and Beckie Heinlein
Arbutus Farm

"Every year we plant little seeds, and as soon as they start coming up, we're always amazed - even after twenty years."

Ken Akopiantz & Kathryn Thomas
Horse Drawn Farm

BAKER

There's no mistaking when you're getting close to Holly B's. The aromas of honey, butter, chocolate, and warm berries guide your feet, bicycle, or car right to the bakery's front door.

"I've been baking here for thirty years now," says Holly Bower, owner of the bakery beloved by both locals and tourists in her small community. Holly has yet to tire of what she calls "the magic of beginnings and seeing how things start. You take a lump of dough, and by what you personally do, it becomes something entirely different."

Balls of shiny white dough rest on the thick, six-and-a-half-foot-long maple baker's bench that dominates Holly's commercial kitchen. Heat from a stack of electric ovens warms the small space. Holly studies her hands as she kneads a round of dough, soon to become a loaf of pugliese, a rustic Italian-style bread with a heavily floured crust. "I've had old hands—a lot of wrinkles, prominent veins, stained fingernails—for a lot of years," she says. "I've always used my hands a lot. When I was young, I drew with pen and ink. When I moved here, I started to garden. I love to work in the earth—it's almost as satisfying as baking. I touch people a lot, too," she says. "I use my hands to love people and comfort them."

After shaping half-a-dozen loaves and setting them aside to rise, Holly takes a rest, too. She perches on the lid of a white plastic flour bin, sips a cup of mint tea, and nibbles the crunchy edge of a cappuccino bar. Her short, curly blonde hair is held

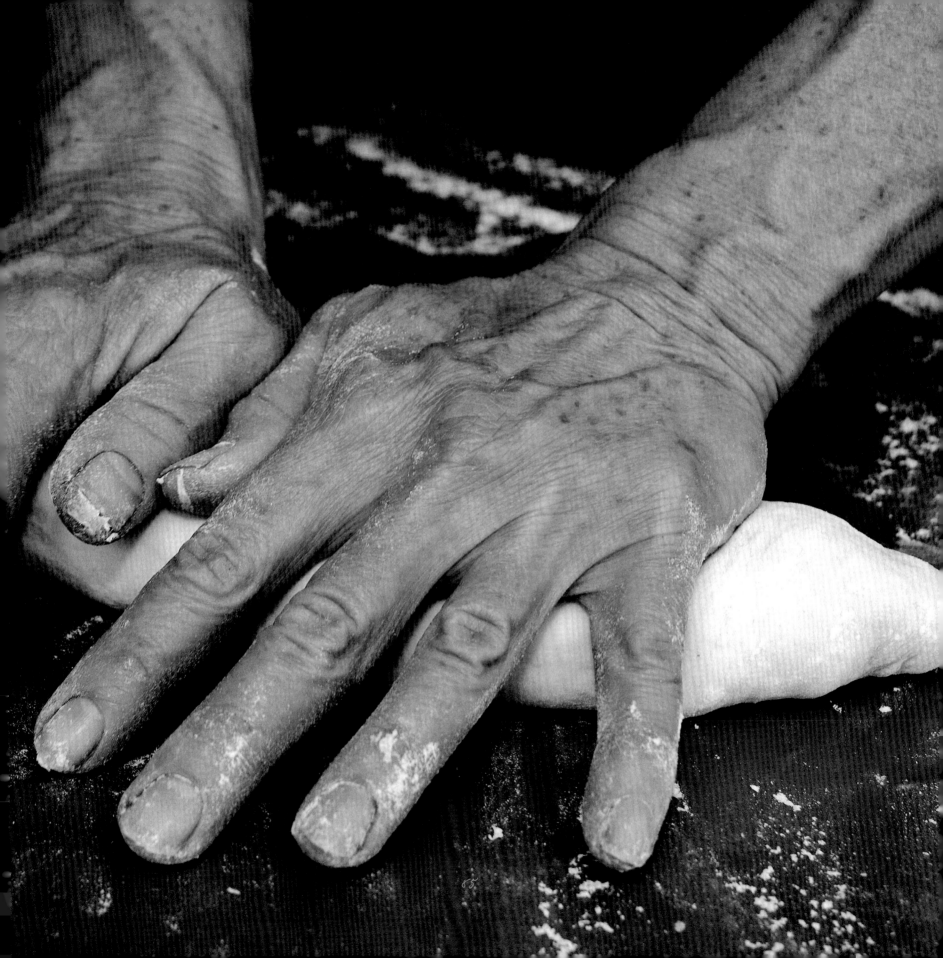

back from her face by a pink paisley bandanna. Reading glasses dangle on a chain around her neck and rest on the bib of her worn blue apron with its faded "Holly's Buns Are Best" logo.

Holly grew up in a home where flavorful, colorful, aromatic food was valued. "My mother is a fabulous cook. At seventy-five, she still cooks every day. Through her, I got interested in baking at a really young age. She baked bread, cinnamon rolls, and oatmeal raisin cookies and made applesauce cakes at Christmas. I started helping her when I was eight or so. By eleven I was baking my first breads."

It didn't take long for neighbors to discover Holly's baking skills, or for her to realize how much she enjoyed feeding others. "At thirteen, I had a bread route in the neighborhood. I made several kinds of bread, took it around, and got orders for the following week. I roped my closest girlfriend into helping me, and we made a lot of

bread in my mom's kitchen." Sixty loaves every Sunday to be exact, in Holly's mother's tiny, 1930s Westinghouse electric oven. "I enjoyed getting up when it was dark and making the dough," she says. "Sometimes I'd go back to bed; sometimes I'd stay up and watch the sunrise."

Holly's childhood endeavor ultimately became her livelihood when she started her own bakery at age twenty. "I love food, and I love to eat, but if I couldn't share the flavors and textures with other people, it wouldn't be important to me," she says. "When I think of working, I think of doing my part, of being able to offer something to people around me. Making food by hand and feeding people is an almost sacred thing."

That's the feeling Holly's customers experience, too, when they step in the bakery's front door and are greeted by the sight and scent of loaves, cooling on wooden racks: oat, whole wheat, sourdough, and several types of baguettes. Hand-built fir and glass cases display blueberry/peach and strawberry/rhubarb scones, cheese croissants, muffins, almond butterhorns, ham and Gruyere brioche, Katharine Hepburn brownies, cheesecake bars, shortbread, and cookies of several varieties, all clamoring for attention.

And, of course, those cinnamon buns of Holly B's slogan. "I came up with that during the first couple of years I was in business. It just occurred to me one day. My mom was really concerned about it at first," Holly says, a smile sneaking out around her words. "But after all these years, she's no longer troubled by it."

Holly slides metal pans filled with cookie dough into the ovens and sets a timer; then she returns to

"Nowadays a lot of people don't make food from scratch for themselves," she says. "It's a different experience buying bread or muffins in a package and not knowing who's made them or where they've come from. At the bakery, that human thread is what we provide."

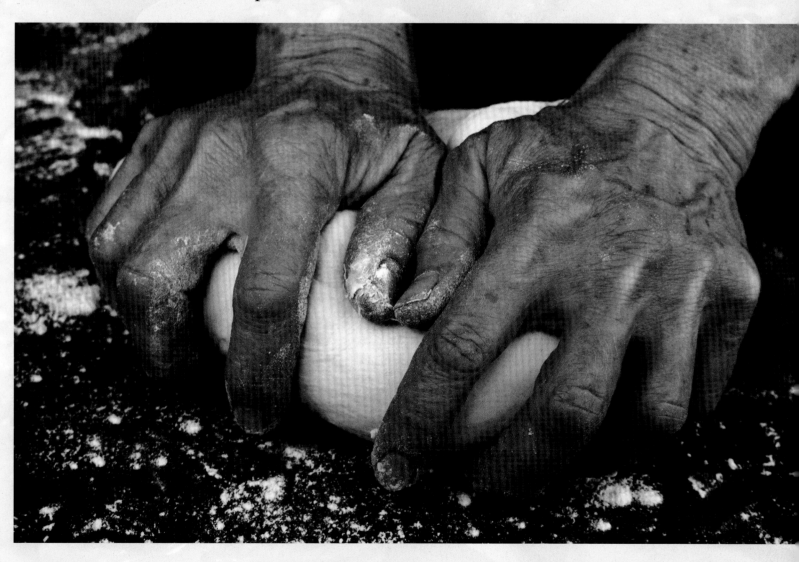

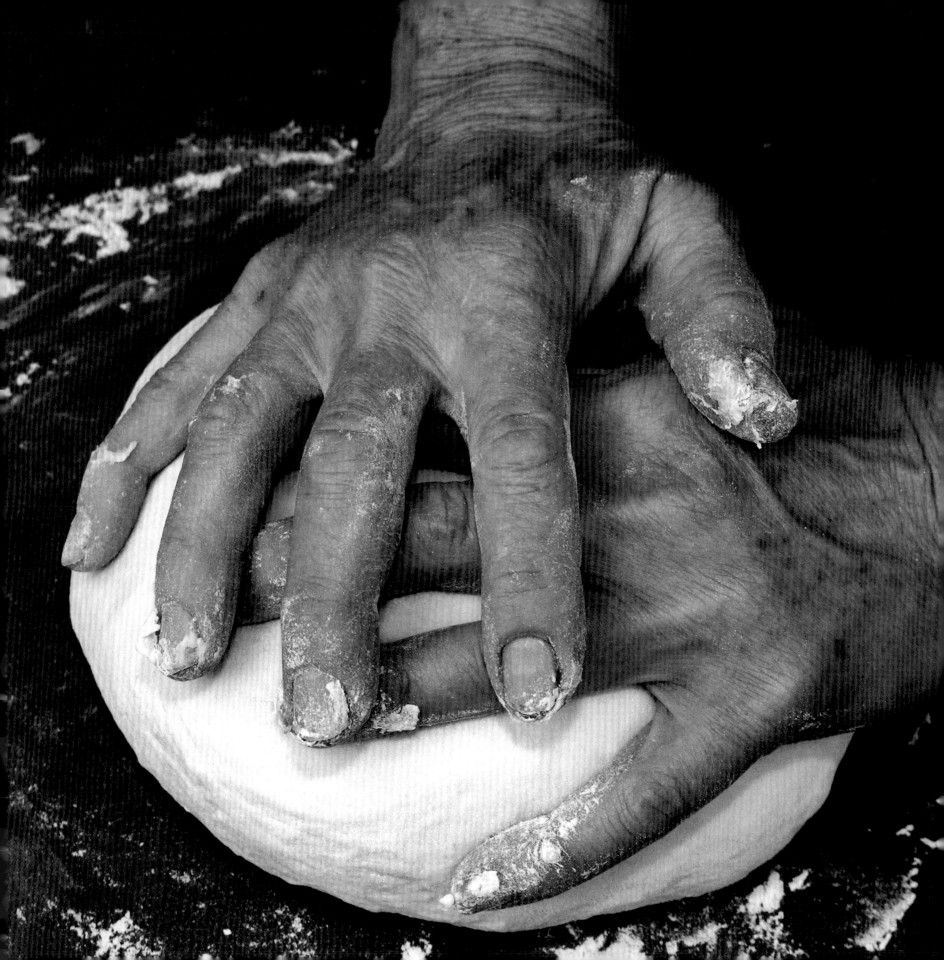

the maple bench to shape hunks of whole wheat dough into loaves. Her strong hands tenderly place the yeasty loaves into pans that are black from years of seasoning. She talks of the pre-dawn baking shift she used to tackle every morning beginning at three thirty. While the rest of the world slept, she blended yeast, warm water, flour, and honey in her 1934 Hobart mixer. "Being up at that hour is very peaceful. It's a good time to focus and get things done—no interruptions, no distractions. When I was younger, getting up, baking, going home and catching a little nap, doing home life—it seemed to work," she says. "But I feel very blessed that others are willing to do it now."

Holly followed that routine every spring, summer, and fall through her three sons' infancy and early childhood. When her oldest son was two, she gave birth to twin boys and went back to baking when they were five weeks old. "I'd nurse the twins, then at three a.m. I'd ride my bike to the bakery in the dark and get the doughs going." Her husband, Andre, would bring all three kids to the bakery around six in the morning. "I'd take a break and nurse the twins. Andre would hang out and do dishes. He got pretty good at rolling out cinnamon rolls and Danish, too."

The couple shifted jobs in the winter, when the family retreated to the mountains and Andre taught downhill skiing. "I have a full third of the year when I get to do something else and recharge my batteries," says Holly, "though in winter I bake bread—I have to keep the sourdough starter alive. And we do need bread."

Even with annual breaks, Holly's work is challenging. "Sometimes I'm uncertain, and sometimes I'm afraid, and sometimes my hands—my whole body—get very tired. I don't always know from year to year how the business will go, whether we'll make ends meet. Although we do have a fairly good track record, the food business is not a for-sure thing."

One thing is for sure, however, and that's the commitment and passion Holly brings to her work and what it means to others. "I feel proud about having been able to maintain the bakery and a high quality of baked goods for so long," she says. "Most of all, I feel proud of the relationships I've established with customers, and moms, dads, and kids. I've been able to give a lot of young people their first jobs. Many have gone from dishwashing to creating beautiful baked goods and having a lot of responsibility. The kids know they're trusted and valued, and they get the chance to learn about themselves and about working."

Holly's generous spirit is also evident in her cookbook, *With Love and Butter.* Her time-tested recipes and her vignettes about a baking life may inspire others to discover the magic that Holly finds in creating baked goods. For those who don't, Holly continues to provide the personal touch she thinks is important.

"Nowadays a lot of people don't make food from scratch for themselves," she says. "It's a different experience buying bread or muffins in a package and not knowing who's made them or where they've come from. At the bakery, that human thread is what we provide."

Short, petite Tamara Buchanan straddles a 350-pound, five-foot column of Kansas limestone that was once a fence post. "When I saw this piece of limestone, I knew immediately what was there. I saw the whole sculpture," she says, pointing to several carved curves. "It's a salmon dancer. She's holding a salmon in each hand, with one arm up over her head. She's in there. My job is just to find her."

Tamara adjusts bright-blue muffs that look like headphones over her ears. "It can be really noisy work," she shouts as her right hand guides an air hammer rhythmically pounding the end of the chisel clutched in her left hand. "I love carving tools. You can't have enough

of them. They just look cool, and they can make the hard job of removing stone a bit easier. Sometimes I use power tools like this air hammer. It's attached to a compressor, so the air does the work instead of my elbow." Tamara moves her entire upper torso back and forth as she furrows into the stone. Today she's working outside despite a light drizzle of rain. Limestone chips and dust bounce in the air.

"I'm reasonably introverted," Tamara claims, blue eyes squinting behind dusty glasses as she tries to envision the emerging sculpture. "I usually don't talk much about myself—the inner me. I express who I am mostly through stone, and I tend to work out my issues in my pieces. Expressing myself in stone feels safe. And it usually takes so long to finish a piece that I've moved past whatever issue I'm working on before I'm done."

A series of square marble vessels, each with a small opening, hint at Tamara's internal work. One piece is named "A Place for Fear," another, "A Place for Malice," and a third, "A Place for Hope." Then there are her Kamis, or Japanese mini-spirits. "I call them my little guys," she says of the foot-tall male figures displayed in the small gallery next to her studio. "I've done one for happiness, one for longevity, another for prosperity. This guy holding the earth in his right hand is hope." Another of her sculptures, entitled "Breaking Free," features a female shape. "She's breaking free from cultural and social constraints," Tamara explains. "On the surface, my work doesn't look so personal, but it's who I am. I'm working out who I am as a woman on earth."

Who she is now is a sculptor, but for twenty-five years, Tamara owned and operated a wholesale nursery with her husband. In the midst of that

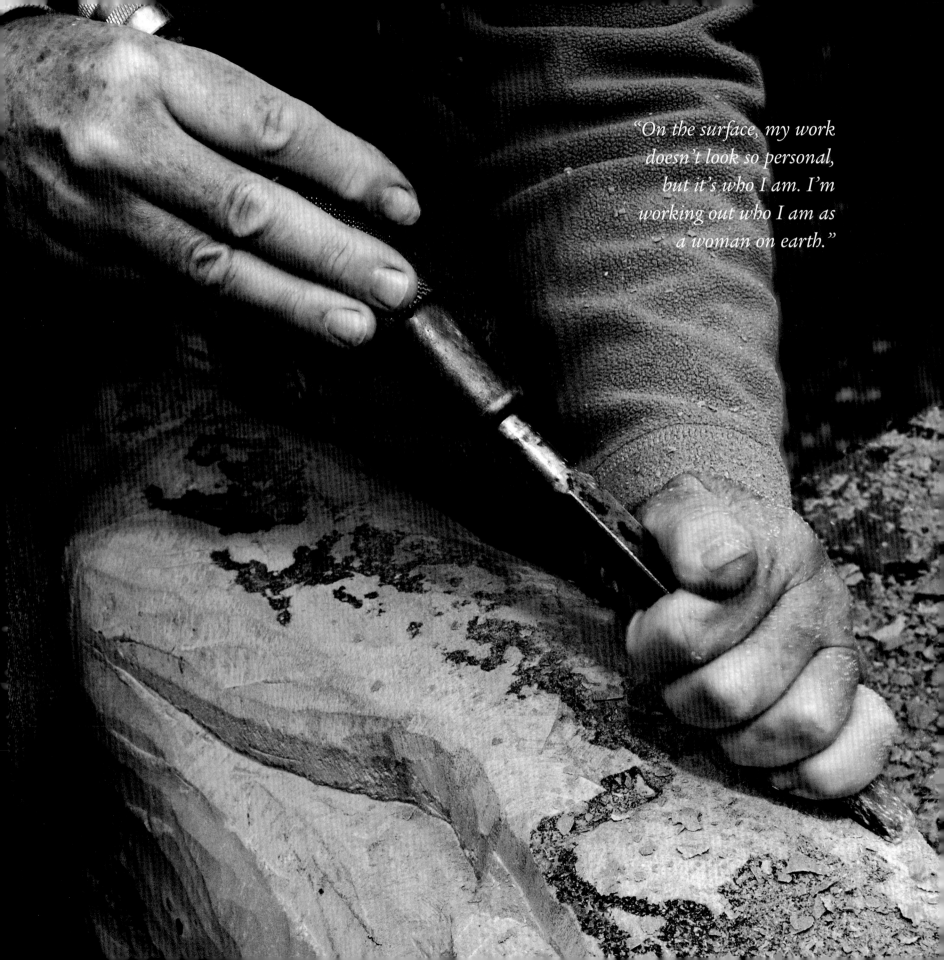

"On the surface, my work doesn't look so personal, but it's who I am. I'm working out who I am as a woman on earth."

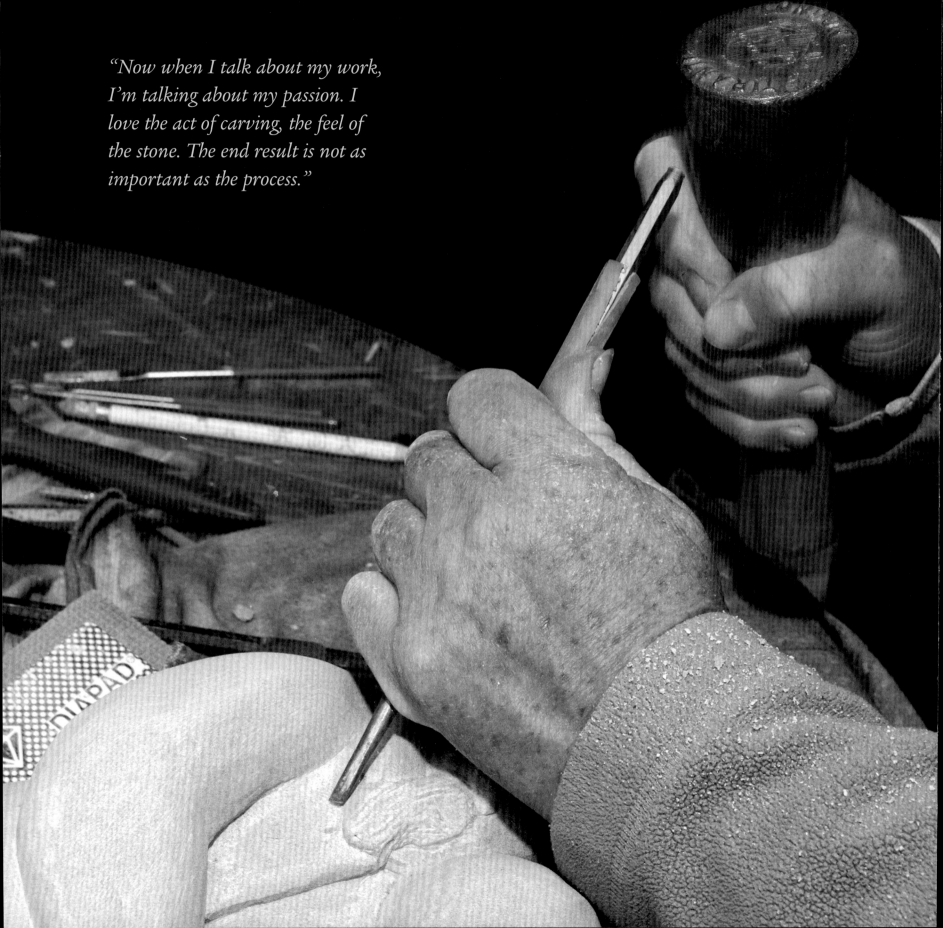

"Now when I talk about my work, I'm talking about my passion. I love the act of carving, the feel of the stone. The end result is not as important as the process."

career, she saw an ad for the Northwest Stone Sculptors' Association Symposium. "I was forty, and I wasn't doing well physically or emotionally," she recalls. "I thought this conference might feed my soul. I got the carving bug there, and I've gone to every symposium since."

Tamara pounds a mallet against the end of a chisel, whittling away more of the limestone. "I sculpted irregularly for about seven years and then told my husband the nursery was no longer fun for me and I needed to carve more. So he took the business over, and I started sculpting full time. Now when I talk about my work, I'm talking about my passion. I love the act of carving, the feel of the stone," she says. "The end result is not as important as the process."

That process requires not only chiseling and hammering but also gouging, carving, filing, and sanding images from large chunks of rock. "There are as many ways to approach stone as there are carvers," Tamara claims. "Some people look at a block of stone and decide what they want to do. Others just start carving and have no idea. And there are lots of sculptors who make a

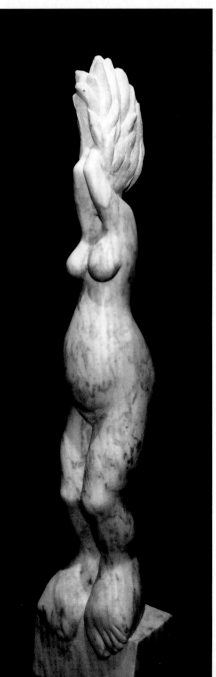

clay model and then make an exact copy in stone. I tend to try to see something in the stone first, and then I carve it," she says. "The most fun for me is to release what's inside the raw rock. I'm starting to get more commissions, and as long as I can find a stone that suggests to me what the buyer wants, I'll do it. With that connection, the piece can come to life."

Tamara rests her hammer and chisel on her dust-covered jeans and shakes small bits of stone from her short, graying hair. "I have a 220-pound piece of beautiful Italian marble that I thought was two dolphins. Usually this marble cuts like butter, but it was fighting me as I sculpted the shapes. Then a flipper fell off, and then the nose of one of the dolphins fell off. I decided, 'OK, this isn't what you want to be.' It's still sitting here, waiting for me to figure it out."

She returns to the piece she believes wants to be a salmon dancer. "Limestone is an easy stone to carve. It's relatively soft. I also use granite and sandstone, and I've been to Italy three times to carve and look for interesting pieces of marble. I go to Pietrasanta, which means 'sainted stone' in

Italian. The whole town is used to people coming there for marble—it's like scrap wood to them. The stones weigh an average of 120 to 190 pounds per cubic foot. Carting it home is the hard part."

Walking to her open-air studio with its wooden shelves sagging under the weight of some of her stones, Tamara describes in detail how she acquires the Pietrasanta marble. "Each piece of stone I've selected is measured by the craters. Four or five days later, they deliver custom-made crates and carefully pack the stones in them. Next, after I've left, my packed marble is taken to the shipper. In about a month I get a call that the stone has arrived in Seattle, and I sweetly ask my husband to drive down in his big truck to pick up my 'little boxes.' I need his big truck, because I've never sent home less than a ton of marble."

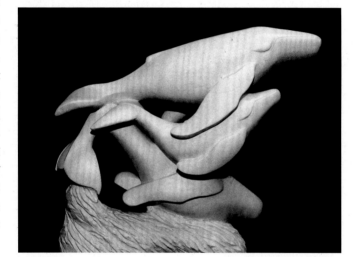

During trips to Italy, Tamara also acquired some of her favorite tools. "I met an elderly sculptor who had carved a rose in pure-white marble," she says. "I automatically went over and sniffed it, even though I knew it was stone. I think he was impressed with that. His eighty-five-year-old brother, who was also a sculptor, had just died, and he offered to sell me two of his brother's tools for half the price of new ones. I estimate those tools are more than fifty years old. They're two of my most treasured possessions."

After she's finished carving, Tamara may spend many hours sanding the surface of the piece to achieve a polished look. "People ask how long it takes to make a sculpture, and I say it takes as long as it takes, and that's always twice as long as I think it will be. One piece took about three thousand hours. My Kamis take twenty to sixty hours because they're not polished. Anything polished takes way too many hours."

Tamara doesn't hesitate a moment when asked about the most important lesson she's learned as a sculptor. "Patience." She pauses and then adds, "And grace for myself, the stone, my tools, and other people."

She struggles with that grace for herself. "When I started carving at forty, I gave myself until eighty. I hope my body can hold up." She looks at her hands, dried by contact with grit from stone. "I'm growing older, and my hands are starting to get knobby with arthritis. I know there's an end, and it's coming too soon."

Tamara lets her gaze slide over the assortment of marble, limestone, and granite still waiting for her to uncover what's inside. "I have a lifetime of work in my head, feelings I want to express. I love what I do, and I want to carve as long as I can."

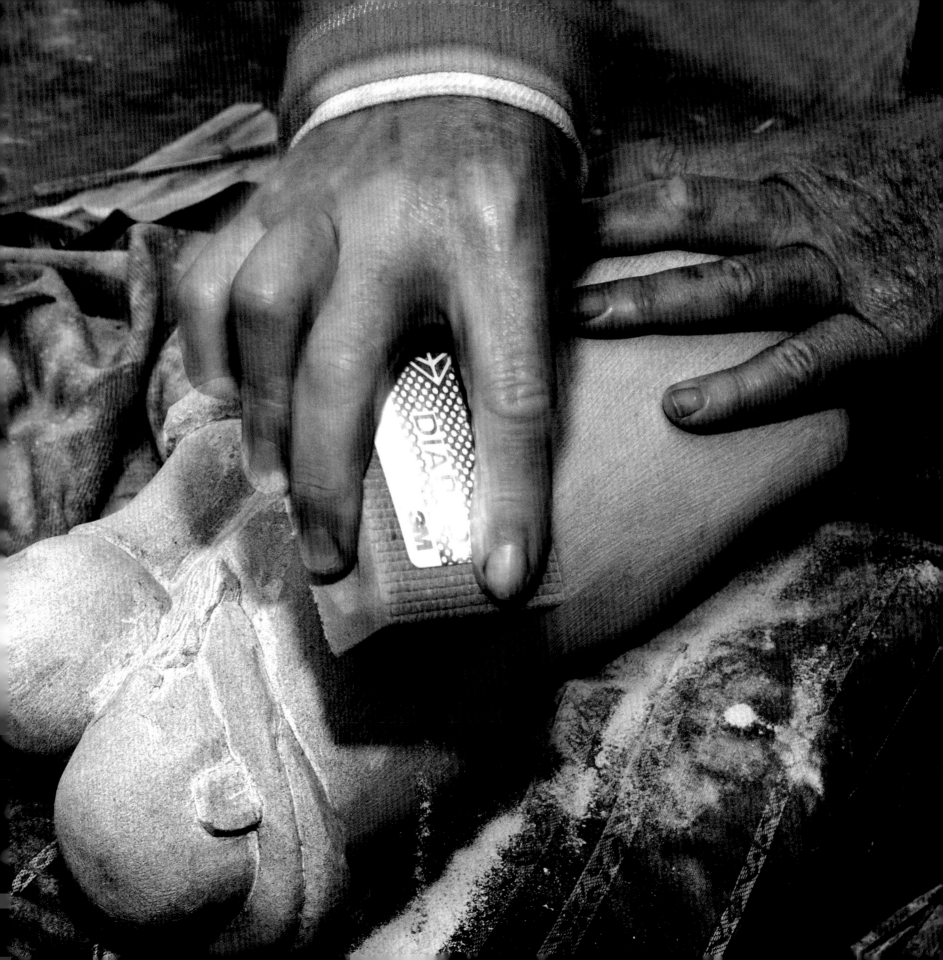

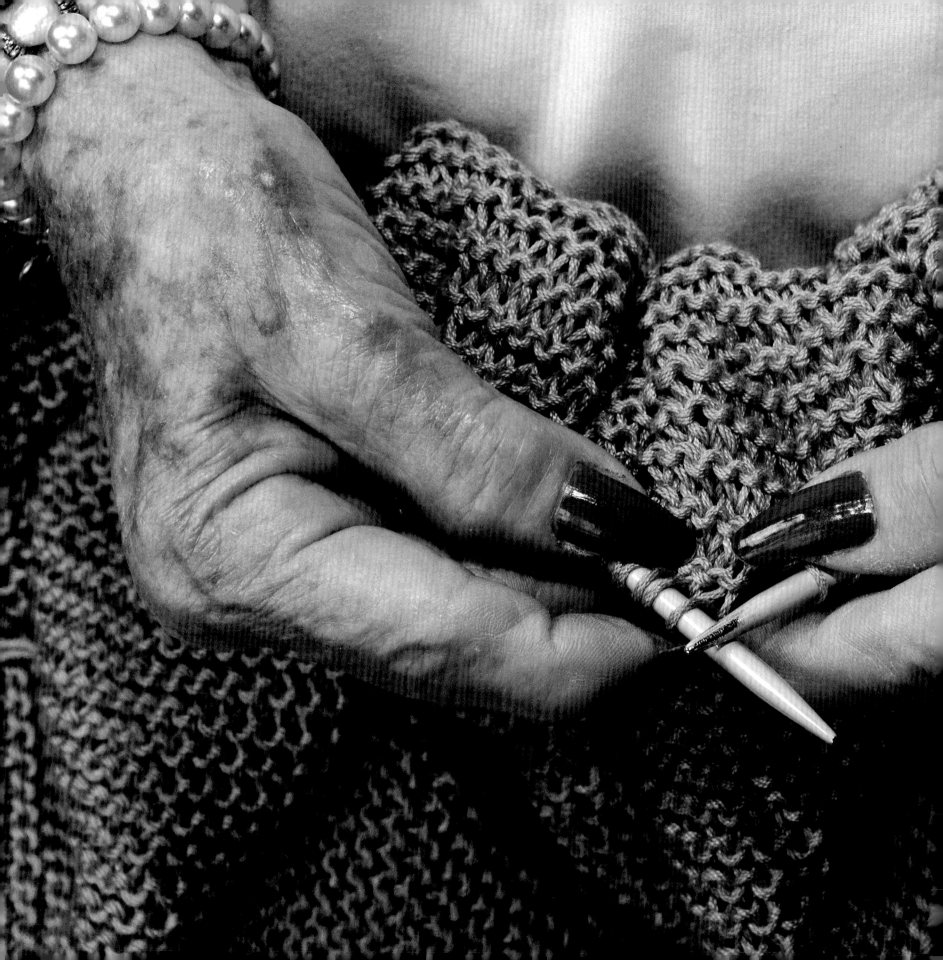

KNITTER

W hen Esther Meneses de Alarcón claims that she has been knitting all her life, she's not exaggerating. "I learned to knit at school when I was nine years old," says this eighty-two-year-old Mexico City woman. "My teacher gave me a ball of yarn and showed me how to knit a simple scarf. I told my mother I needed six balls of yarn and ended up being the only one in the class to make a sweater." Now she creates one-of-a-kind baby sweaters in three days.

Esther recalls that after that first sweater more than seventy years ago, "I just started making things for a cousin who had babies." One of Esther's sons brings over a lidded black box the length of his outstretched arms. It is brimming with miniature sweaters in pale melon, creamy yellow, brown, sky blue, pink, and spring green. Some have lacy collars, ribbing, white accents, or ribbon trim; each has matching buttons—some square, others round. The tiny sweaters are piled four deep; there are nearly seventy in all. Esther knitted most of them for the babies (twelve so far) of her twenty-one grandchildren, just as she did for them and their parents before them. Her first grandchild received thirty sweaters. "That was a little much," Esther (or Teté, as her family calls her) admits with a smile. "She couldn't wear them all before she outgrew them."

When she started dating her husband, Marco, in 1940, Esther knitted four dresses for herself, one with a full-length coat. For the fifty-three years of their marriage, until Marco's death ten years ago,

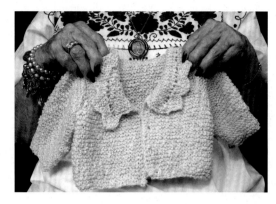

she made his socks, vests, and ties as well as many items for her twelve children. "I made everything for the older ones and then handed them down to the younger ones," she says. Esther picks up a pair of knitting needles that hold the beginnings of a turquoise sweater; her arthritic fingers move smoothly and quickly, transferring stitches from one needle to the other creating the pattern she carries in her head.

Initially, Esther followed others' patterns, but she began improvising during the two years she lived in Dallas while her husband worked for the Mexican Consulate. "I got patterns from a book," she says, "but I didn't understand the instructions in English. So I looked at the pictures and made up my own designs." And it was in Dallas that she knitted her first blanket, "because it was so cold there! I got twenty balls of yarn in different colors," she says as she unfurls the multicolored blanket she crafted twenty-six years ago. With the remnants, she made a smaller blanket.

Now, everything Esther makes is her own design. "My patterns come out of my hands," she says. "I'm always knitting—it gives me something to focus on. The patterns are very intricate, and I must concentrate on them. I see it as therapy." According to Esther's doctor, it's probably been a kind of therapy for her arthritic fingers as well. "He thinks my hands are still flexible because of knitting," she says as her bent fingers with perfectly manicured and red-polished nails shift strands of yarn effortlessly across the needles. The metal needles quietly click a

rhythm. "When it's cold, my joints hurt, but not when I'm knitting."

Esther directs a grandson to a room upstairs to retrieve some of the ponchos she has knit for women. Those designs are all different, too, she explains as she models one with a collar. Although none of her children took up knitting, one of her daughters crochets the flowers and makes the lacy edges on some of Esther's creations.

The phone rings and Esther directs her grandson, "You get it, please. I'm busy." She demonstrates how the crocheted flower is pinned onto the poncho and can be attached in different places. She removes that poncho, slips another one over her perfectly coiffed red-tinted hair, and swivels back and forth to show off the diagonal stripe going one direction in the front and the opposite direction in the back.

"If I don't have my knitting, I get nervous," Esther says. "On a road trip, I knit, and then I'm there. When I'm riding with my two sons, they want me to knit so I don't notice their driving." Once, on a drive from Dallas to Mexico City, she knitted a sweater for one grandchild on the way there and a sweater for another on the return trip.

And it's those grandchildren, and now great-grandchildren, as well as countless other children she knits sweaters for, who continue to inspire Esther. They recognize her passion for this lifelong work as well. "At my eightieth birthday party," she recalls, "the top of the cake had a woman knitting! I've knitted all my life, and I want to die with knitting needles in my hands."

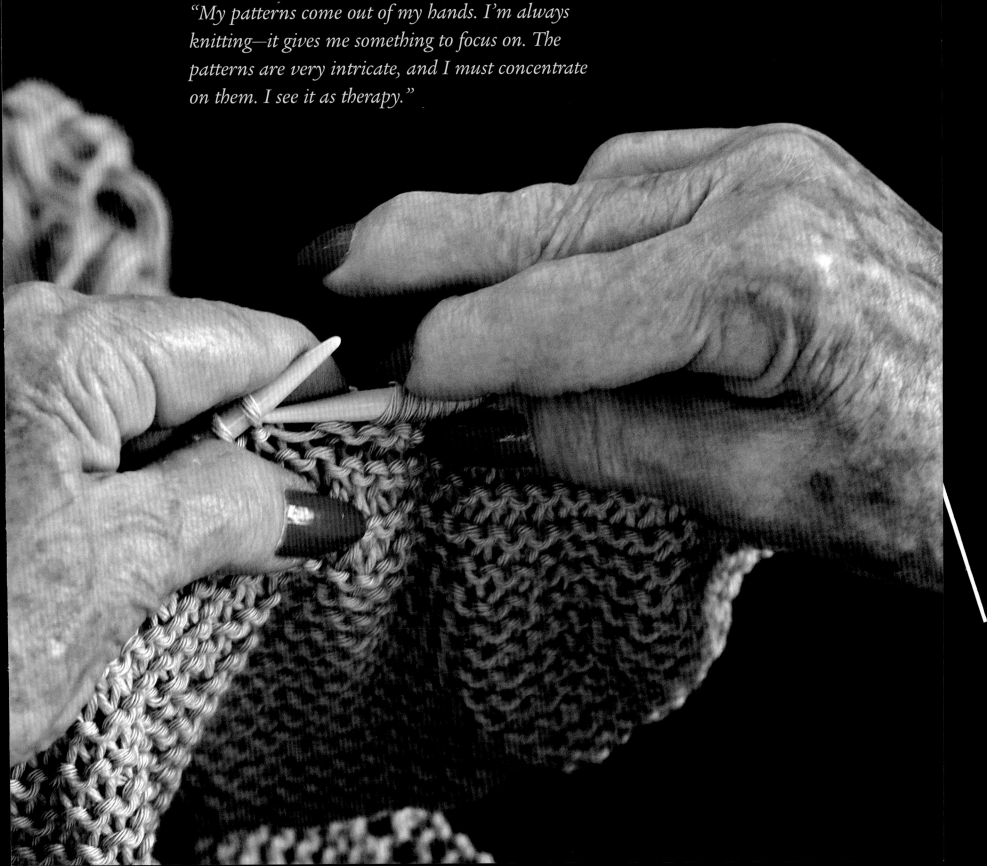

"My patterns come out of my hands. I'm always knitting—it gives me something to focus on. The patterns are very intricate, and I must concentrate on them. I see it as therapy."

Blacksmith Craig Withrow moves casually between the forge, anvil, vise, and cooling tank in the workshop he built in 1999. "If I had to sit in a cubicle, I'd probably die," he says, as he crafts a barbecue utensil. He smiles often, his blue eyes gleaming. His goatee is sprinkled with gray; reading glasses are hooked on the neck of his forest green t-shirt. Today Craig fits the classic image of a blacksmith in black leather apron, black jeans, and leather work shoes, but it's not his normal attire. "I usually wear a Utilikilt, but this morning I went for a motorcycle ride before work, so I put on my jeans."

Craig's preference for a kilt tells a lot about him. "The kilt is about freedom," he says. My mother's family was mostly Scotch-Irish, and I wanted to embrace my heritage. I didn't especially like the tartan of my clan, but then I found the utility kilt and liked that. It doesn't care about your nationality." Made of tough cotton fabric with cargo pockets and a hammer loop, the Utilikilt, like traditional plaid kilts, has pleats and hits at the knee. "It's fun making people do double takes," he says. "I like sticking my tongue out at convention. People take themselves way too seriously."

Evidence of Craig's sense of humor can be seen throughout the shop. A plastic elephant perches on the pneumatic forging hammer that dominates the middle of the shop. Compressed air powers its pounding for heavy-duty shaping. A toy gecko lounges on an anvil. Antique posters and goofy cards adorn the walls.

Craig has his serious moments, though, especially when he's working with metal heated to fifteen hundred degrees. "Everything I work on is hot. I burn myself every day." As proof, he holds out scarred hands, grayed by the metals he works with. His bare right hand grasps the cool end of a glowing, salmon-colored steel rod and pulls it from the fiery forge. The nine-inch by fourteen-inch oven is fueled by propane and heats metal to a plastic state. "When it's this hot, it's much like working with glass. You can stretch it, twist it, and squish it."

Craig grips a hammer in his right hand and pounds the heated end of the rod. As it cools, the steel changes to champagne silver. Metal pings against metal as Craig begins forming the rod into a tool he designed for turning meat on a grill. "I have a short period of time before the steel cools down and I can't work with it," he says, moving back and forth between hammering and returning the steel to the forge.

When the metal has been shaped to his satisfaction, Craig shifts to making a hook on the end of the meat turner. The air warms briefly as he again pokes the rod into the forge. When the rod glows orange, he carries it to his anvil with conical horns, or beaks, on each end.

With his left hand, Craig grasps the rod and rests its glowing end on one horn of the anvil. With his right, he hammers the point, curving it around the end of the anvil. "I need more heat,"

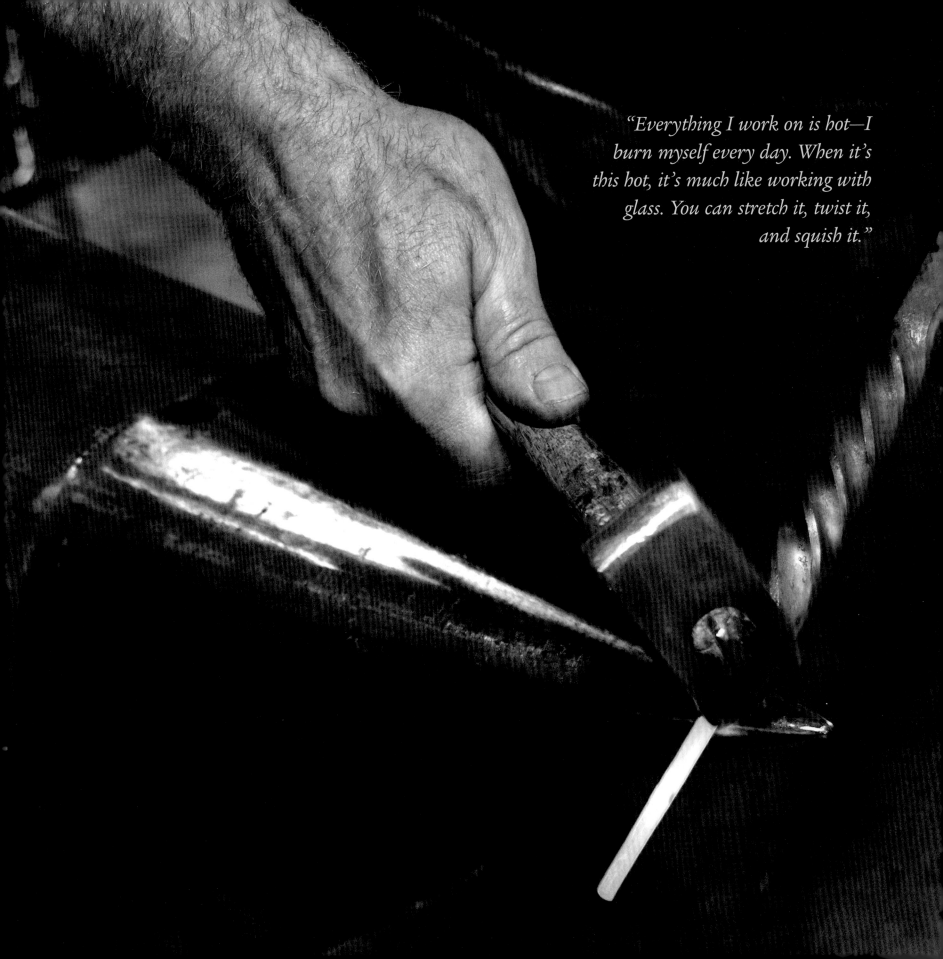

"Everything I work on is hot—I burn myself every day. When it's this hot, it's much like working with glass. You can stretch it, twist it, and squish it."

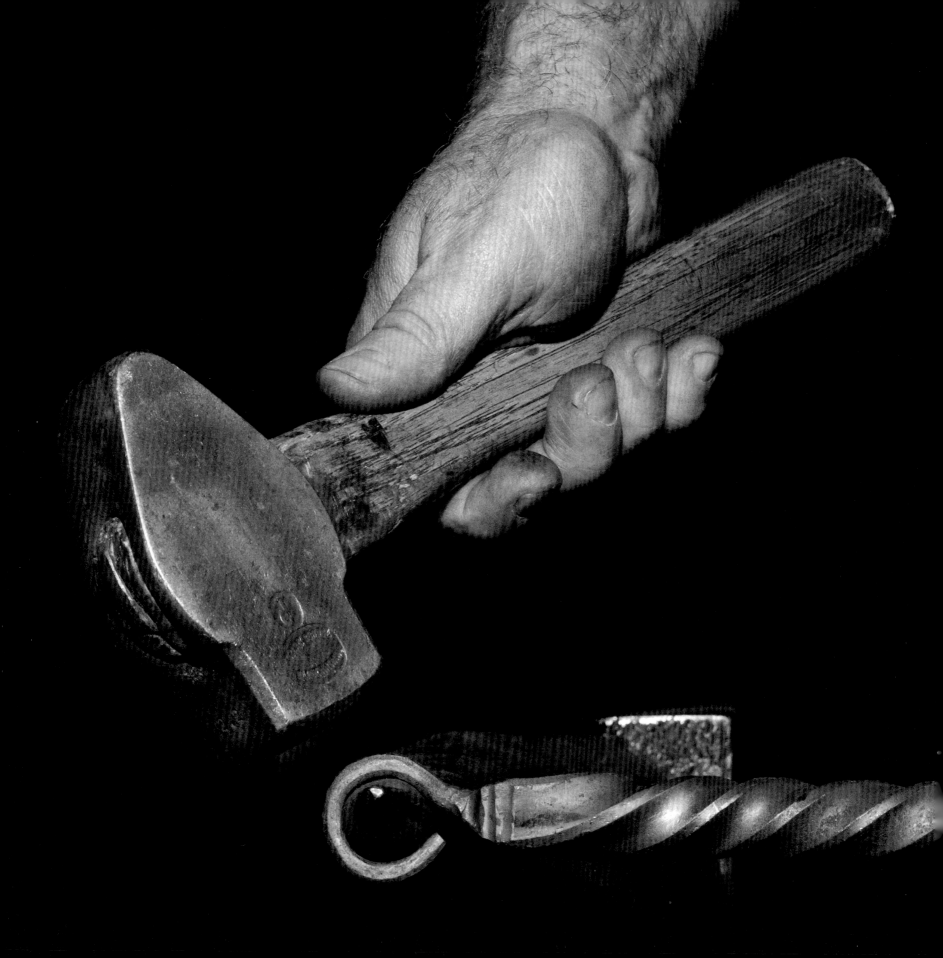

he says, sliding the rod back into the forge for a few minutes, then returning it to the anvil and slowly turning and pounding the hook. When he's satisfied with its shape, Craig plunges the hot staff into the quenching tub, a barrel of cold water that quickly lowers the temperature. "Even though the metal looks cold, it could still be five hundred degrees," he says, the sizzle and damp campfire scent of steam drifting up from the water.

"I love working with my hands in a creative way," Craig says. "I'm a blacksmith, but I also have no problem being called an artist. Some people are put off by that term, but I think we're all artists. In the blacksmithing world, there is some debate about whether it's an art or a craft. For me, blacksmithing is an art form rich in tradition and expressed through craft."

It took Craig some time to arrive at this work that has captivated him for nearly fifteen years. "My road to becoming a blacksmith is full of twists and turns, and most of them are medically related," he says. "After serving in the Navy, I took a photography course and started printing pictures. Within six years, I developed an allergy to the chemicals. My wife was working in film, and my photography skills were transferable, so I became a camera assistant. In another six years, everyone in film making switched to video, and I had no interest in that. We had a couple of horses at that point, so I took a class in horseshoeing. I fell in love with horse hoof anatomy."

Next came more schooling and seven years of shoeing horses. "I blew my back out doing that work and had to either stop horseshoeing or have my spine fused. I opted to move on." Inspiration for his next career came from *The Anvil's Ring*, the journal of the Artist Blacksmith Association of North America. Craig pulls out an issue of the magazine and points to a photograph of an elegant iron sculpture. "I saw work like this, just beautiful stuff, and thought, 'Wow! You can do that with metal? I want to do this.' So, since 1996 I've been doing ornamental and architectural ironwork."

Now Craig uses his skills to make shimmering copper bowls and platters, iron candelabras that hang from the ceiling, and a variety of candle holders for the table. One style, the candle spinner, is popular in the art gallery where he shows his work. Reminiscent of a balance, a curved steel frame rests on a pointed rod and holds two candles that can gently spin.

"I get inspired by other blacksmiths," Craig says. "I don't try to copy them, but their work is important. I try to bring in my own vocabulary and make my pieces my own." For instance, the meat turner he's making today for a friend's birthday gift "sort of happened. I saw one and thought, 'I want to make those.' It's the perfect tool for flipping meat on a barbecue grill. Now I want to figure out how to make a metal paddle to use in a wood-fired oven—something you can use to move pizzas as well as shift the fire around."

Willie Nelson's gravely voice accompanies the clank of metal. Some of Craig's inspiration comes from music. "I can't work without it," he says. "I listen to all kinds while I work—bluegrass, jazz, guitar, mandolin..."

Like most artists, Craig signs his work, but not with a pen. Instead, he uses a touch mark—a rod with a small steel circle on the end in the shape of his initials, CW. He heats a piece of copper in the forge and then hammers the touch mark into it. "Mine is from a company back east that has been making them for a hundred years."

Grins, chuckles, and the occasional belly laughs punctuate Craig's talk about his work. "I can make a living doing things I really enjoy," he says, "and it's great knowing that someone gets joy from

"I love working with my hands in a creative way. I'm a blacksmith, but I also have no problem being called an artist."

something I've made." He also likes the challenge of commissions. "Someone will say, 'I have an idea,' or 'I need some kind of thingy.' It's always a collaboration between me and the client."

One of those collaborations is a project he's just started—his first spiral staircase railing, designed like kelp twisting and twining in saltwater. "My big goal is to move more into sculpture," he says, "making my own original pieces, things that tickle my fancy, make me laugh." He smiles broadly, then shares more about what fuels his work. "Once you think you know everything, you're doomed. I learn something every day—a different technique, style, aesthetic."

Any downside to this passion? "I don't mind getting dirty and sweaty. In fact, I like that. But blacksmithing hurts my body—my hands, back, and feet. I'm starting to get arthritic bumps, and my joints are getting gnarly."

And there's that roundabout way Craig took to get where he is today. "There's this blacksmith from Santa Fe named Tom Joyce, who was just awarded a MacArthur Genius Grant," Craig says. "Tom discovered blacksmithing at age fourteen. I'm disappointed I found this so late in life. But at least I found it."

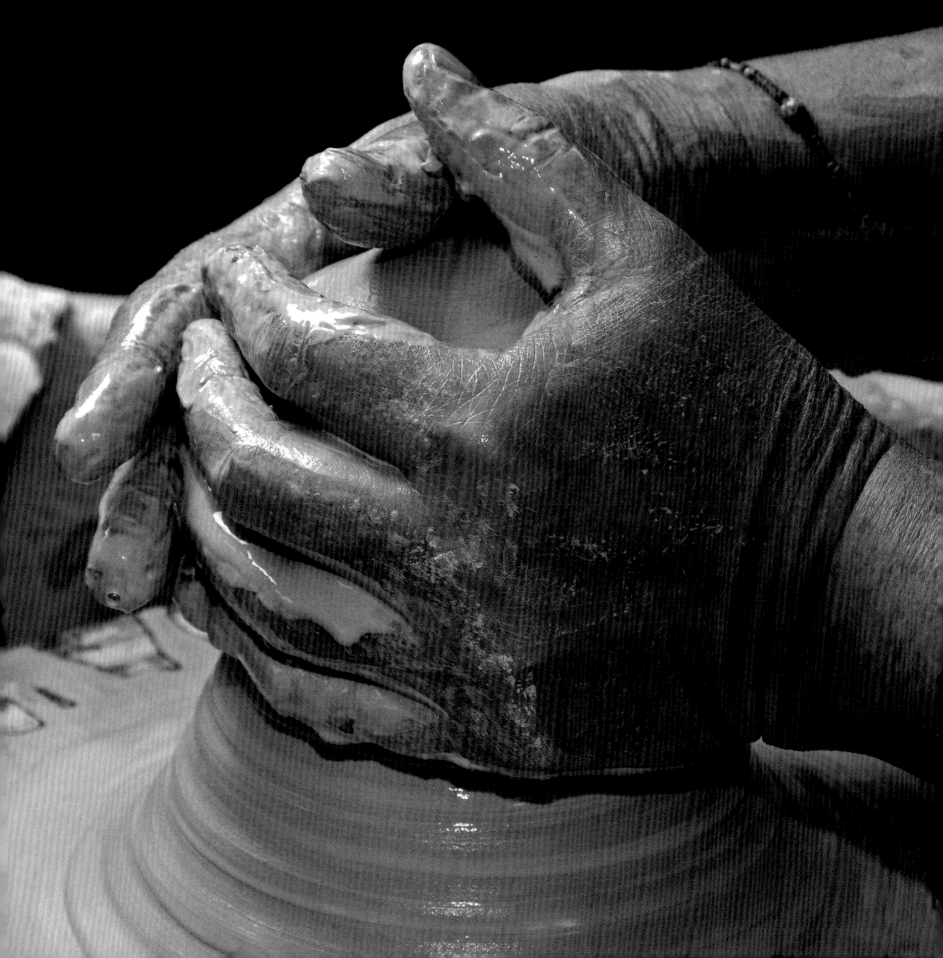

First she was Steamboat Pottery. Then Redwing Pottery. Now it's just Nancy Bingham and a business card with a graphic of a pair of hands. A potter for forty of her fifty-eight years, Nancy considers her hands her best sense organ. "I feel an amazing amount of stuff," she says. "I live in my hands."

Thoughts about her work take shape as easily as the rust-colored clay on her wheel. Nancy's body curls forward slightly as the clump she's sliced from a twenty-five pound "pug" spins, glistening and spiraling upward under pressure from her hands. She pokes a hole in the top of the moist clay and enlarges it, her fingers pulling the clay outward to form a symmetrical pot. "I went to a ceramics conference in 1980," she says, using the strength of her forearms and fingers to shape the clay cylinder and keep it centered on the revolving wheel. "An old potter held up his hands, and his fingers curved up and out. All of us young potters looked at our hands, and mine didn't curve up, not then." Nancy straightens her back and removes her red, clay-tinged hands from the pot still rotating on the wheel. Her fingers spread apart and arch out like palm leaves. "When you do something physical all your life, your body changes. I'm curving in, and my fingers are fanning out. It's sort of a nice combination," she says.

"I'm an artist," Nancy announces. "I can say it without any question. It's my nature." Back in the small Michigan town where she was born, Nancy played in a sand box in the back yard. "Like most kids, I loved to dig down into the sand. But then I dug below the sand to the good stuff—the clay. I was lucky enough to have a vein of pure clay running right under my sandbox!"

Nancy's mother was an art teacher. "She allowed my artisticness," says Nancy, dressed in a T-shirt and baggy cotton pants, a faded red bandanna around her short gray hair, and garden clogs of two different colors on her feet. "But from the age of four, I felt I didn't fit in, like I was different from everyone else around me."

Nancy didn't have to travel far from her home to find where she did fit in. She enrolled at the University of Michigan to study art, and vividly remembers one night when she was nineteen. "I was outside, and I felt I was completely who I was; I came into focus." One semester she took English literature and anthropology. "I was afraid studying art wasn't academic enough," she says. She made the honor roll and then returned to the art school. "I was in heaven. I was surrounded by all these other creative people.

"In a funny way, I think all those rules I grew up with allowed me to be totally far out in my ideas," Nancy says. "I can be a kind of comfortable regular person, but I have this boundlessness. I'm a really accepting person with little judgmentalness." That quality served her well in her first career as a social

worker. "When I got out of college, I was clueless about how to make a living as an artist. I had just gotten married and moved to New York City. That's when I became a caseworker—all you needed was a bachelor's degree." She enjoyed that profession, but "I didn't last long." While working in the field for five years in three different cities, Nancy kept making pottery and finally realized she had to earn her living as a potter.

In 1985, after the end of her fifteen-year marriage, Nancy moved to a rural community in Washington with her two school-aged daughters and her new partner. "Maybe the biggest challenge I had in my whole life was to make a living as an artist and be a good mother," she says. Teaching offered a way to pursue her art and provide for her children. "I worked as an art teacher for ten years and resurrected the art program at the school." Still, she longed to devote more energy to her own art. "As soon as my kids graduated, I was out of there."

Now that her children are grown, Nancy's life follows a seasonal rhythm. From late spring until early December, she works every day in the studio behind her house, making white stoneware bowls, platters, vases, and mugs—all glazed in her signature blue and green. Each one tells a story with images of ravens, herons, owls, mountains, suns, and moons. She makes these functional pieces for specific events in the community, such as the Labor Day weekend tour of artists' studios and the annual holiday bazaar.

Teaching remains a part of the equation, and Nancy has a following of adults who sign up for her drawing and clay classes. In the spring and fall, she opens her studio for "Art for the Artistically Afraid." Originally she offered these classes in her home as a way to ease students' anxiety about making art. "What could be safer than the kitchen table?" Nancy asks, a broad smile spreading across her face. "It's a total good thing, not just for the people I teach, but for me. When I'm teaching, that's often when I come up with something I hadn't expected."

On most Saturdays during the summer, Nancy transports a couple of scarred, clay-and-paint-stained folding tables, colorful fabric to cover them, and a selection of her pottery to the Farmers' Market. "It's a great place for me because I sell the things people like. About halfway through the summer, I've usually accumulated requests that fill my order board to the brim. I really, really love doing what I do. I make things that I love to hold in my hand and that you'd want to hold in your hand," she says cradling an unglazed red clay pot.

"I'm proud of the times I've put my best creative stuff out. I glow then." That radiance suffuses Nancy's face as she stands in her living room, holding out the smoothly burnished coil pot she made ten years ago while living with Hopis on a reservation in northern Arizona. "I'd longed for tradition in my life, so I went to a place where people make pottery right from the earth—they didn't have Seattle Pottery Supply," she laughs. That long-ago summer, everything fell into place to allow Nancy some time away. Her youngest daughter decided to live with her dad. The owners of the house Nancy was renting wanted to return for the summer. And she had a list of contacts in the Southwest, one of whom offered her a place to stay.

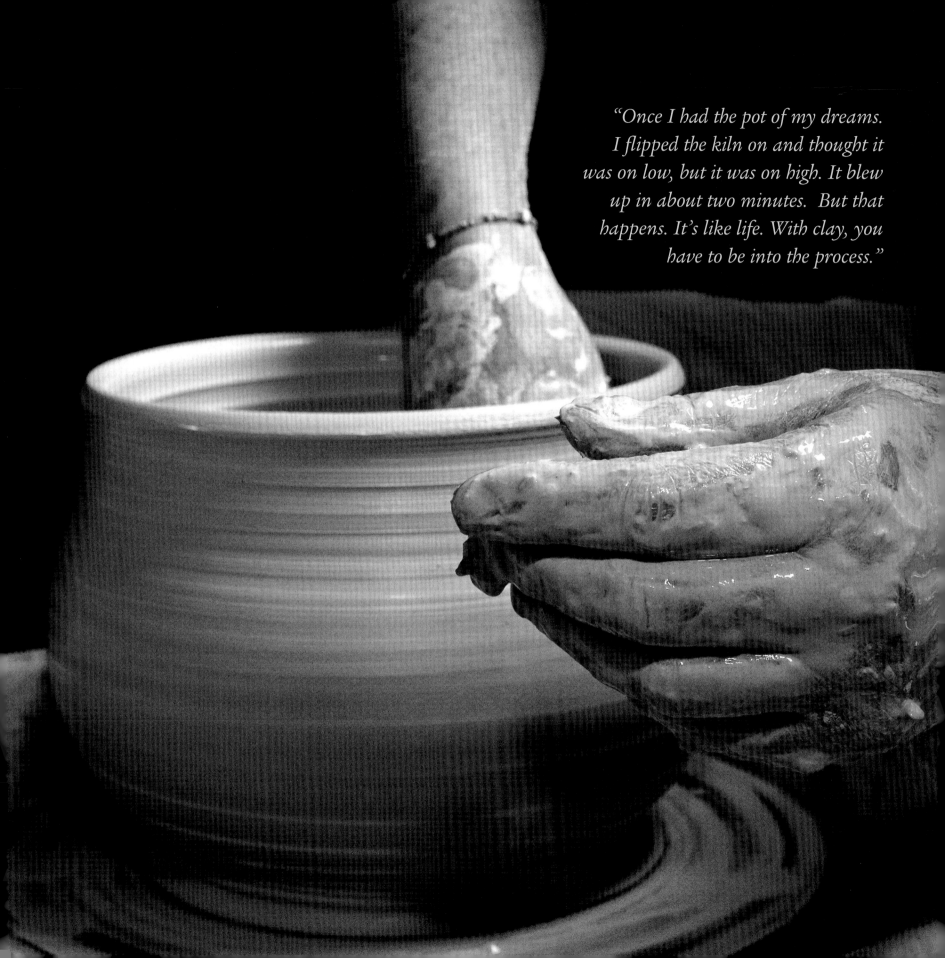

"Once I had the pot of my dreams. I flipped the kiln on and thought it was on low, but it was on high. It blew up in about two minutes. But that happens. It's like life. With clay, you have to be into the process."

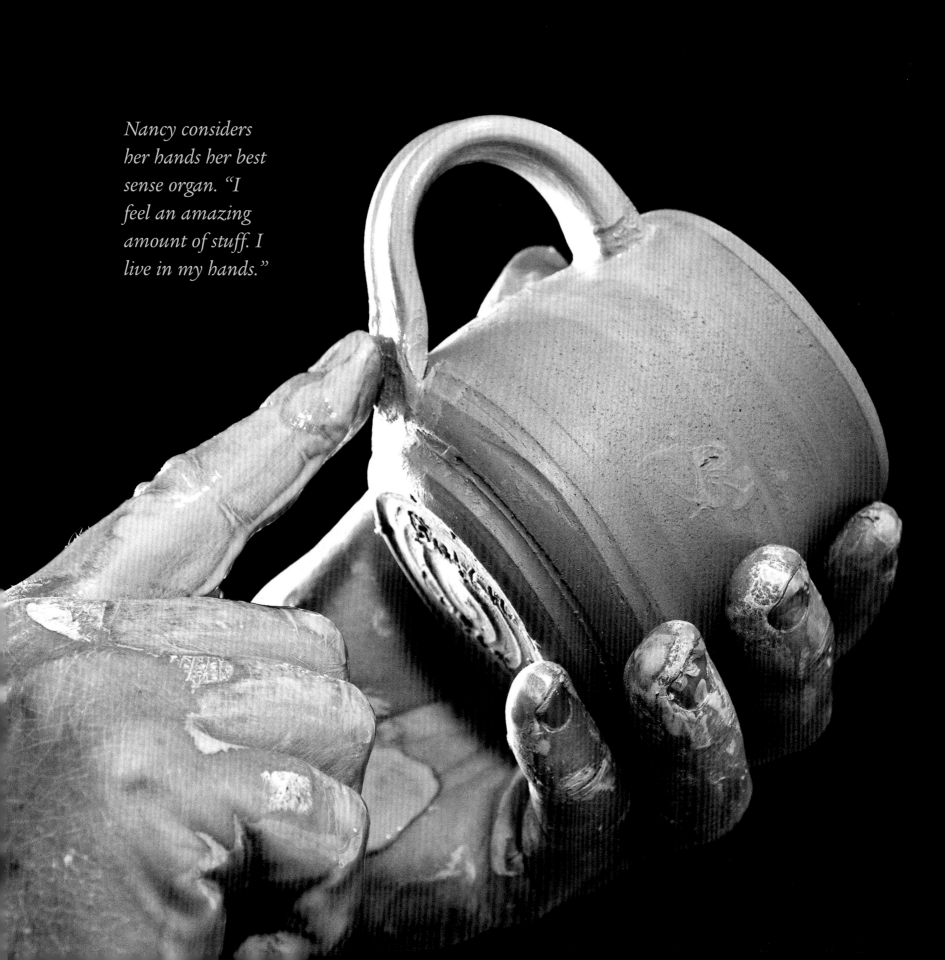

Nancy considers her hands her best sense organ. "I feel an amazing amount of stuff. I live in my hands."

"My whole mission was to make pottery," Nancy remembers. "I met some people who are Hopi legends, and I did everything in the traditional way. I found my own clay and chewed yucca to make my own brush." She also slept outside. "It was a way to be a part of nature, and it was the first time I experienced my mind being quiet." It also was the first time she had ever really been alone, and she found she liked the solitude. "I got a little scared that I wouldn't know how to leave." Nancy cherishes that experience and still carries the name the Hopis gave her: Naposaya, meaning "Clay Grandmother."

Back in her studio, Nancy pauses a long moment when asked about disappointments she's had. She shakes her head. "I don't feel any." Another pause. Then, "Oh, occasionally things blow up! Once I had the pot of my dreams. I flipped the kiln on and thought it was on low, but it was on high. It blew up in about two minutes." She stops again, smiles, and shrugs her shoulders. "But that happens. It's like life. With clay, you have to be into the process."

Nancy ignores the ringing telephone. "I remember the first time I held a three-thousand-year-old pot in an art museum. I felt my connection with all of humanity. It's as core as you get. This is the one thing that has always been constant—it's my first relationship. I'd rather do this than anything else."

Wooden shelves fill the spaces between the windows on every wall of her studio. The shelves are crammed with glazed and unglazed pots, brushes jammed into yogurt containers, books, and photos of people, hands, and landscapes. The white board behind her wheel is wiped clean, with just shadows of the orders she received during her summer at the Farmers' Market. Those commissions are completed now. Soon Nancy departs for Guatemala where she and her partner, a photographer and graphic artist, will spend three months living in a small Mayan community on Lake Atitlán. There, she works with clay in ways reminiscent of the time she spent with the Hopis.

"In Guatemala, I'm back at scratch," Nancy says. She digs local clays instead of using commercial varieties, and she fires her pottery in a gas kiln that she built herself. Unlike the electric kiln she uses at home, it's not at all predictable. "I love that," she says, "because there's magic in the fire." She teaches pottery and art classes in Guatemala, too, and looks forward to her return there each year. Each time she leaves, she bids good-bye as Guatemalans do: "I'll see you next year... hopefully."

Nancy leans back in one folding chair, props her feet on another, and ponders what she wants to do in the future. She talks of working more in sculpture, painting more, and maybe doing something with her writings. "I feel very humble, but at the same time, I know I have a lot of stories and a lot of wisdom. I wish there were some venue for telling some of those stories. I'm in the wait-and-see part of life right now. Hopefully..."

"I remember the first time I held a three-thousand-year-old pot in an art museum. I felt my connection with all of humanity. It's as core as you get."

Bouzouki player
Karjam Saeji

A painter paints pictures on canvas. But musicians paint their pictures on silence.

Leopold Stokowski

Musical

Saxophone player
Rafael Quiñones

It's easy to play any musical instrument: all you have to do is touch the right key at the right time, and the instrument will play itself.

Johann Sebastian Bach

Trumpet player
Yacek Manzano

Piper
Helen Sanders

Music expresses that which cannot be said and on which it is impossible to be silent.

Victor Hugo

Percussionist
Jaime Cordova

Hands

Music can name the unnameable and communicate the unknowable.

Leonard Bernstein

Accordion player
Sam Bernardi

When you walk in the door of Vita's Wildly Delicious, your eyes go directly to the six-foot-long, five-foot-tall glass case at the far end of the shop. The promise of a movable feast awaits you with take-out dishes such as risotto-stuffed chicken breast, organic smoked Portobello lasagna, shrimp cakes, spinach-feta timbales, skewers of chicken satay, and spicy noodle salad. A red sign behind the case says simply, *Eat.*

You likely will breeze right past the racks of wine, many organic, from all over the world, and you probably won't notice whether anyone is sitting at the brick-red lunch counter you swerve around to get to the display case. You might reluctantly force your gaze up from the case's offerings to the chalkboard listing sandwich choices: grilled eggplant and sweet red peppers with ewe's milk feta and pesto; smoked pastrami, sauerkraut, and Swiss; roasted turkey and smoked mozzarella with sun-dried-tomato tapenade; ham and Gruyere with honey-mustard sauce.

Only when you place your order do you finally make eye contact with Vita's owner, Joyce Brinar.

"I'm a chef, and that says it all. My hands are everything about it," Joyce says, holding them out in front of her. She surveys their wrinkles, cracks, and stubby fingertips. "They're gnarly. I've spent a lot of my life hiding them. They ache. They're tired. But they're strong."

Before she was a chef, Joyce was a modern dancer and a potter. "I've always worked with my hands from the creative side of my brain," she says. Although she had "cooked a bit," she didn't pursue cooking as a livelihood until 1982, when she moved to a rural community. Soon she was working and learning with the generous chef/owner of a fine dining restaurant. When he sold the restaurant, Joyce stayed on, by then running the kitchen, buying the food and wine, developing menus, and, of course, cooking. "Then I came to a point where I was done," Joyce says. "One day I told the owner, 'I quit.' It was as if someone else spoke through me. I didn't have any other job lined up. But that afternoon I went home and started designing my pie cart."

The inspiration for her pie cart came from a trip to New Zealand the previous year. "Savory pies are the ubiquitous road food in New Zealand, like burgers and fries are here," Joyce explains. She saw the single-serving pies everywhere—in fancy restaurants, sidewalk stands, roadside stops—and decided they would be good sellers at her community's Saturday Farmers' Market. A carpenter friend gave her a wooden cart he no longer needed; she outfitted it with a cast-off oven to keep the pies warm, enticing customers with the scent of herbs, vegetables, lamb, chicken, and buttery pastry.

Every Friday night, two young neighbor girls joined her in her kitchen to help make the pies for

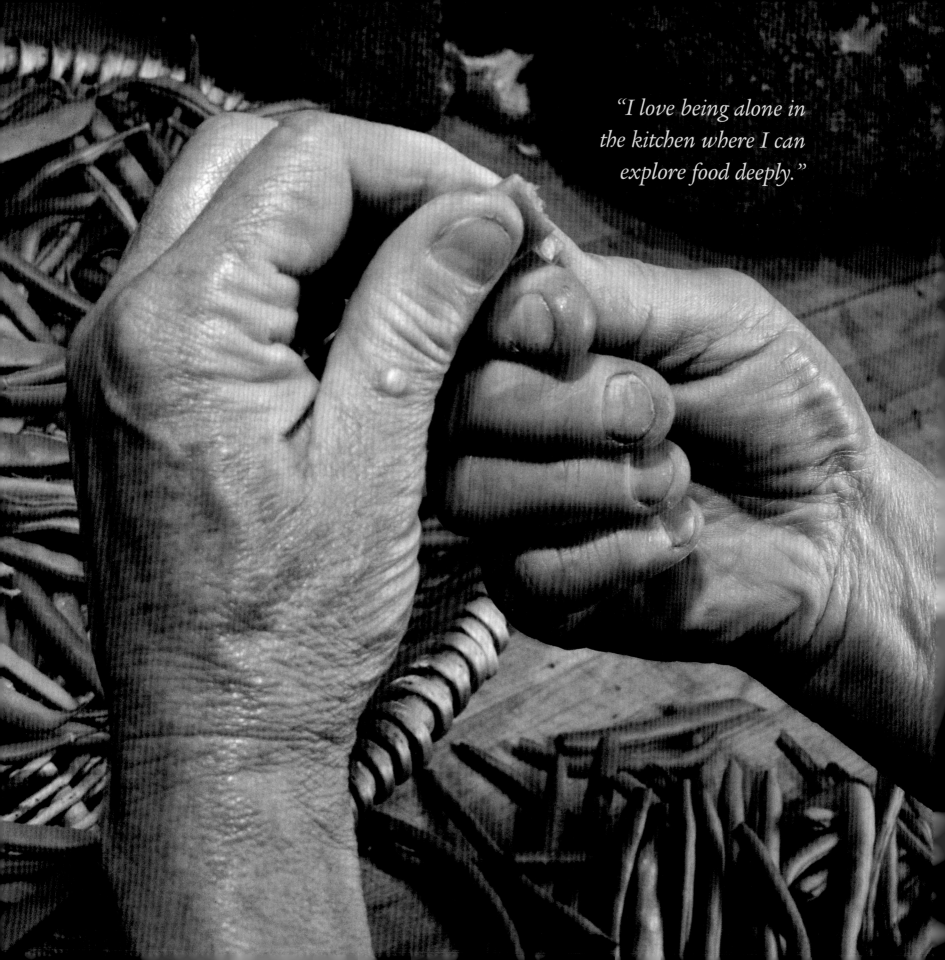

"I love being alone in the kitchen where I can explore food deeply."

the next day. "I told them we'd make pies until it was no longer fun. I had no idea how many pies I could sell." That first week they made three dozen pies. "I sold them all in fifty-four minutes," Joyce recalls. "We finally got up to making fourteen dozen pies every week." During that summer of making and selling pies, another dream began to take shape.

Working with friends to create Vita's, her storefront take-out restaurant, Joyce designed and built the kind of kitchen where people linger. The aroma of onions and garlic simmering in olive oil on the six-burner stove lures customers in through the flower garden surrounding Vita's doorway. Regulars and tourists alike lean on the wooden counter that Joyce painted coppery red, squash yellow, and okra green. Their mouths water as they watch Joyce's hands swiftly dice tomatoes or efficiently slide heavy metal pans filled with golden, cream-sauce-covered chicken breasts out of the double oven.

"People often call me Vita," Joyce says, "but I don't think a restaurant should be somebody." She shapes a mixture of chopped shrimp and herbs into bite-sized round cakes, dips them in egg and fine cornmeal, and arranges them in rows on a tray. "Vita was my alter ego. She was the one who could step out of unemployment and do something like this. She was the one who was brave enough to do it."

Because of that courage, Joyce's cooking is no longer limited to Friday night in her own kitchen. "What drives me is how turned on by the food I am, and that's what makes the seasons so exciting," she says. "I start most days at seven a.m. and go to

the garden for a little bit." Last year she planted tomatoes and herbs in a community plot across the street from Vita's. "This year I got a bigger plot, got rid of some of the herbs, and will plant everything—beans, carrots, tomatoes, squash.... I love planting the vegetables and then bringing them in to cook with. Each time you come into a season, you get to have the food new again. It's as though you've never had it before. It's very exciting

to grow hundreds of pounds of tomatoes and use them in my cooking. And when they're gone, I'm just not going to cook with tomatoes until I have them in my garden again."

Even with nearly twenty years of cooking experience, Joyce says, "I'm always learning new stuff in the kitchen. There's still so much I don't know,

and I *love* that. Tasting food as it's cooking is the only way to know if it's right, and I'm really fussy." She pops a shrimp cake into her mouth. "That's yummy," she says to the co-worker overseeing the sizzling pan and then continues her commentary. "The media portray the kitchen industry as a nasty, harsh place. I don't believe in that. I think we can create a sustainable, happy environment where people can make a living and enjoy it."

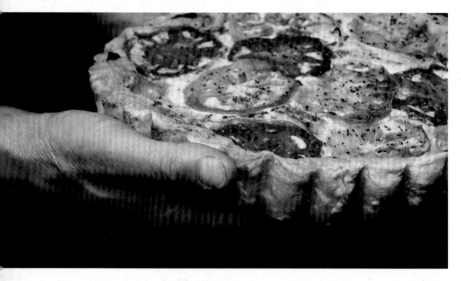

Joyce intentionally never committed to a specific menu or to a certain kind of restaurant. "I love being alone in the kitchen where I can explore food deeply. People who come here get that about me, and they bring me stuff, like this paprika from Hungary," she says, holding a little cotton bag of the spice and inhaling its scent.

"And these mushrooms!" Her voice raises an octave as she glides the tip of a knife through the cream-colored flesh of a porcini mushroom the size of a softball. "A friend went into the mountains and was enthralled with picking these," she says. "Then he brought them to me. I think they're the royalty of mushrooms. The flavor is unbelievable." So is the nutty, earthy scent as Joyce sautés half a dozen of them with garlic in olive oil and butter.

She grasps the skillet handle with her right hand and gently swirls the t-shaped slices of mushroom. Her green eyes suddenly swim with tears. "At this time in my life, my biggest desire is to be of service," she says. "Feeding people fills that for me. It's exciting when someone brings me mushrooms he's just picked at three thousand feet in the mountains, but what's more beautiful is the exchange that happens when I fix people the food they want. It's community. Vita's is a little bridge between all the different communities here, because we all eat food. With six feet of real estate," she says, waving her hand toward the glass case loaded with her creations, "we try to feed them all."

Joyce brushes away a tear as a grin pulls at the corners of her mouth. "But what makes my heart sing the most is the kids I hire. When I was building Vita's, the only thing I cried about, besides plumbing, was realizing, 'Oh my God, I'll have to hire people.' Now it's my biggest joy. I look up in the afternoon and see these high school kids eating our food. Having that relationship with these ladies has been outrageous for me."

Chopping, slicing, stirring, serving. Joyce's hands elevate a universal act—feeding—to high art. "The kitchen is our studio—with lots of refrigeration," she says. "Everything that happens here is something I have an opinion about, of course, but there's something else way bigger and better than me going on. It's really magical."

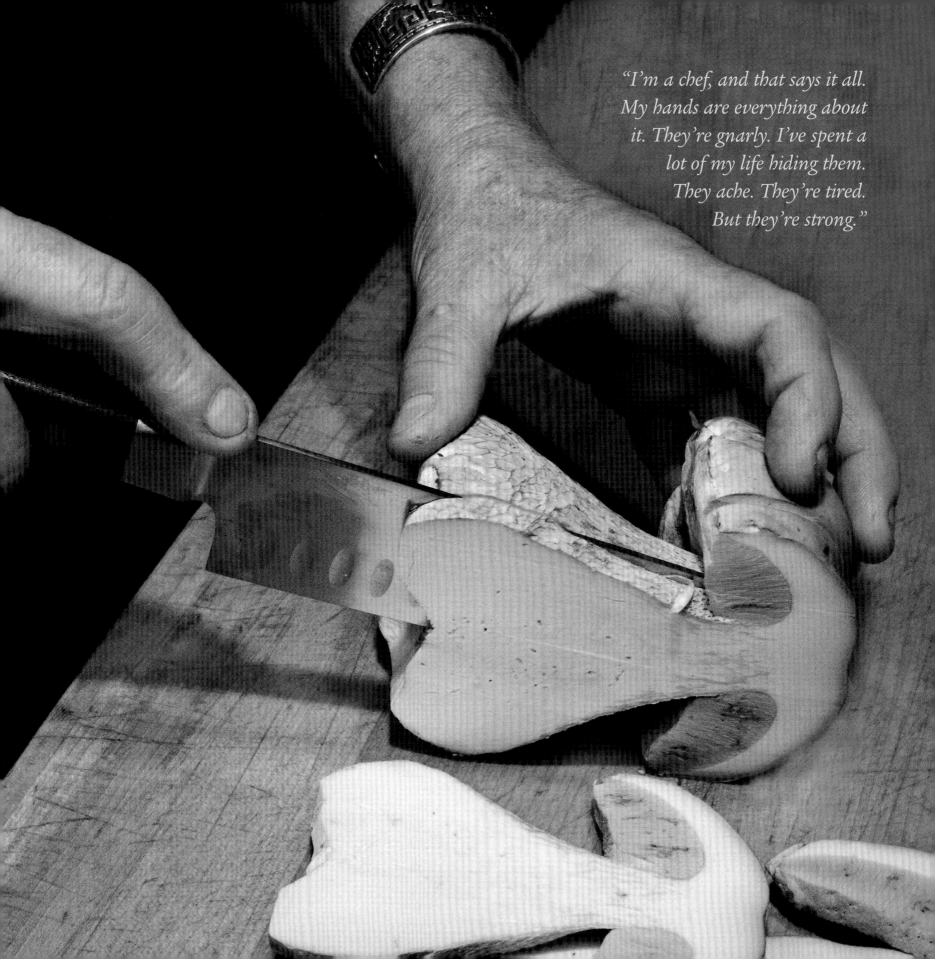

"I'm a chef, and that says it all. My hands are everything about it. They're gnarly. I've spent a lot of my life hiding them. They ache. They're tired. But they're strong."

At twenty, Anne Dawson dreamed that someday she'd live in the country and have a quilting studio. At forty-five, after working in fabric shops, making quilts, and teaching quilt making, she rented a space for her restoration quilt business in her small, rural community. Every day since, she's gone to her studio to "do something with fabric." She might stay for just a few hours—or ten.

"I love to rescue quilts," Anne says, sitting at a seven-foot-long table with an 1860s-era quilt spread out in front of her. Remnants of red roses and flowing green leaves dance across the cream-colored fabric. "This was a twenty-five-dollar thrift store find," she says. "The design is called Whig Rose, and I'm guessing it wasn't an everyday bedcover. It was exquisite, but the fabric on the appliquéd flowers had deteriorated. Everything on this quilt was done by hand. It was too beautiful to end up in the trash."

At a rack holding a couple hundred spools of thread in every color imaginable, Anne selects a spool of red and returns to her quilting table. Her brow furrows as she peers through the reading glasses settled on the tip of her nose and passes a length of thread through the minuscule eye of a delicate needle. Her right hand steers the needle around the edges of antique crimson fabric cut to match the original flower appliqué. Her left hand, hidden beneath the fabric, waits for the needle to pierce the quilt. "I use a thimble on my right hand to push the needle through the fabric," she says,

clicking the silver dome against the needle's head. "But I have to feel the needle with my left. That hand gets pretty chewed up."

She places her hands on the quilt she's been restoring bit by bit for years. "I have peasanty hands," she says, examining the chapped fingertips of her left hand. "Fabric is drying to the hands. And sometimes I get pain in my right thumb, or zings in my fingers, but they're not too far gone yet."

As Anne stitches, words flow easily about her quilting passion. "I'm using silk thread because it disappears into the red flower and because I like natural materials. I prefer one- hundred-percent cotton goods—fabrics, threads, batting. We know the long-term durability of natural fibers, and if you're going to put five hundred hours into something, you want it to last more than twenty years."

Five hundred hours? "Oh, easily," Anne says.

Anne treasures those hours for contemplation. "I like to think about the context in which the piece might have been used, what was going on at the time it was made—the social history aspect," she says. "As I work on it, the quilt tells me what it needs to have done. I feel connected to the quilt as well as to the unknown woman who originally made it. I'm honoring her work, and I believe she would appreciate someone fixing it up."

Anne describes herself as a quilt maker and an artisan. "I've always been drawn to 'early American' things. I perceived quilts as part of that," she says. She made her first quilt in the 1970s as a project

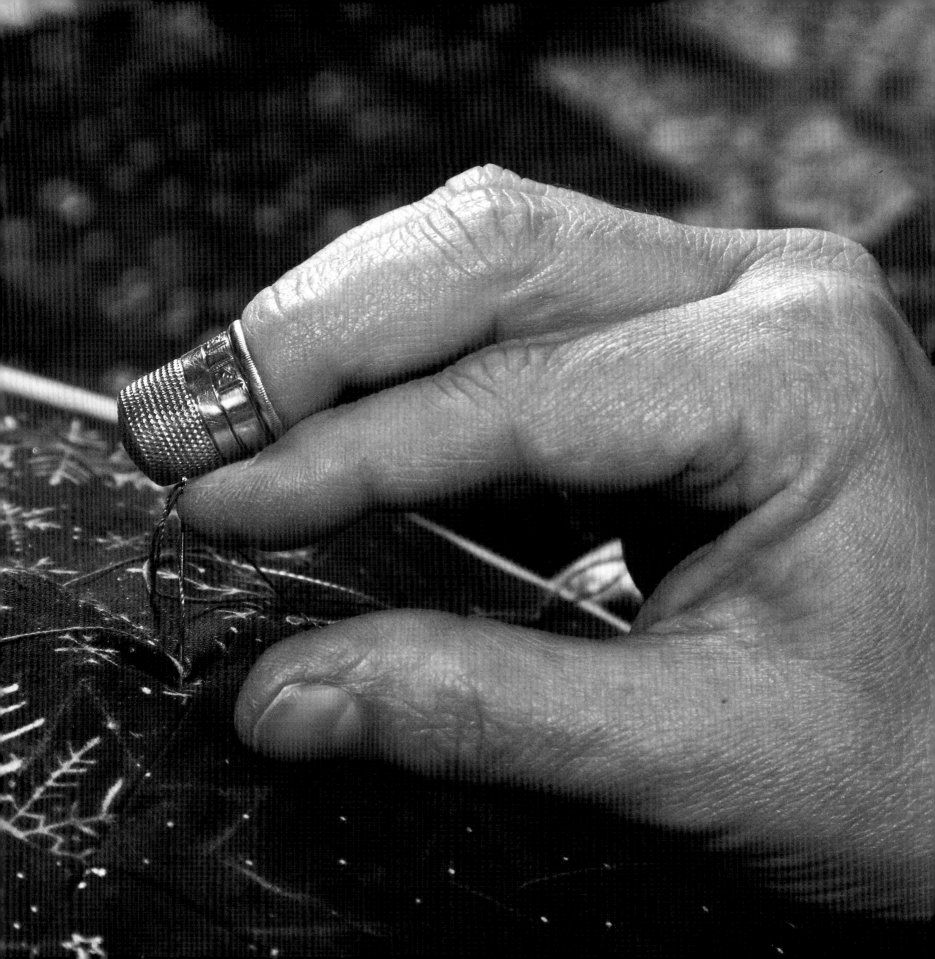

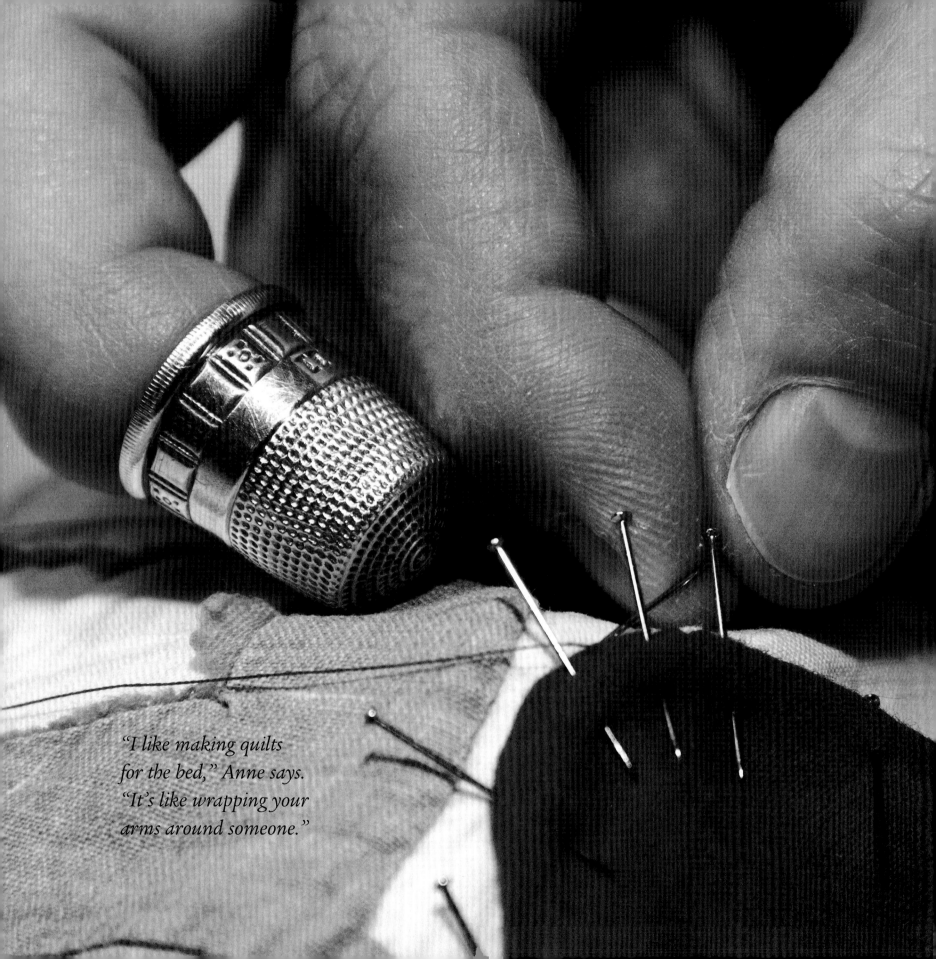

"I like making quilts
for the bed," Anne says.
"It's like wrapping your
arms around someone."

for her high school American History class. "It was an eclectic quilt based on patchwork patterns. I also wrote a paper about quilt history," she says. "Quilt making is a good vehicle for studying women's history, and that appealed to me too."

Around that same time, Anne bought her first vintage quilt. "It was 1975, and I was in upstate New York for my brother's college graduation. I went into an antique store, and there it was—a quilt top with double pinks. In the 1860s, that was a popular bubblegum-pink pattern printed on top of pink fabric." Anne paid about twenty dollars for the quilt, and still has it—along with upwards of fifty other quilts. Some are displayed in her studio on eight-foot-high racks, each precisely folded and draped over the wooden rods. Quilts with delicate floral patterns of pale pink, cream, and yellow vie with others in bold geometric designs in vivid oranges, reds, and greens. "Many of them are 'finds' that I'm restoring," Anne says.

Squares and rectangles of gingham, calico, madras, and chintz fill clear plastic boxes stacked from the floor to the ceiling, adding more color to another wall of Anne's studio. "Printed cloth is what drives me the most. I see a piece of fabric I like, and I want to do something with it." She also collects vintage and antique fabrics for her restoration work and is often the recipient of people's cast-off material. "It's amazing what people give me," she says.

The framed original of the logo for her quilt restoration business, an outstretched hand holding a heart, sits on top of an antique bookcase. Books about quilts crowd all the shelves. "I really don't have a great desire to do art pieces," Anne says as she resumes restoring one of the red roses, neatly

making nearly invisible short stitches around its edge. "Clients entrust me with their family treasures, and my job is to put them back together in a form the next generation will want to keep. I've worked on many quilts that were meaningful to their owners, from a quilt using the only piece of material culture remaining from a family member, to memorial quilts made of T-shirts," she says. Anne documents the quilt's history on a label sewn to the back of each piece, so its story travels with it as it's passed down through the family.

In simplest terms, a quilt consists of three layers of material stitched together. The top— the decorative part—is made of fabrics cut and pieced together to create a pattern with such names as Flying Geese, Wedding Rings, and Log Cabin. Some, like Anne's Whig Rose quilt, have appliqués—fabric pieces shaped like flowers or other objects—sewn onto the top. The middle is batting—fluffy cotton that gives the quilt its weight and warmth. The backing consists of more fabric, either plain or patterned. All three layers are basted to hold them in place while Anne stitches, or quilts, them together with a traditional or original design.

Despite her focus on restoring old quilts, Anne sometimes makes new ones. "Everyone has a quilt story and quilts in the closet. This one," Anne says, unfurling a double-bed-sized quilt in blues and greens, "was supposed to be for my son's high school graduation. He's turning twenty-one soon, and maybe I'll have it done by then. Probably not. It's called Delectable Mountains—he's a ski bum extraordinaire." She traces around a star template with chalk to mark the pattern for her stitches. "I'm quite happy to use someone else's drawing to make the design for both the piecing and the quilting," she says. She snaps a wooden embroidery hoop onto a portion of the quilt. Right hand on top, left hand underneath, Anne guides a needle with shimmering blue-green thread in and out of the fabric, stitching the layers together. "I like making quilts for the bed. It's like wrapping your arms around someone."

Anne knows that her preference for quilting by hand is rare today. "People make amazing patterns with machines that require a whole different set of skills," she says. "Plus, one of the main appeals to machine quilting is you can do in eight hours what it would take about a hundred hours to do by hand." She points to the gleaming, modern sewing machine on a table in the corner of her studio and admits she uses it to stitch together squares, triangles, and strips of fabric when she makes a new quilt top.

But when it comes to sewing the intricate curving, swirling, or geometric designs that hold it all together, Anne relies on her hands. She leans back slightly and surveys the star emerging on her son's quilt. "I really like the tradition of hand quilting. The stitching looks quite different from machine work, and it has a little softer feel to it. I think some things are aesthetically better when done by hand. You invest so much of yourself in them."

Although quilting by hand gives her more control, it still demands patience, persistence, and practice. "Quilting has taught me there's no one right way to do anything," Anne says. "You have to be able to approach things from many directions. Ultimately, all that matters is if you like it."

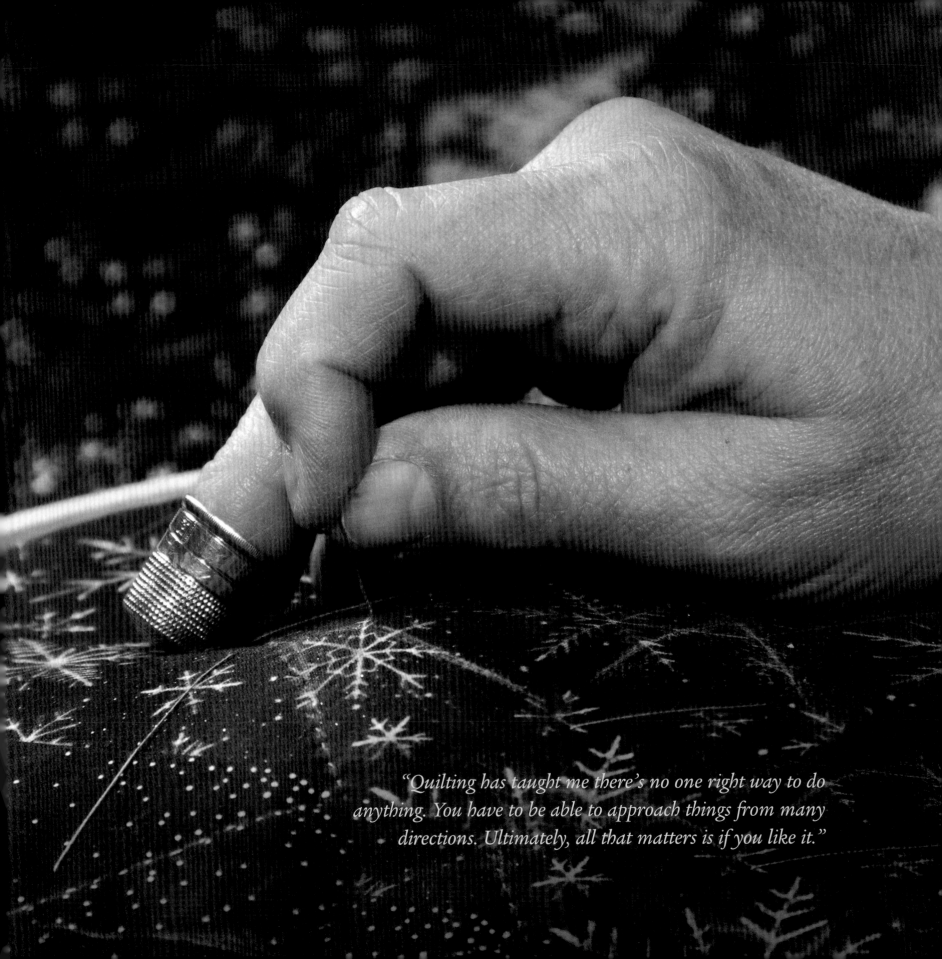

"*Quilting has taught me there's no one right way to do anything. You have to be able to approach things from many directions. Ultimately, all that matters is if you like it.*"

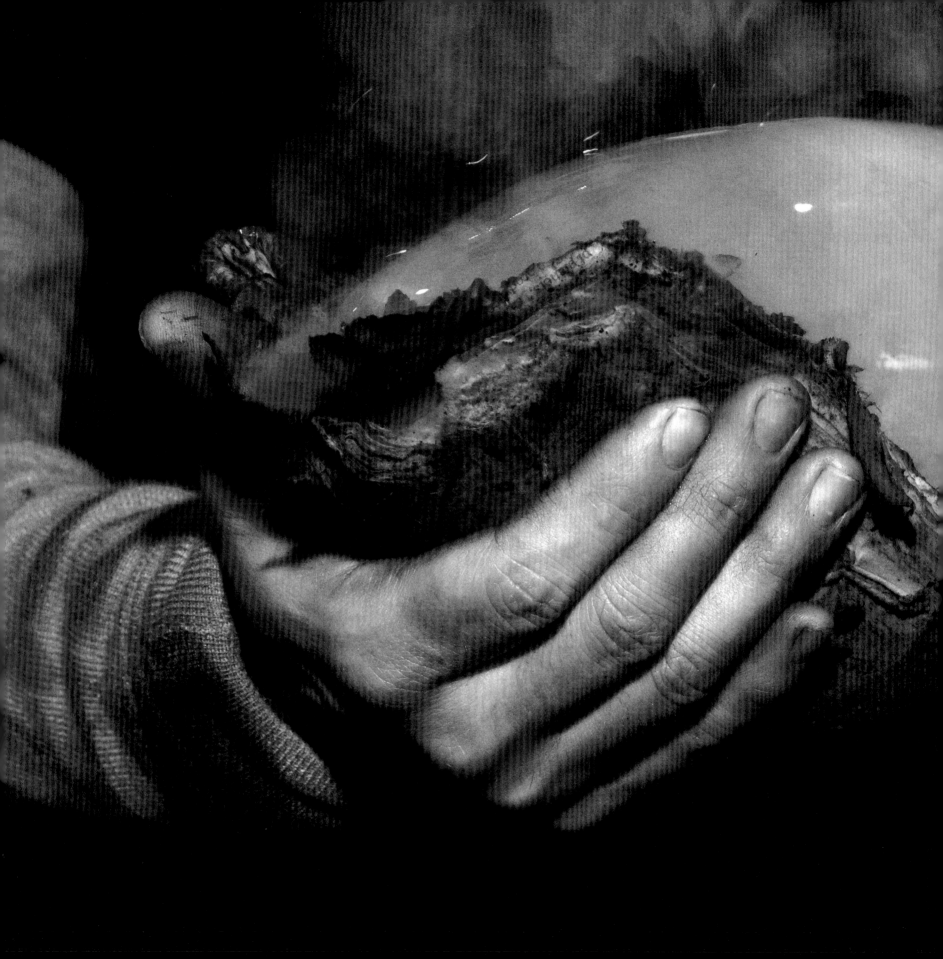

Fun. Just so much fun. Those are the words Raven Skyriver uses repeatedly to describe his work and life as a glass sculptor. Fun, despite the seventy-hour workweeks. Fun, despite the scars from healed burns on his wrists, partly concealed by gray plumeria-blossom tattoos. And fun, despite (or perhaps because of) the 2,400-degree furnaces and 1,400-degree glass he handles.

As he talks, Raven struggles to stifle an occasional yawn. He's still suffering from jet lag after his return from Brazil, where he apprenticed with Lino Tagliapietra, one of the world's best glass artists. And he's been up all night cleaning and organizing in the "Hot Shop" at the prestigious Pilchuck Glass School created in 1971 by master glass blower Dale Chihuly. Within days, students from all over the world will arrive at the school for summer courses with accomplished glass artists. Raven will be managing their use of the octagonal barn-like structure where all the glassblowing takes place. But today he gets a chance to work on one of his own pieces, a jumbo shrimp.

He pushes his shoulder-length brown hair behind his ears, shields his eyes with filtered glasses, and slides a hollow five-foot-long metal blowpipe into a mound of molten glass, glowing orange-yellow on the floor of a seven-foot furnace. A blast of hot air swirls around Raven's bare arms as he gathers a glob of liquid glass onto the tip of the pipe as if dipping honey from a jar.

Raven steps back from the oven, covers the other end of the hollow pipe with his lips, and blows into it, creating a bubble of glowing red glass. Then he walks the pipe to a bench, where he sits and rests the pipe on a stand. With his left hand, he rhythmically rolls the pipe back and forth, the bubble of glass dangling from its end. His right hand palms a

stack of wet newspaper like a potholder and molds the hot glass. The studio smells as if someone has just doused a campfire. As the red glow of the glass fades, Raven totes the bubble back to the furnace to pick up more liquefied glass, then returns to the bench to continue shaping the sphere.

When he's satisfied with the size of the oblong glass on the end of the pipe, Raven carries the pipe to a metal table and rolls the sphere in a pile of glass crushed to a powder pigmented with metal oxides. Then he quickly walks the pipe to one of the five "glory holes," round drums of fire roaring

at 2,250 degrees. He glides the pipe and glass into the glory hole, rearing back a bit at the gust of heat coming from the open door. The powder melts and turns the glass the salmon-pink that Raven wants for this piece. He'll repeat these steps to add layers of red, peach, and silver.

"After I get all the glass and the color, it's ready to be sculpted," he says, lifting the lid of a battered brown Samsonite suitcase. Inside is a jumble of tools for cutting and shaping glass: steel tweezers (some with pointed tips and others with flat ends), metal spatulas, picks, wooden blocks, calipers, and several sizes of shears. "Everyone keeps their tools in a suitcase," Raven says as he carries an armload of tools to the bench. With a foot-long pair of tweezers, he transfers the glass from the blowpipe onto a solid pipe called a punty to hold the emerging form. With smaller tweezers and shears, he plucks and pulls the glass to shape sockets for the eyes of the shrimp. "I love these tools."

Using a spatula, Raven flattens one end of the glass sphere. Then, with wet newspaper in his right hand, he squeezes the molten glass until the beginnings of a tail appear. Another trip to the glory hole reheats the flattened end, and then it's back to the bench, where he squishes the tail some more and sculpts ridges with a metal spatula. During the next three hours, he'll repeat these steps over and over to shape the shrimp's three-foot body. "I try to be accurate, but I kind of stylize my work a little bit, too," he says, carving lines on the shrimp's snout.

Six peach-colored glass legs that Raven made several days ago have been resting in the "garage," another oven that keeps glass warm. Before he can attach the legs to the shrimp body, Raven will warm

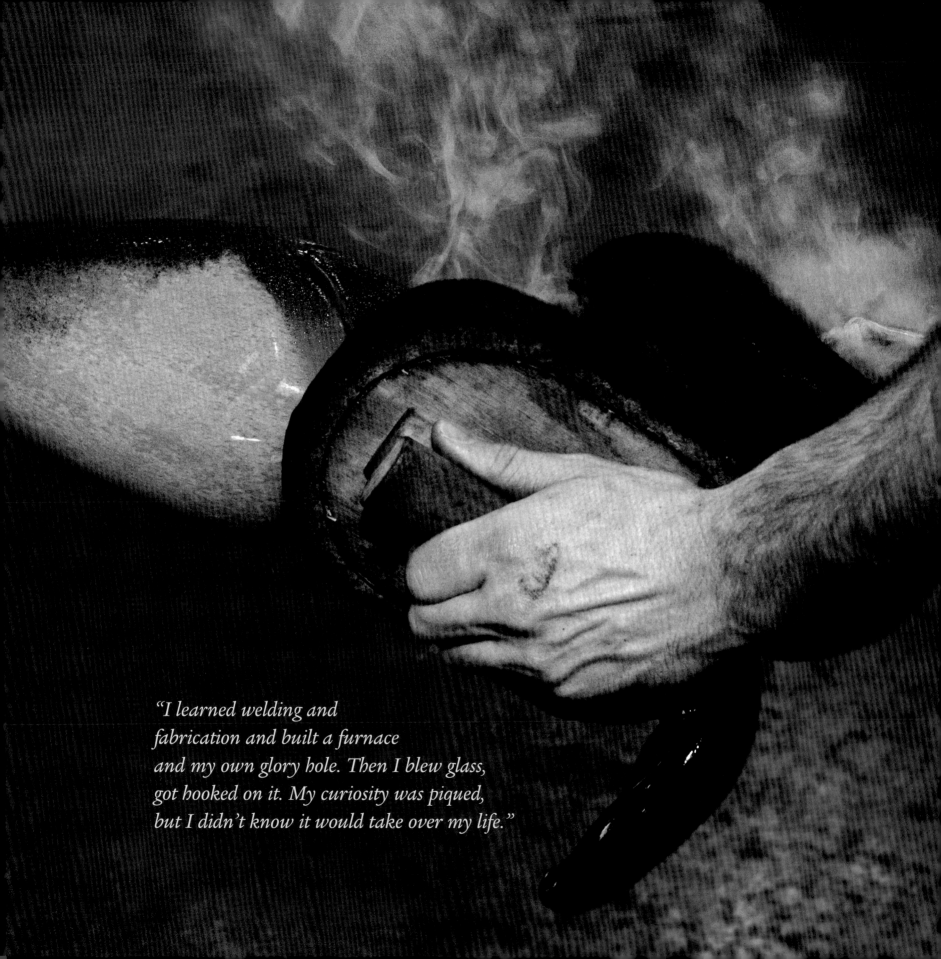

"I learned welding and
fabrication and built a furnace
and my own glory hole. Then I blew glass,
got hooked on it. My curiosity was piqued,
but I didn't know it would take over my life."

the pieces to 1,200 degrees in the garage. With tweezers and spatulas, he'll stretch and pinch the hot glass to connect the legs and body. Then he'll slowly cool, or anneal, the entire piece in another oven. If he let the still-hot form cool in the air, it would shatter.

At this stage, the glass, and Raven, can rest for a bit. Away from the ovens, he wipes a sheen of perspiration from his forehead, pulls on a hooded "Pilchuck School Staff" sweatshirt, and lounges on his bench. "I've been making a lot of sea creatures," he says, "and I like shrimp a lot. I like to eat shrimp, and I wanted to make something fun and funny. Jumbo shrimp is an oxymoron. And it's also a way to get people thinking about food, where it comes from and how we look at—or don't look at—what we eat."

He rests his hands, gray from gripping steel pipes and wet newspaper, on his faded black Carhart pants and reminisces about his introduction to glassblowing on the rural island where he grew up. "I got pretty lucky," the twenty-five-year-old says. "I wasn't academically inclined in high school, but there were several other students like me, and our school was open to an alternative of allowing us to work with someone in the community." Raven sought out glass blower Lark Dalton. "He gave me my whole foundation," Raven says. "I learned welding and fabrication and built a furnace and my own glory hole. Then I blew glass, got hooked on it, and Lark couldn't keep me away. My curiosity was piqued, but I didn't know it would take over my life." He pauses and smiles. "It's so much fun."

After graduating from high school, Raven went to Venice to attend a two-week class in traditional

Venetian blown glass offered by world-renowned glass artist Maestro Davide Salvadore. "Then I came home and did construction work and blew glass at night, mostly cups and bowls, for a couple of years," Raven recalls. "I had my own little workshop that was super basic."

Next he studied at the Tacoma Glass Museum and five years ago began working at Pilchuck, assisting sculptors William Morris and Karen Willenbrink. "Unlike other art mediums, in glassblowing and sculpting you work as a team," Raven says, "and everyone has a role." When he's not coordinating the Hot Shop, Raven's role is gaffer, or main assistant, to Willenbrink. She and her team make large-scale art pieces that collectors and museums buy for $18,000 or more. "Working as a team is really fun," Raven says. "It allows you to do things you couldn't do alone. And teamwork teaches good life skills that make it easier to deal with people and for people to deal with you."

Through the windows of the Hot Shop, Raven can see Puget Sound, home to some of the sea life he honors in his own work, such as the matte gray Humpback whales he's sculpted that weigh ten to fifteen pounds and are nearly four feet long. Several of them have been purchased by art collectors who share his concern for the environment.

"Marine mammals are a good barometer of what's happening environmentally," Raven explains, "and they're having a tough time. I'd like to address some of that and get a little more political in my artwork." His latest piece, "Fisherman's Foe," is a two-foot-high sculpture of three glass sea lions lazing on a glass boulder. "For me," Raven says, "this sculpture is an interesting dialogue because

sea lions are being killed to protect salmon. But that's what sea lions eat, so why would you shoot them for monetary gain of the fishing industry?"

Two new pieces he's developing also offer comments on the environment. One, with Arctic seals on top of an iceberg, is called "Vanishing

Habitat." Another, "Thin Ice," will feature a polar bear on a shrunken piece of ice. Raven surveys the Hot Shop and the heat waves blurring the air around the propane-fueled glory holes. "I feel like a hypocrite, though, using lots of fossil fuels to melt glass," he admits. "I don't really know yet how to reconcile this internal conflict."

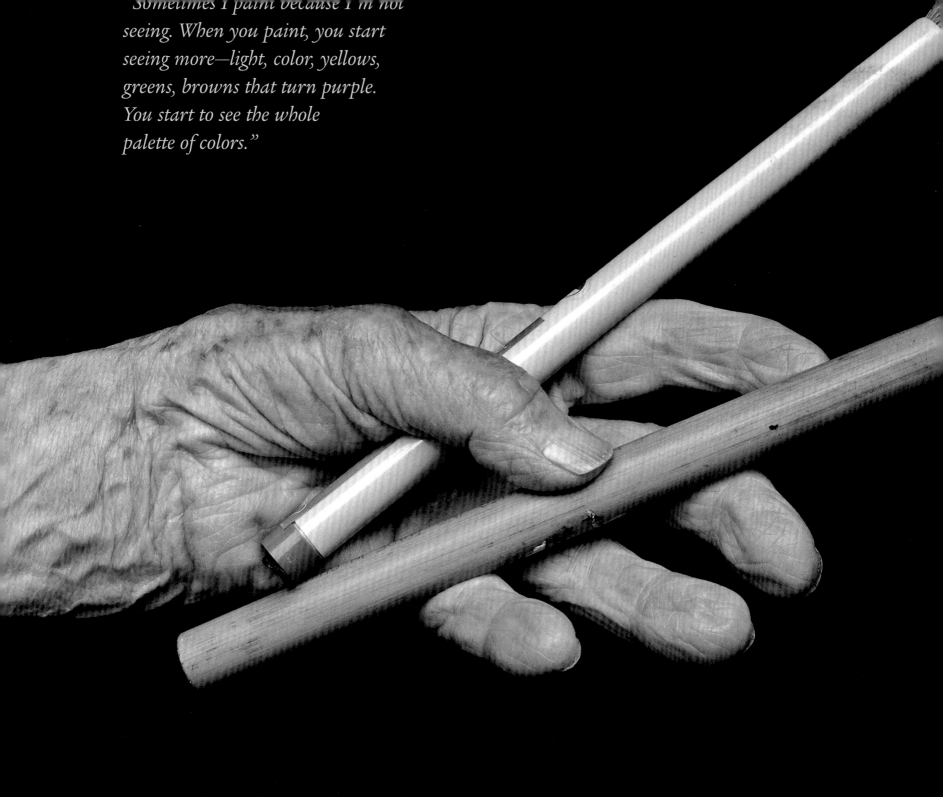

"Sometimes I paint because I'm not seeing. When you paint, you start seeing more—light, color, yellows, greens, browns that turn purple. You start to see the whole palette of colors."

Watercolors of a man with bright-blue eyes, white hair, and a beard are propped up on easels. The blue-eyed cat in another painting is orange. So is the real, but unplugged rotary dial telephone that resides on the paint-spattered plastic drop cloth on the floor. A spiral sketchbook featuring another orange cat leans against a wall. A book sticks out from a pile of magazines, newspapers, and books on the coffee table. Its title: *Age Doesn't Matter – Unless You're a Cheese.* Hildegarde Goss, eighty-eight, gazes out the picture windows that make up the entire west wall of her living room and contemplates the stunning view of Outer Bay. A dark-blue Earth flag in the front yard flaps in the wind.

"I haven't got a technique," says the woman who has painted for most of her life. "I'm after color. It doesn't matter if it's chalk, pastels, acrylics. I like any color." Hildegard is the living embodiment of that statement, with her snowy white hair in a topknot and her turquoise sweatshirt and navy-blue sweatpants, spattered with dabs of yellow, green, and red. She waves her age-spotted hands in the air as she talks.

"I'm trying to communicate feelings—anger, loneliness, outrage—when I paint," she says. "Sometimes I paint because I'm not seeing. When you paint, you start seeing more—light, color, yellows, greens, browns that turn purple. You start to see the whole palette of colors." What Hildegarde sees, however, isn't always what others see. "At age nine," she says, "I did a painting of a bright-yellow streetcar. The teacher thought it was terrible. I said, 'No, it's good.'"

At twelve, Hildegarde left her hometown of Los Angeles for a boarding school in Sweden where she had little chance to paint. "My school didn't have any art classes until my last semester, when a German teacher came and taught art," Hildegarde recalls. But she developed an appreciation for art from a Swedish aunt who had studied with Toulouse Lautrec and from a cousin's husband who knew a museum curator. "They'd take me to the museum and show me paintings," she says. "When I said I liked one, they'd ask 'What do you like and why?' I got a good background in painting from that."

Hildegarde returned to Los Angeles at seventeen. "It was the Depression and to get a job was unheard of. My older sister had one of the first massage parlors in Hollywood. She taught me how to do Swedish massage, and then I took the test for a physiotherapy license," a career Hildegarde pursued for thirty years. She also took art classes at the Art Center in Los Angeles, "because it was fun."

It was in Los Angeles that she met her husband, Bill Goss. "He was singing in the opera," Hildegarde explains, "and I went there to be a super—you're on stage like an extra and they give you a dollar

for the evening. And supers also got to go to the performances and the rehearsals." After one of the rehearsals Bill offered her a ride home. They courted for a year before their marriage, which lasted sixty-seven years. Bill died in 2002, four days before his ninety-second birthday.

When Hildegarde was in her fifties, she was ready to quit doing massage therapy, and Bill was ready to retire from AT&T and leave Los Angeles. They moved to the island community in Washington they had visited many times, and Hildegarde began painting in earnest.

"The painting is just part of your living. I paint because my paints are out there," she says, motioning to the jumble of tubes and tin cans on a folding table in front of the picture windows. "You buy all these dumb paints, so you have to use 'em up. Then you run out of some color and you have to get some more. I'm too cheap to just throw them out. That's how you get to be an artist."

Hildegarde usually paints early in the day. "I'm a morning person. By late afternoon, the light has changed so much. If it's dark, who has the energy to paint?" But she admits, "If the house is very straightened up, I'm dodging painting. When I dodge doing anything creative, I do housework. The avoidance is because you haven't quite solved the problem in your head—most often that comes in little driblets."

What Hildegarde likes most about her work is, simply, "the doing it, putting the paint on." Her home enjoys a spectacular view of the ocean so near you feel you could touch the water with an outstretched hand, but Hildegarde confesses, "I prefer to paint cats, dogs, animals, still lifes—not landscapes. With landscapes I don't want to tie it down. And people!—the damn fools change."

Her work has been featured in several solo exhibitions, and she frequently has paintings in group shows in the community. Many of her paintings have been purchased by friends and former massage patients, and some have ended up in places she didn't expect. "I'm always amazed when people buy my paintings," she says. "And I'm most proud when a total stranger buys my work."

Hildegarde has never let an absence of supplies stop her from painting. "If I'm out of a canvas, I'm not afraid to paint an old one out and use it again. There are about three paintings under this one of the woman with two dogs. But if I know I've done something that is good, I don't touch it."

She points an arthritic finger to a framed watercolor of a cat. "I was taking an art class in 1947, and I always got to class late and always forgot something. One night the teacher said, 'I suppose you forgot your paper.' I said, 'I did not,' and I smoothed out a paper sack. Then I just

whipped out that cat painting. I said to my teacher, 'You know, that's a helluva good painting.'" Hildegarde recalls her teacher saying, "Yes, but think how much better it would have been on good paper." Hildegarde's response: "If I'd had good paper, I wouldn't have done it."

The phone rings, and Hildegarde slowly gets up. "I'm coming, I'm coming," she says as she shuffles to the phone in her bedroom.

"Now, where were we?" she asks as she settles back into the rocking chair that faces the picture windows. "Oh yes. Every time I do a painting, I want to do something different. Once I get started, it might come out totally different than I expected."

Many aspects of Hildegarde's life have turned out differently than she expected, including aging. "Being eighty-eight is hard work—almost as if you were five," she says. "I think a lot of people forget they were children once. But, by my age, you should have learned not to be resentful. That's part of old-age learning—take life as it is."

Hildegarde rarely stays on a serious topic for long. She no sooner shares her philosophy about what she has learned during her long life than she's talking about her plans for a big party when she turns ninety. She's already decided on the wording for the invitation: "Come whether I'm dead or alive!"

Puppeteers Stephen and Chris Carter meld skills in acting, set and costume design, and wood carving to inspire audiences of all ages. "Our work goes through various cycles," Stephen says as he describes the ancient art of puppet theater that he and Chris have been devoted to for more than thirty years. "We're usually involved with numerous projects that are in different phases. We might be in the conceptual phase of a new show, talking and thinking about that, and then a busload of kids will arrive at our puppet center and we'll do a show. Then it might be back to quiet time in the workshop to do some carving."

Which is where he and Chris are today as they work on the hand-carved wooden marionettes for their upcoming production of a baroque opera. Stephen first started carving wood at sixteen, and his mastery is evident as a face emerges from the piece of linden wood he's chiseling. Cream-colored shavings glide off the sharp, flattened end of the chisel as he shapes the puppet's hairline, mustache, and cheek.

Next, Stephen props a miniature wooden hand on his left knee to sculpt the puppet's fingers. They're much smoother than his own, which are scarred and have short fingernails, one of them blackened from a recent collision with a hammer. Stephen slowly slices a crease between the puppet's thumb and forefinger with a thin blade. More shavings float to the floor as he sets the puppet

parts down amidst his collection of Swiss-made carving tools.

Over the next few weeks, these pieces, and others Stephen has carved, will become the characters in *Don Giovanni*, the opera set in Spain in the 1600s about the legendary womanizer Don Juan. Stephen, Chris, their son, Dmitri, and their granddaughter, Xajida, will operate the puppets and act out all the parts, accompanied by professional opera singers and a live chamber orchestra playing Mozart's score.

Two completed puppets, a man and a woman dressed in costumes made by Chris, lean against each other on a shelf. The mustached man in red knickers has a patterned vest over his white satin shirt; the woman wears a flowered scarf on her head and a red shawl around her shoulders. Her left arm rests on his right, as if they are about to clasp hands.

"Ours is a very tactile profession," Chris says as she picks up the foot-and-a-half-tall puppet woman. Her left hand grasps the "control," a wooden cross with black strings attached to the puppet's head, arms, and legs. The puppet dances, kneels, and nods as Chris's hand twists and turns the control. There's a callus on her index finger, where she's wrapped black thread that lifts the puppet's skirt. "I often have to work two puppets at once, so I usually use both hands," she says. "I have strong shoulders, too. Some puppets are very

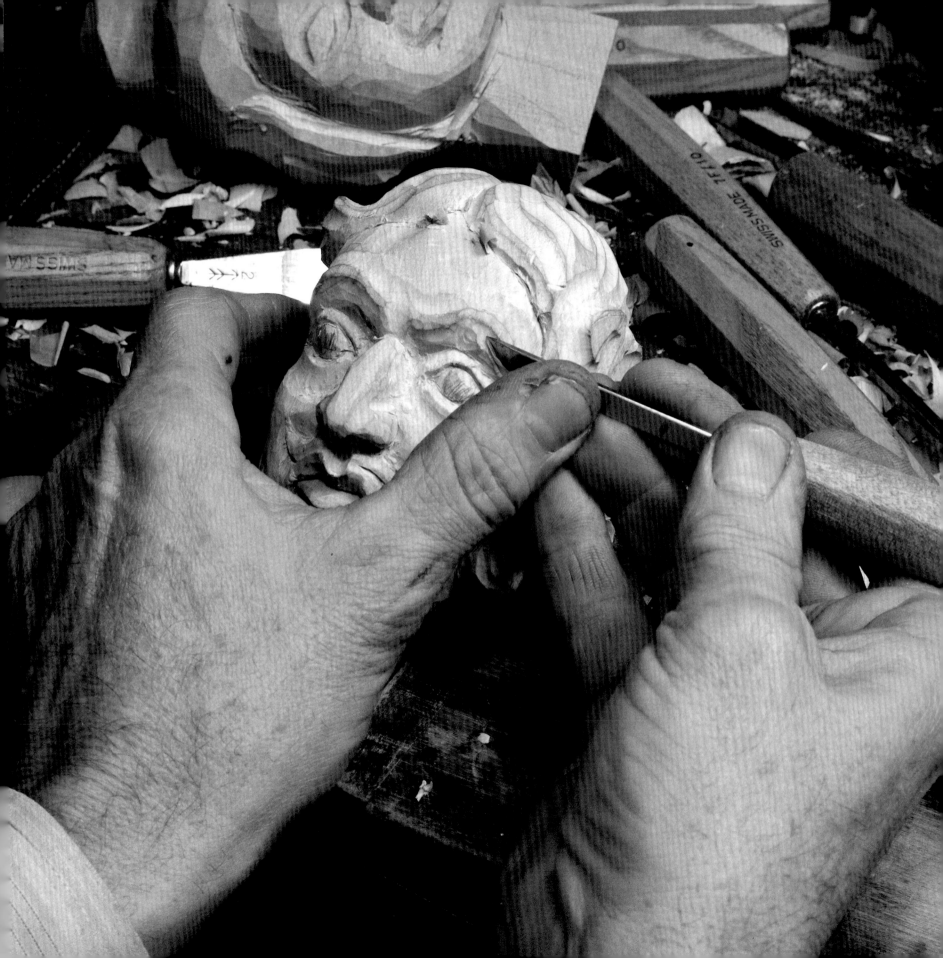

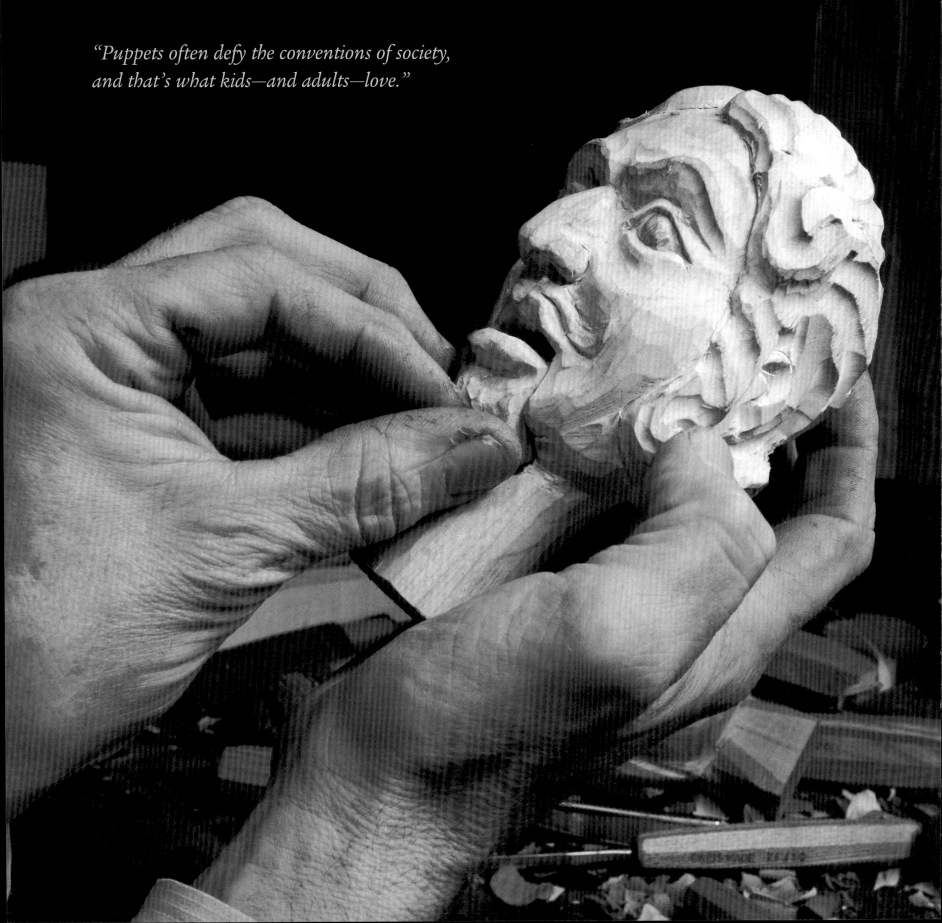

"Puppets often defy the conventions of society, and that's what kids—and adults—love."

heavy. Eight to thirty pounds is typical, but some weigh as much as fifty pounds. And sometimes we hold our hand puppets over our heads for forty-five minutes."

Chris and Stephen's mutual love of theater and creative expression grew from childhoods rich in literature and visual arts. They met in a high school drama class. "We had an extraordinary drama teacher who taught Stephen old-fashioned stage painting with dry pigments and rabbit-skin glue," Chris remembers. The couple married soon after high school graduation and started doing puppet shows in 1974 while they were students at the University of California. In 1984, Stephen received a Fulbright to study at the Institute of Theater and Cinema in Bucharest. He and Chris and their son and daughter lived in Romania for two years and then settled in Seattle to found the Northwest Puppet Center, the site of many of their 250 annual performances.

"Originally, puppet theater was for adults," Stephen says, "and occasionally had bawdy, political elements. We like that." He chuckles and his hazel eyes light up. "Every culture has a character like Punch," Chris says, "an anti-authority anarchist that people can relate to. He does the things people wish they could do." Stephen elaborates, "Puppets

often defy the conventions of society, and that's what kids—and adults—love. We walk a fine line to keep the traditional aspects yet still make our shows work for children, since they're our primary audience."

The next day, Chris and Stephen set aside puppet making to perform one of their favorite productions, *Madeline and the Gypsies*, adapted from the book by Ludwig Bemelmans. Dozens of elementary school children squirm on the floor

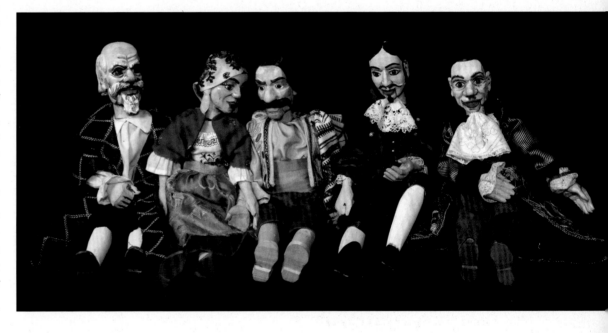

in front of the sixteen-foot-wide stage as Chris and Stephen arrange forty handmade rod puppets backstage.

Three hand-painted backdrops are rolled up behind the stage curtain. Stephen releases the cord for one backdrop, a scene of Paris streets, and he and Chris bring their puppets to life. In

an intricately choreographed dance the audience can't see, the two sit on wheeled, padded wooden boxes and roll from puppet to puppet. Sometimes they climb stepladders or crawl or run, swapping puppets back and forth between each other, returning the puppets to their racks when they're finished, and grabbing other puppets and props. Simultaneously, these veteran actors portray the play's characters using a variety of voices and accents.

Out front, the kids shriek as the chicken puppets cluck, prance across the stage, and shake their tail feathers. They giggle and point when the giraffe puppet swoops her long neck down to Madeline and when the gypsy sees Madeline and Pepito in her crystal ball. Forty-five minutes later, the curtain drops to loud applause. The children imitate their favorite scenes as they stream out of the gym. "Puppeteering is a physical experience," Stephen says, as he and Chris start to pack up. "I channel belief into the outside object and turn my brain off. *I* believe the puppet is alive."

After the show, the dance continues as Stephen and Chris talk more about their multifaceted work. They complete each other's sentences and deliver lines to each other just as they do during performances. "The nice thing about being working and

living partners," Chris begins, "is that discussions about concepts, show ideas, and the business can happen over breakfast. But we've agreed not to talk about puppetry in bed."

Stephen clarifies. "But humor is an important part of puppetry, and my best jokes come to me at three in the morning. I often get up to write them down, but I don't wake Chris to try them out on her."

Stephen describes himself and Chris as hard workers. "Yes, but our work often entails play," Chris adds. "There's a reason the word for theater is a play. For us, work and play are kind of the same thing."

Stephen nods. "In performing arts there are lots of ups and downs," he says. "And there's a lot of discipline in theater because you have to perform emotions you may not be feeling at that particular moment. There's no sick leave in our job."

"No understudies," Chris points out.

"There's that theater ethic—the show must go on," Stephen says.

"And then the lights go up," Chris adds, "and the kids are squealing and giggling at our hand-crafted puppets. And I think, oh, good, the puppets haven't lost their magic."

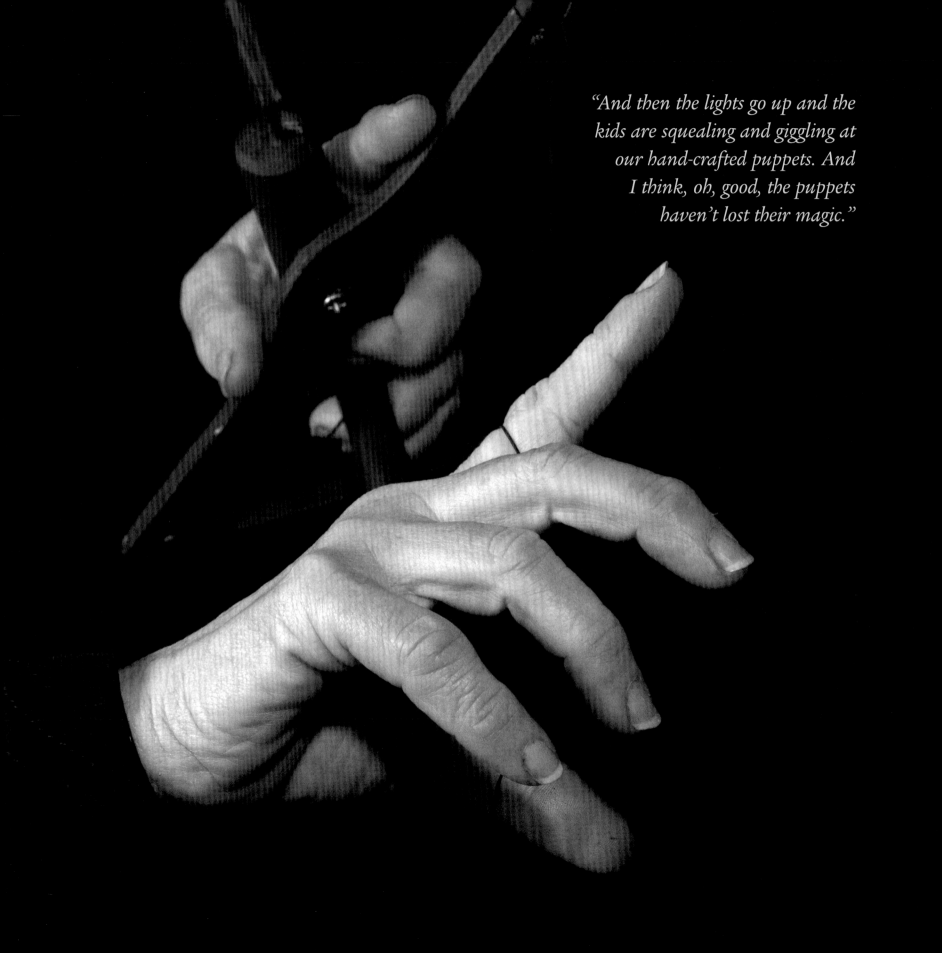

"And then the lights go up and the kids are squealing and giggling at our hand-crafted puppets. And I think, oh, good, the puppets haven't lost their magic."

 Diana Bower
Letterpress Printer

 Nancy Bingham
Potter

 Hildegarde Goss
Painter

 Irene Skyriver
Gardener

 Kenny Ferrugiaro
Spinner

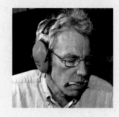 Steven Brouwer
Boat Builder

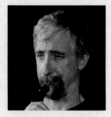 Sand Dalton
Oboe Maker

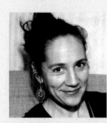 Ali Tromblay
Midwife

THE PEOPLE
WHO WORK
WITH
THEIR HANDS

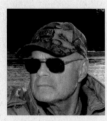 Jack Giard
Reef Net Fisherman

 Alwyn Jones
Automotive Technician

 Tina Finneran
Studio Jeweler

 Craig Withrow
Blacksmith

 Anne Dawson
Quilter

 Joyce Brinar
Chef

Stephen Carter
Puppeteer

Chris Carter
Puppeteer

Raven Skyriver
Glass Sculptor

Terri Drahn
Physical Therapist

Suzanne Whalen
*Sign Language
Interpreter*

Tamara Buchanan
Stone Sculptor

Holly Bower
Baker

Sheila Metcalf
Weaver

Esther Meneses de Alarcón
Knitter

Hawk Arps
Vibraphonist

Photo: Gregg Blomberg

Author **Iris Graville's** interviews, essays, and memoir pieces have been published in national and regional journals and magazines. Her son and daughter are grown, and she lives on Lopez Island, WA with her husband.

Photo: Gregg Blomberg

Summer Moon Scriver is a trusted wedding photographer, and her portrait and landscape photography has been shown in galleries across the Pacific Northwest. She lives on Lopez Island, WA with her partner and two sons.

Photo: Ken Burton

An award-winning graphic artist, **Robert Lanphear** has been designing books and publications for over 15 years. He lives and works in Seattle, WA.

Hands

©1972 Phil Ochs Estate

I've seen the hands of the laborer lifting all the loads.
Granite stuck to their fingers as they built the canals and the roads.
Now they're cleared and the bridges span,
Rivers paused by a power dam
and now, the hand of the laborer is reaching out to you.

Chorus:

Oh, the hands, hands, hands
That work to build the land, land your land.
The labor of the woman and the man
working with their hands.

I've seen the hands of the miner digging out the coal.
Black dust stuck to their fingers as they lived their lives in a hole.
Now the rock it's still under the ground and the mine is closing down
and now, the hand of the miner is reaching out to you.

Chorus

I've seen the hands of the lumberjack, forests swaying in the breeze.
Splinters stuck to their fingers as the lumber was torn from the trees.
Now the wood from your timers tall
has built your buildings from wall to wall
and now, the hand of the lumberjack is reaching out to you.

Chorus

I've seen the hands of the farmer plowing across the field.
Topsoil stuck to their fingers as the earth was split by the steel.
Growing all that they could grow to fill your tables row after row
and now, the hand of the farmer is reaching out to you.

Chorus

ACKNOWLEDGMENTS

Since we undertook this project four years ago, we've been blessed, supported, cajoled, advised, critiqued, and encouraged by large handfuls of friends, family, and colleagues. As inadequate as words are to acknowledge their contributions, we offer our sincere thanks to:

Our families—Jerry, Rachel, Matthew, Jaime, Cosmos, Rio, Irene, and Gregg—who were with us every step of the way with their love and unconditional support. They believed we would get to this day even when we didn't.

Our writer and photographer colleagues— Alice Acheson, Gregg Blomberg, Brooks, Amalia Driscoll, Greg Ewert, Karen Fisher, Kip Robinson Greenthal, Lorrie Harrison, Steve Horn, Heather June, Kimberly Kinser and the Pizarra Blanca Writers, Rita Larom, Leta Currie Marshall, Lorna Reese, Helen Sanders, John Sangster, Alie Smaalders, Mark Smaalders, Alysia Tromblay, Louis Webster—who generously shared their knowledge, experience, ideas, and contacts. They knew how and when to bolster us when we were discouraged, to push us to keep refining, and to tell us when to stop. Extra thanks to Lorna who read, critiqued, and re-read the manuscript nearly as many times as we did; and to Lorrie and Greg whose work inspired us and whose previous travel down the self-publishing road saved us many headaches.

Dorothy Conway and Maripat Murphy, copy editors and proofreaders extraordinaire, read every word and punctuation mark and between the lines as well. Every writer should be so lucky to have the skillful assistance they so graciously provided.

Bob Lanphear of Lanphear Design was an equal partner in this endeavor. He's a mix of computer geek and artist; a wizard with a computer keyboard and mouse; and a mystic who taught us to trust what he believes: "This book will tell us what it wants to be."

Most of all, we are indebted to the people presented in these pages. We arrived at their homes, farms, workshops, and studios with lights, cameras, black back-drops, notebooks, pens, and the gift of a jar of locally-made, soothing hand salve. We left with deep respect for the work they do as well as appreciation for their willingness to reveal its joys, frustrations, disappointments, and rewards. We thank them all for the privilege of entering their worlds of work and for being entrusted with their stories.

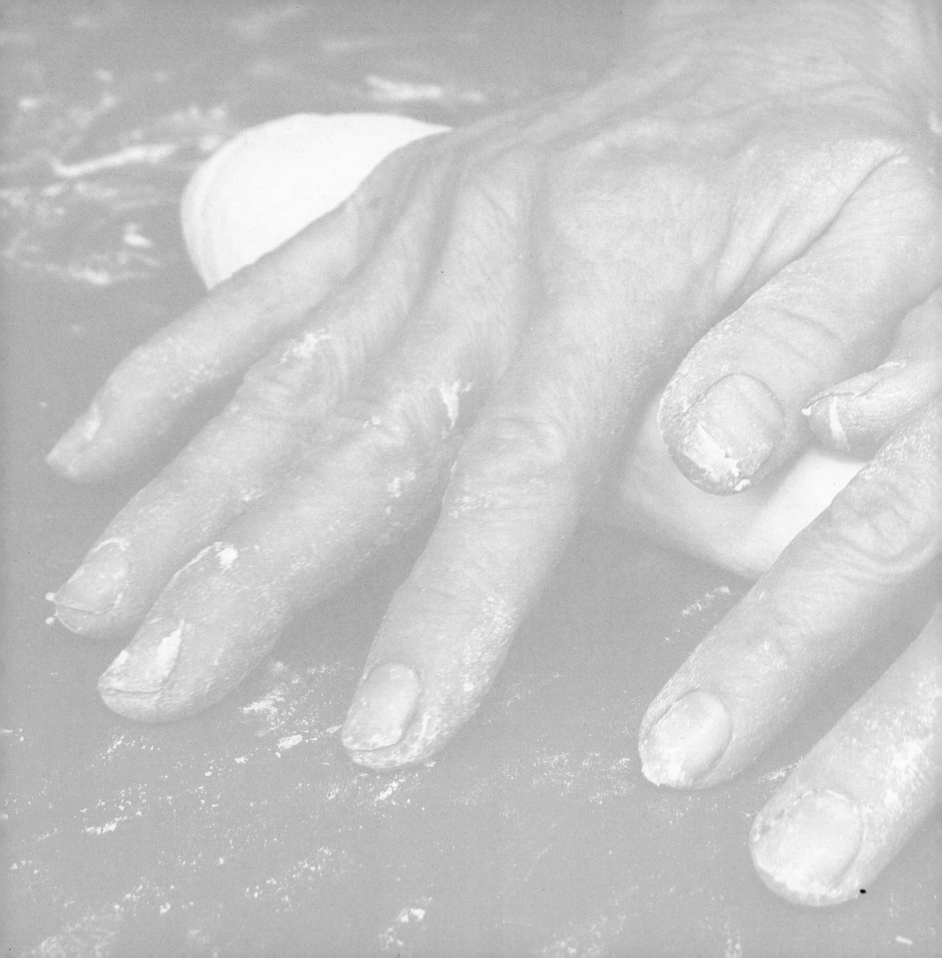